MW00563111

JEWELS OF THE NILE

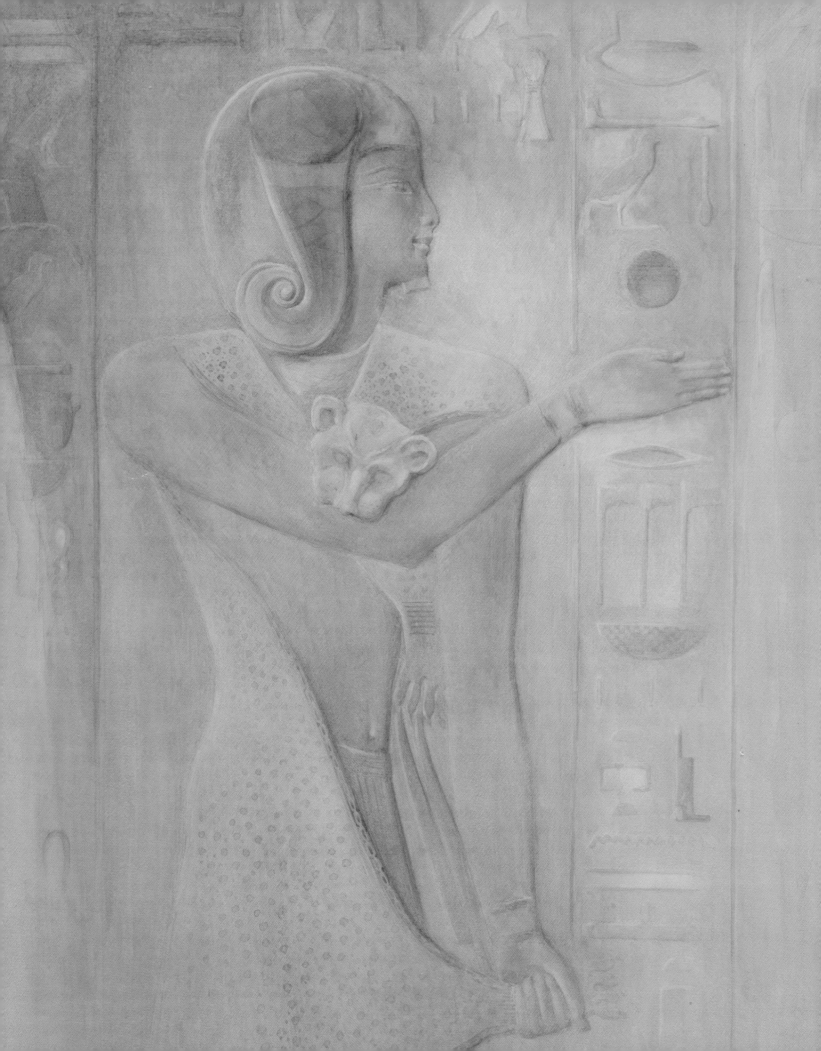

JEWELS

of the

NILE

Ancient Egyptian Treasures from the Worcester Art Museum

Peter Lacovara and Yvonne J. Markowitz

Edited by Sue D'Auria
With contributions by Paula Artal-Isbrand, Erin R. Mysak, and Richard Newman

WORCESTER ART MUSEUM

g

Worcester Art Museum, Worcester, Massachusetts, in association with D Giles Limited

Jewels of the Nile: Ancient Egyptian Treasures from the Worcester Art Museum is presented with support from the Fletcher Foundation. Additional project support is provided by Dr. Sohail Masood, his wife Mona Masood, and their children Laila Masood and Omar Masood.

The Worcester Art Museum expresses gratitude for the general operating support provided by the Mass Cultural Council, a state agency supported in part by the National Endowment for the Arts, Patrick and Aimee Butler Family Foundation, and the Carl Lesnor Family Foundation.

This catalogue accompanies the exhibition *Jewels of the Nile: Ancient Egyptian Treasures from the Worcester Art Museum* on display at the Worcester Art Museum, June 18, 2022–January 29, 2023

© 2020 Worcester Art Museum

First published in 2020 by GILES
An imprint of D Giles Limited
66 High Street,
Lewes, BN7 1XG, UK
gilesltd.com

ISBN: 978-1-911282-79-2
(hardcover edition)
ISBN: 978-0-578-68919-7
(softcover edition)

All images are © 2020 Worcester Art Museum, Worcester, Massachusetts, all rights reserved, unless otherwise indicated.

No part of the contents of this book may be reproduced, stored in a retrieval system, or transmitted in any form or by any means, electronic, mechanical, photocopying, recording, or otherwise, without the written permission of the Trustees of the Worcester Art Museum, and D Giles Limited.

Every effort has been made to contact the owners and photographers of objects reproduced here whose names do not appear in the captions or in the illustration credits at the back of this book. Anyone having further information concerning copyright holders is asked to contact the Worcester Art Museum so this information can be included in future printings.

The exhibition was curated by Peter Lacovara and Yvonne J. Markowitz

For Worcester Art Museum
Authors: Peter Lacovara and Yvonne J. Markowitz
Editor: Sue D'Auria
Contributors: Paula Artal-Isbrand, Erin R. Mysak, and Richard Newman
Project Manager: Claire C. Whitner, Director of Curatorial Affairs and James A. Welu Curator of European Art

For D Giles Limited
Copy-edited and proofread by Sarah Kane
Designed by Alfonso Iacurci
Produced by GILES, an imprint of D Giles Limited
Printed and bound in Slovenia

All measurements are in centimeters and inches; height precedes width precedes depth.

All the artifacts illustrated in the essays are from the collections of the Worcester Art Museum unless otherwise indicated. All the objects illustrated in the catalogue section are from the Mrs. Kingsmill Marrs Collection at the Worcester Art Museum unless otherwise stated.

Front cover:
Brooch featuring a skiff with blossoms and an ancient plaquette
New Kingdom, ca. 1539–1077
BCE (plaquette);
late 19th–early 20th century (mount)
Gift of Mrs. E.D. Buffington, 1914.2

Back cover:
Faience Ball-Bead
Necklaces (detail)
Middle Kingdom,
ca. 1980–1760 BCE
Mrs. Kingsmill Marrs Collection,
1925.632, 1925.633, 1925.634

Frontispiece:
Howard Carter
(British, 1873–1939)
Iunmutef, Priest from
the Tomb of Seti I (detail)
1909
Mrs. Kingsmill Marrs
Collection, 1925.141

Contents

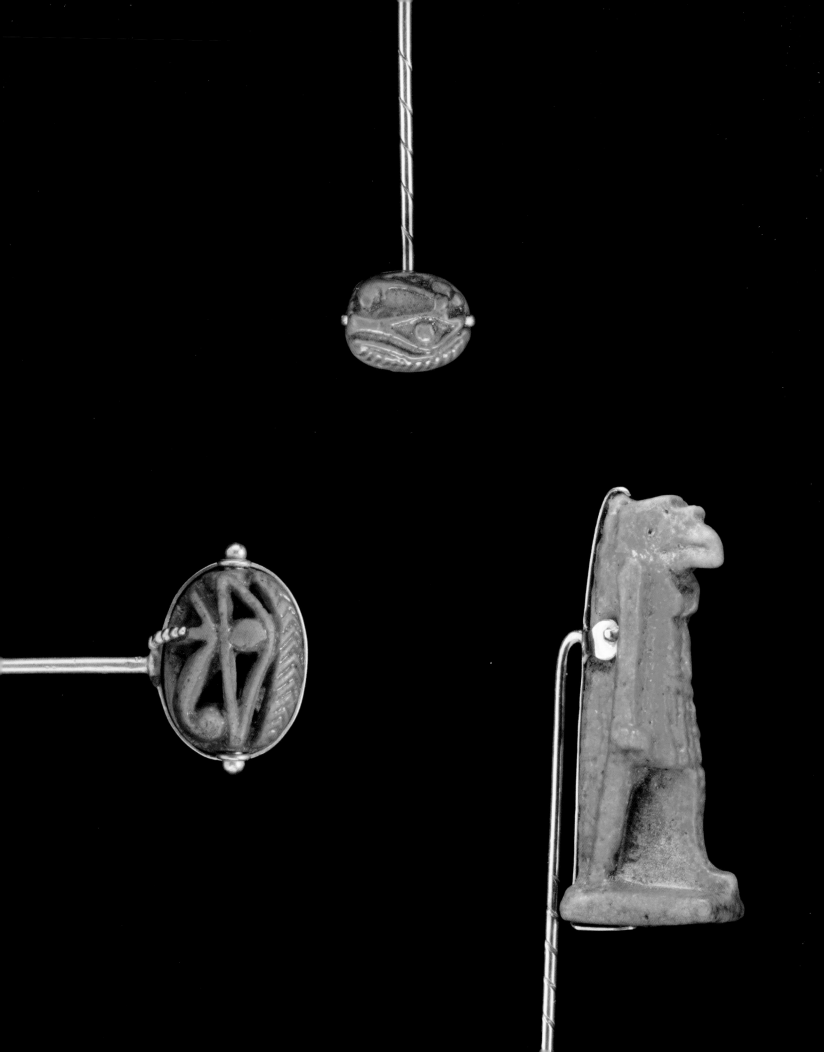

Foreword

Among the lesser known treasures in the Worcester Art Museum is a collection of extraordinary ancient Egyptian rings, necklaces, scarabs, pendants, and other ornaments assembled by Laura Marrs (1845–1926), the daughter of Boston's nineteenth mayor Otis Norcross. These works came to us in the mid-1920s and this exhibition marks the first time they have been shown comprehensively.

Captivated by the ancient world, Laura first traveled to Egypt with her husband, Kingsmill, in 1905. There, the couple met Howard Carter, who would later—in 1922—become famous for finding Tutankhamun's tomb. Prior to this career-burnishing discovery, he offered tours of Egypt's archaeological sites to well-heeled visitors and sold watercolors to them as souvenirs. The Worcester Art Museum (WAM) has six of Carter's paintings, which Laura and Kingsmill purchased during their trips. As a friendship developed between Carter and the Marrses, he offered his connoisseurial eye and professional connections to them as Laura began to put together the exceptional collection of Egyptian jewelry.

Director of the Ancient Egyptian Archaeology and Heritage Fund, Dr. Peter Lacovara first encountered Worcester's collection while working at the Michael C. Carlos Museum at Emory University. To enhance the presentation in his permanent collections galleries, he borrowed a selection of Egyptian objects from WAM from 2001 to 2005. Our then Curator of Greek and Roman Art, Dr. Christine Kondoleon, had brought his attention to these treasures in storage, and, through grant funding from the Museum Loan Network led by Lori Gross at MIT and underwritten by the Pew Charitable Trust, he was able to fund conservation treatment for some objects and pay for their transport to Atlanta, Georgia. WAM's Chief Conservator at the time, Lawrence Becker, provided the treatment for the objects traveling to the Carlos Museum with the assistance of Egyptian adornment expert Sheila Shear. The outstanding quality of the Marrs jewelry collection lingered in Dr. Lacovara's memory for many years, and, as the centenary of Carter's great discovery approached, he proposed a comprehensive presentation of these exquisite objects to be curated with Yvonne J. Markowitz, the Rita J. Kaplan and Susan B. Kaplan Curator Emerita of Jewelry at the Museum of Fine Arts, Boston. WAM's former Director of Curatorial Affairs Dr. Jon Seydl immediately saw the value in bringing new scholarship to this understudied area of our collection and supported the exhibition with great enthusiasm.

Yvonne Markowitz and Peter Lacovara, our esteemed guest curators of *Jewels of the Nile: Ancient Egyptian Treasures from the Worcester Art Museum*, have brought their extensive knowledge of Egypt and adornment to bear on this distinctive collection. Through their research and curatorial expertise, they have deftly interwoven the narrative of a previously unsung female collector with the history of Egyptian technology and implementation of a wide array of materials to create astonishingly intricate designs at an intimate scale.

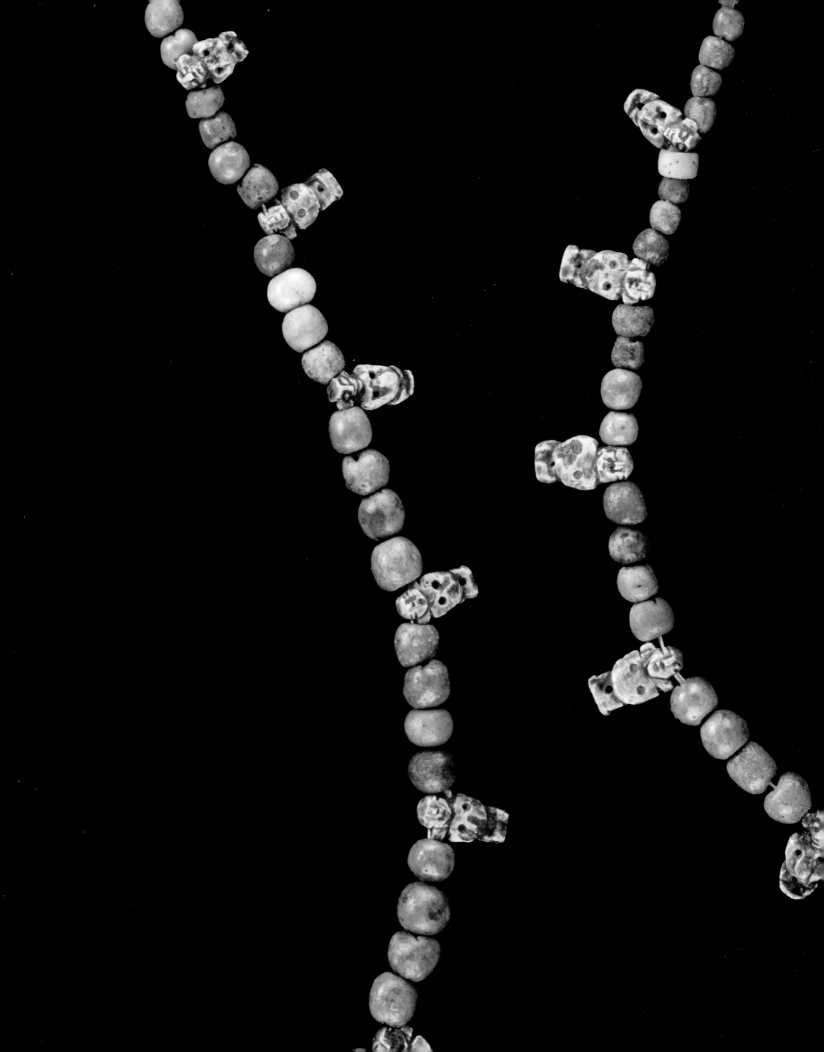

Working closely with the exhibition's curators, the Worcester Art Museum's Objects Conservator Paula Artal-Isbrand has surveyed, cleaned, and when necessary provided conservation treatment for each object on this extensive checklist. She also replaced the string of necklaces and armlets. Her study of the objects yielded numerous discoveries that are discussed in this catalogue.

Curatorial research for the exhibition and catalogue was bolstered by access to primary source documents available at archives, libraries, and other institutions in Massachusetts. We are particularly grateful to Katherine Gardner-Wescott, Curator at the Wayland Historical Society, and the generous staff of the Massachusetts Historical Society, particularly Curator of Art and Artifacts Anne Bentley, and Vice President for Collections Brenda Lawson. Additional expertise and assistance was lent by Dr. Denise Doxey, Curator of Ancient Egyptian, Nubian, and Near Eastern Art, Ariana Bishop, Research Assistant for Jewelry, as well as Richard Newman, Head of Scientific Research at the Museum of Fine Arts, Boston, and Erin Mysak, independent conservation scientist. We are similarly thankful to Jennifer Riley, Visual Archives Manager at the MFA Boston. We express our gratitude to everyone at the Worcester Art Museum who dedicated themselves to ensuring the success of this exhibition. In particular, we would like to highlight the long hours Associate Registrar Sarah Gillis dedicated to assembling images and securing publication rights for this catalogue—a complex task that demanded uncommon attention.

The catalogue for *Jewels of the Nile* benefited from the editorial oversight of renowned Egyptologist Sue D'Auria. Our collaboration with D Giles Ltd. has produced this beautiful volume, and we therefore wish to thank Dan Giles and his staff for their thoughtful design and marketing of this catalogue.

Important loans from Tiffany & Co. Archives, facilitated by Corporate Archivist Annamarie Sandecki, allowed the curators to establish the context for the period in which Laura Marrs was collecting with stunning examples of Egyptian revival jewelry. Additional key objects were lent by the Mineralogical and Geological Museum at Harvard University with the support of Curator Dr. Raquel Alonzo Perez and Assistant Curator Kevin M. Czaja. Sue McGovern-Huffman of Sands of Time Ancient Art, Robin Beningson at Antiquarium Ltd., and Dr. Robert Brier also lent material that enriched the exhibition's content. Lastly, we are grateful to the exhibition's underwriters, who made it possible for us to present this wonderful collection. We wish to express our gratitude to Dr. Sohail Masood, his wife Mona Masood, and their children Laila Masood and Omar Masood as well as the Fletcher Foundation for their extraordinary support of this exhibition and catalogue. On the centenary of the discovery of Tutankhamun's tomb, we invite our visitors to enjoy the intricate treasures of Laura Marrs's collection and usher in a twenty-first-century resurgence of Egyptomania.

Matthias Waschek
Jean and Myles McDonough Director
Worcester Art Museum

Claire C. Whitner
Director of Curatorial Affairs and
James A. Welu Curator of European Art
Worcester Art Museum

Chronological Table of Ancient Egypt[1]

Predynastic Period to Dynasty 0 (before 2900 BCE)

Archaic Period (ca. 2900–2544 BCE)

Dynasty 1	ca. 2900–2730 BCE
Dynasty 2	ca. 2730–2590 BCE
Dynasty 3	ca. 2592–2544 BCE

Old Kingdom (ca. 2543–2118 BCE)

Dynasty 4	ca. 2543–2436 BCE
Dynasty 5	ca. 2435–2306 BCE
Dynasty 6	ca. 2305–2118 BCE
Dynasty 7	?[2]
Dynasty 8	ca. 2150–2118 BCE

First Intermediate Period (ca. 2118–1980 BCE)

(Heracleopolitan) Dynasties 9 & 10	ca. 2118–2080 BCE
(Theban) Pre-Conquest Dynasty 11	ca. 2080–1980 BCE

Middle Kingdom (ca. 1980–1760 BCE)

Post-Conquest Dynasty 11	ca. 1980–1940 BCE
Dynasty 12	ca. 1939–1760 BCE

Second Intermediate Period (ca. 1759–1539 BCE)

Dynasty 13 (Egyptian)	ca. 1759–1630 BCE
Dynasties 14–16 (Hyksos)	?–ca. 1530 BCE
Dynasty 17 (Theban)	?–ca. 1539 BCE

New Kingdom (ca. 1539–1077 BCE)

Dynasty 18	ca. 1539–1292 BCE
Dynasty 19	ca. 1292–1191 BCE
Dynasty 20	ca. 1190–1077 BCE

Third Intermediate Period (ca. 1076–655 BCE)

Dynasty 21	ca. 1076–944 BCE
Dynasty 22	ca. 943–746 BCE
Dynasty 23	ca. 845–730 BCE
Dynasty 24	ca. 736–723 BCE
Dynasty 25 (Kushite)	ca. 722–655 BCE

Late Period (664–332 BCE)

Dynasty 26 (Saite)	664–525 BCE
Dynasty 27 (Persian)	525–404 BCE
Dynasty 28	404–399 BCE
Dynasty 29	399–380 BCE
Dynasty 30	380–343 BCE
Dynasty 31	343–332 BCE

Greco-Roman Period (332 BCE–642 CE)

Macedonian Dynasty	332–305 BCE
Ptolemaic Period	305–30 BCE
Early Roman Period	30 BCE–2nd Century CE
Late Roman/Byzantine Period	2nd Century–642 CE
Arab Conquest	642 CE

Endnotes

1. The dates on this list are based on those published in Hornung, Kraus, and Warburton 2006.
2. The dates and existence of this dynasty are in dispute.

Maps of Egypt, Nubia, and Thebes

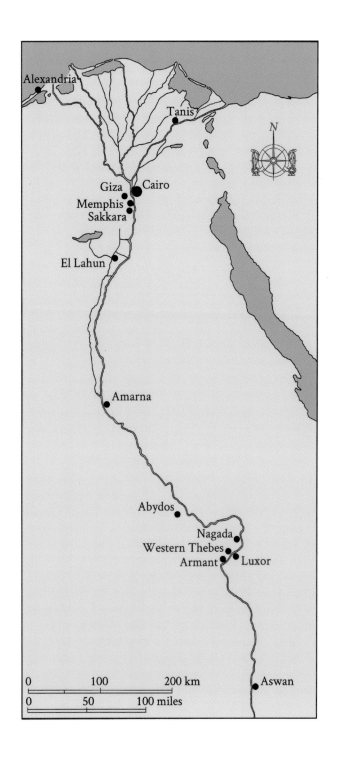

Alexandria

Tanis

N

Giza
Cairo
Memphis
Sakkara

El Lahun

Amarna

Abydos

Nagada
Western Thebes
Armant
Luxor

Aswan

0	100	200 km

0	50	100 miles

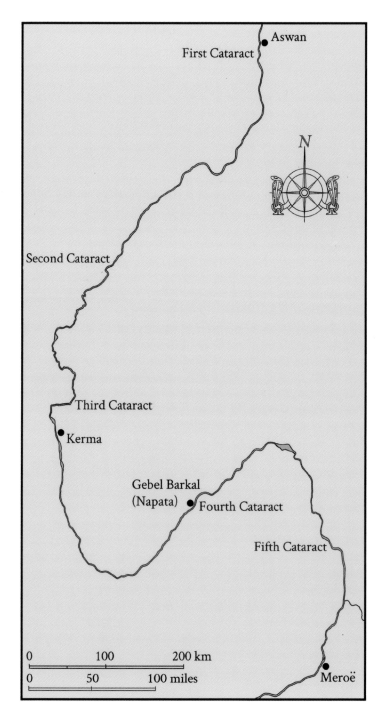

Aswan
First Cataract

N

Second Cataract

Third Cataract

Kerma

Gebel Barkal
(Napata)
Fourth Cataract

Fifth Cataract

0	100	200 km

0	50	100 miles

Meroë

West Valley
(Tomb of
Amenhotep III
& Queen Tiye)

Valley of the Kings
(Tomb of Amenhotep II)
(Tomb of Tutankhamun)

Dra Abu
el-Naga

Howard Carter's
House

Deir el-Bahri

Tomb of Menna

Valley of the
Queens

(Tomb of
Nefertari)

Tomb of Ramose

Seti 1
Mortuary
Temple

Malqata

Medinet
Habu

Karnak
Temples

Western Thebes

NILE

Luxor

0 1 2 km

0 1 mile

Winter Palace
Hotel

N

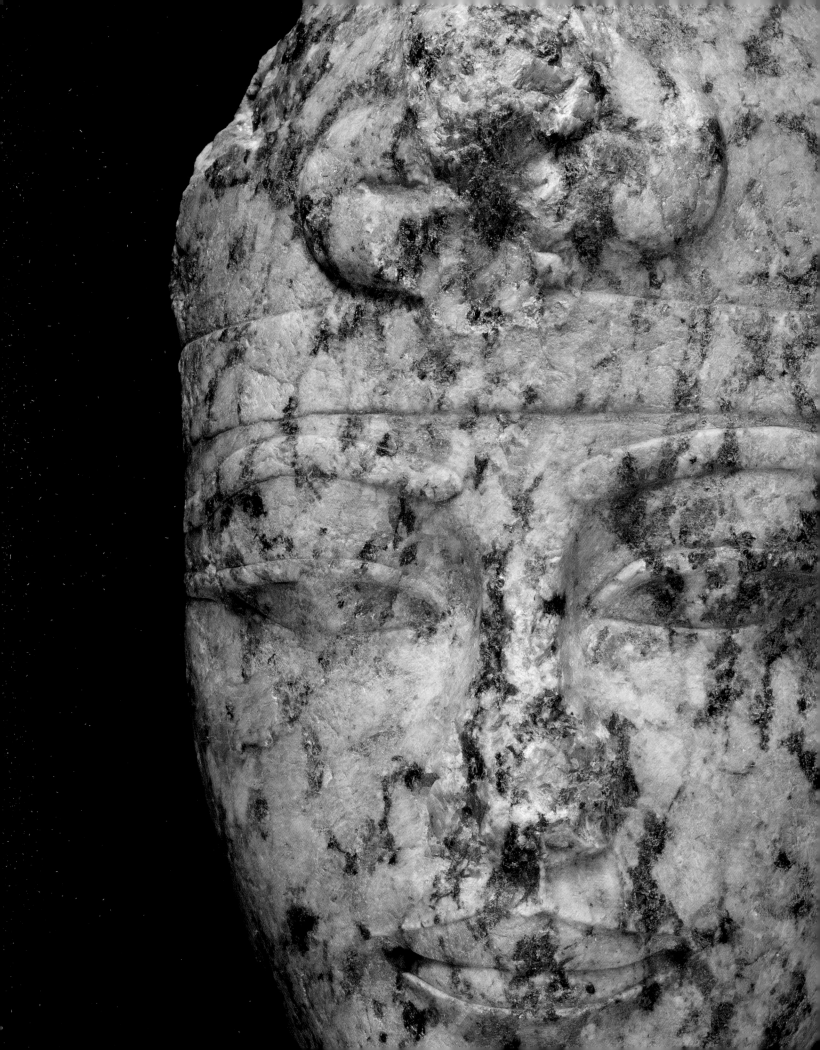

A BRIEF HISTORY OF ANCIENT EGYPT

Peter Lacovara

INTRODUCTION

Ancient Egypt was one of the earliest civilizations and perhaps the longest lasting, and it has fascinated the rest of the world from antiquity to the present day. Located in northeast Africa at the eastern end of the Sahara Desert, the ancient state occupied similar territory to that of the present-day Arab Republic of Egypt. The name "Egypt" comes from the Greek *Aegyptos*, which was how they pronounced the ancient Egyptian *Hwt-Ka-Ptah* and translates as "The Mansion of the Spirit of Ptah"—the name for the ancient capital city of Memphis, near modern-day Cairo. Other names used were *Kemet*, meaning "The Black Land," referring to the alluvial soil of the Nile Valley, as opposed to *Deshret*, "The Red Land," meaning the inhospitable desert that bordered both sides of the river. If geography is destiny, it certainly smiled on the land of Egypt. The Nile would flood annually, bringing down fresh, rich mud that was deposited along the wide banks of the river in the Nile Valley and spreading out fan-like in the Delta, where the river branched off and met the Mediterranean. This would give the country agricultural wealth unrivalled anywhere else, while the sea and the deserts as well as the rocky cataracts, or rapids in the Nubian stretch of the Nile, gave it a measure of protection on all sides and allowed a great civilization to grow and flourish. The geographical designations used by the ancient Egyptians follow the direction of the Nile River, one of the few in the world that runs south to north, so Upper Egypt is in the south, and Lower Egypt in the north.

Given its extraordinarily long duration, for convenience sake Egyptologists have divided Egypt's history into a number of periods, and within them dynasties, which often, though not always, constituted members of a ruling family, as recorded somewhat imperfectly in antiquity. The period before Egypt developed into a single nation is known as the Predynastic Period (before 2900 BCE), the prehistoric period before the appearance of written records, which begins with the First Dynasty. The Nile Valley had been the main route by

which early man left Africa and spread throughout the rest of the world. By the end of what is commonly known as the Old Stone Age, the Sahara Desert was occupied by nomadic pastoralists herding cattle, sheep, and goats, but as the climate changed and gradually became drier, people began to migrate to the Nile Valley and Delta, creating permanent settlements and adopting agriculture (fig. 1). This seems to have first occurred in the area around Khartoum, the present-day capital of Sudan, and by about 4500 BCE a culture known as the Badarian, named after the site of Badari, appeared in Upper Egypt with many similarities to the Sudanese cultures to the south.

The Predynastic culture of Upper Egypt then developed through several stages named for the various type sites where the remains were found. These are known as the Amratian or Naqada I, the Gerzean or Naqada II, and Naqada III, based largely on the stylistic development of their pottery. They were closely related to Sudanese African traditions, while in the area of the Delta, known as Lower Egypt, craft traditions were more closely aligned with those of Southwest Asia. Over time, the villages coalesced into increasingly larger political units, until finally, around 3100 BCE, the entire country was unified under a single ruler. This was recorded on the palette of Narmer commemorating a victory over his enemies, which depicts the king wearing the Red Crown, symbol of Lower Egypt, and the White Crown, the insignia of Upper Egypt. Throughout the rest of Egyptian history, a duality was maintained between Upper Egypt in the south and Lower Egypt in the north, and the ruler was called "King of Upper and Lower Egypt."

Fig. 1

Arrowhead
Predynastic Period, before 2900 BCE
Flint
6.5 × 2.6 cm (2 9/16 × 1 in.)
Mrs. Kingsmill Marrs
Collection, 1925.382

As the area of North Africa that is now the Sahara Desert began to dry up, people moved into the Nile Valley, which was teeming with fish and game and blessed with lush vegetation. During the end of the Old Stone Age (ca. 10,000–7000 BCE), arrowheads first appear, and, by the beginning of the Predynastic Period (ca. 4800 BCE), the hollow-base arrowhead appears, characteristically in the area of the Fayum Basin in Lower Egypt. These projectile points were most often made from flint, which was found in abundance in the form of cobbles lying on the high desert's surface where it had been weathered out of the limestone. Whether these arrowheads were attached to wooden or reed shafts to be shot as arrows or used in spears is unclear.

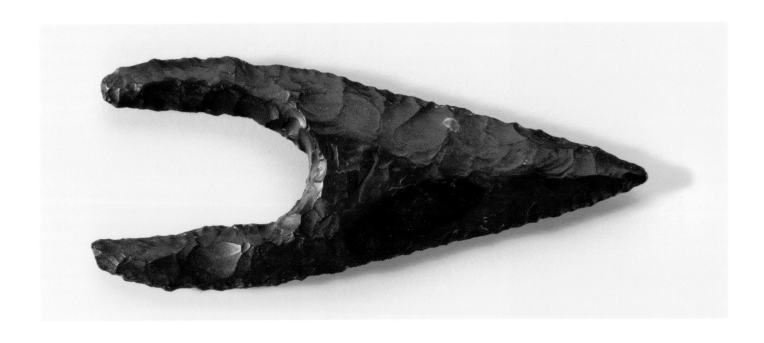

Fig. 2

Henry Bacon (American, 1839–1912)
**The Stepped Pyramid at
Sakkarah at Noon**
1903
Watercolor over graphite on medium,
smooth cream wove paper
35.7 × 53.6 cm (14 1/16 × 21 1/8 in.)
Gift of Mrs. Frederick L. Eldridge in
memory of Henry Bacon, 1943.29

The Step Pyramid at Sakkara is one
of the most remarkable structures
in the world: not only the first
pyramid, but also the first large stone
building. Its architect, Imhotep,
would achieve divine status for this
feat. Built for the Third Dynasty king
Djoser, it started out as a rectangular
stone mastaba tomb, before being
enlarged and turned into a four-
stepped pyramid by the addition of
further mastabas one on top of the
another. It was finally transformed
into a six-stepped pyramid, reaching a
height of 205 feet.

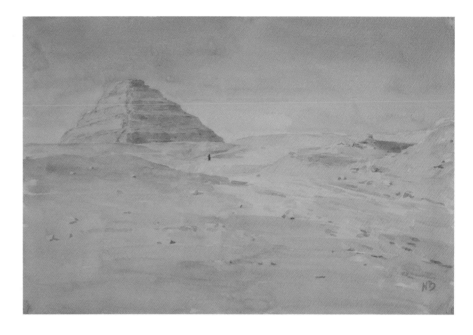

THE ARCHAIC PERIOD, DYNASTIES 1–3 (CA. 2900–2544 BCE)

The first few dynasties are grouped by Egyptologists under the term the Archaic Period (sometimes the Early Dynastic Period). This saw the unification of the north and south under a king named Menes, as recorded by an Egyptian priest called Manetho, who wrote down the history of Egypt up until his own lifetime, in the third century BCE. Though his original writing has not survived, it was later documented by the Jewish historian Josephus. It had been thought that "Menes" was Narmer, but it is now believed that he was in fact his successor, King Hor-Aha. It is the first of many uncertainties in the chronology of Manetho.

One of the problems facing scholars trying to reconstruct the history of ancient Egypt is that there was no standard record of time. When a new king came to the throne, the clock would start again at year one, so that our chronology is built up of many hundreds of pieces that are constantly being reinterpreted and revised. It has even been suggested that the Narmer palette may not depict an actual military victory, but was just royal propaganda; this would hardly be the only case in Egyptian history, since the rulers often embroidered their own exploits. But what is remarkable about the palette is that it sets artistic conventions for more than three millennia: not only the standard depiction of people with the face and legs in profile and the chest frontal, but also certain iconographical features—for example, Roman emperors depicted on Egyptian temples appear in the same pose smiting enemy captives as Narmer and wear basically the same costume.

What we see in the Archaic Period is the development of the standards of expression—artistic, architectural, and literary—that course through the rest of ancient Egyptian history. Much of this development at its beginning was spurred on by contact with Mesopotamia, which inspired the Egyptians to create monumental brick architecture and a writing system, though very much their own. The family of Narmer appear to have come from the southern city of Hierakonpolis and were buried at the site of Abydos in the middle of Egypt. Later Egyptian myth equated Abydos with the burial place of the first king of Egypt, who was believed to be the god of the dead, Osiris. As a result, Abydos became a place of pilgrimage and the most holy city in Egypt.

The early kings were buried in elaborate brick tombs, known as "mastabas," from the Arabic word for a rectangular mud bench. By the end of the Second Dynasty, the royal burial ground had moved to the site of Sakkara near the new capital, Memphis. Throughout this period the royal tombs grew larger and larger and gradually incorporated the use of stone until finally Imhotep, vizier and architect to King Djoser at the beginning of the Third Dynasty, created first a stone mastaba and then a series of them piled one upon another to create the first pyramid, the Step Pyramid of Sakkara (fig. 2).

Fig. 3

J. Pascal Sébah (Turkish, 1838–1890)
The Great Sphinx
ca. 1880
Albumen print from wet collodion negative
20.7 × 26.5 cm (8 1/8 × 10 7/16 in.)
Transferred from Museum Library, 2005.285.9

The true pyramid with straight sides appears at the beginning of the Fourth Dynasty and reaches its zenith with the pyramids at Giza. The first of these, known as the "Great Pyramid," was constructed for King Khufu. Much of the limestone of the inner core of the structure was quarried locally, so that when it came time for Khufu's son Khafre to build his monument, the level of the plateau had significantly dropped, but a large outcrop of rock remained. Since it was in the area where the entrance causeway and its associated Valley Temple were to be placed, the stone was sculpted into the form of a lion, with the king's head becoming the Great Sphinx. In later times the statue was even worshipped as a god.

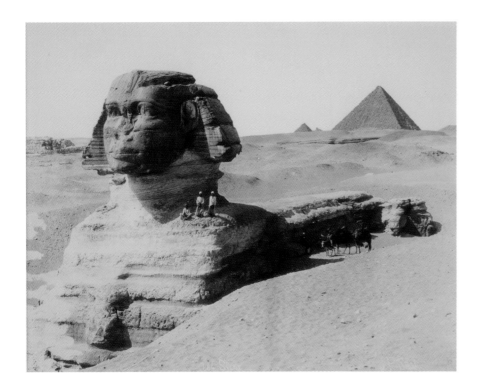

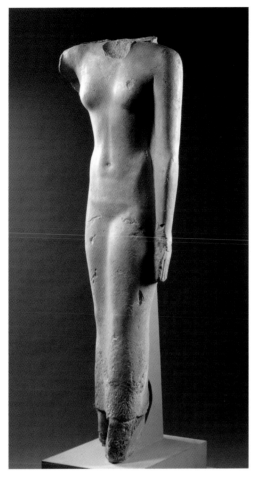

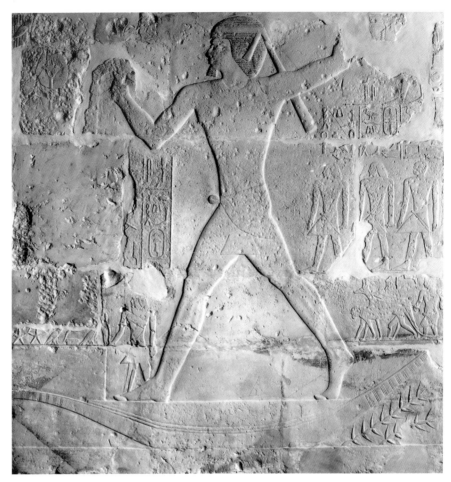

Fig. 4

The Royal Descendant Hetepheres
Giza, Old Kingdom, Dynasty 4,
ca. 2543–2436 BCE
Limestone
137.2 × 44.6 × 26.5 cm
(54 × 17 9/16 × 10 7/16 in.)
Museum Purchase, 1934.48

The Pyramids at Giza and elsewhere
were surrounded by the mastaba tombs
of members of the court and royal
family. While the burials were sealed in
subterranean chambers below ground,
the tomb chapels were open to visitors
and decorated with carved reliefs and
statues. This sculpture of Hetepheres
was originally part of a group set in a
stone niche in the chapel. It depicted
Hetepheres along with her son—a
senior official named Ra-Wer—and
two of the latter's children. Ra-Wer
had a string of important titles that
included hairdresser to the king. As
in later European courts, individuals
of high rank were associated with
intimate duties for royal figures.
These sculptures were not merely
decorative or commemorative but
served as substitute bodies for the
soul of the deceased should anything
happen to the mummy.

Fig. 5

Ny-ankh-nesuwt Hunting on the Nile
Sakkara, Old Kingdom, Dynasty 6, ca. 2305–2118 BCE
Limestone
177.8 × 172.7 cm (70 × 68 in.)
Museum Purchase, 1931.99

The walls of the chapels of elite tombs
in the Old Kingdom were decorated
with scenes of daily life so that the
deceased would be able to participate
in them after death. This relief from
a tomb at Sakkara depicts Ny-ankh-
nesuwt standing in a papyrus skiff,
hunting birds on the Nile. In front of
him is shown his eldest son, depicted
in much smaller scale to emphasize
the exalted status of his father. He
holds a throwing stick in his right
hand, similar to the one his father
has raised and is about to toss at
a flying bird.

Standing behind them are three rows
of individuals, also at a small scale.
Only a fragment of the legs of a man
in the upper register survives, while
two other sons of Ny-ankh-nesuwt
and a priest appear in the middle
register. A comical dwarf leads a
monkey and a dog on leashes in the
lower register. There are still traces of
paint on the relief as well as ancient
graffiti including a cat, a dog, a bird,
and some plants, that were scratched
into the relief at a much later date.

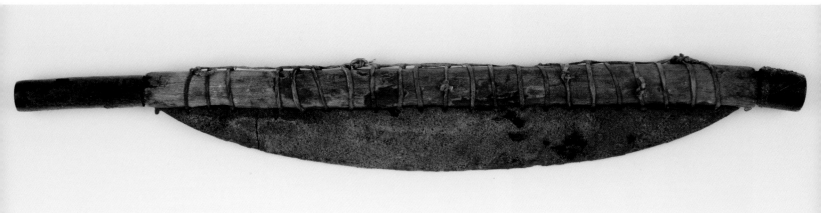

THE OLD KINGDOM, DYNASTIES 4–8 (CA. 2543–2118 BCE)

In the succeeding Old Kingdom, Egypt developed at an incredible rate and created some of its most iconic monuments, the Pyramids of Giza and the Great Sphinx (fig. 3). Snefru is credited with constructing the first true pyramid, having built at least two—the Bent Pyramid and the Red Pyramid at Dahshur—and his son, Khufu, created the "Great Pyramid." Also at Giza are the pyramid of Khafre and the Great Sphinx, and the pyramid of Menkaure. The pyramids were surrounded by vast cemeteries of stone mastaba tombs belonging to royal relatives and officials of the government (fig. 4). All this construction served to unite the country and acted as the economic motor that powered it. Over time, however, the grandeur of the pyramids diminished, while the size and decoration of the private tombs became ever more elaborate (fig. 5), reflecting the growing power of the bureaucracy and the regional governors in particular.

THE FIRST INTERMEDIATE PERIOD, DYNASTIES 9–10 AND PRE-CONQUEST DYNASTY 11 (CA. 2118–1980 BCE)

The weakening of the central government in the late Old Kingdom would usher in an era known as the First Intermediate Period. The history of Egypt is marked by high points like the Old, Middle, and New Kingdoms but also by periods of turmoil and collapse known as the Intermediate Periods (First, Second, and Third). Although these were times of economic downturn and internecine warfare (fig. 6), they also saw artistic and social change. During the First Intermediate Period, independent districts developed, each with its own rulers. Eventually two rival principalities arose, Heracleopolis in Lower Egypt and Thebes in Upper Egypt. Ultimately, the Theban king Mentuhotep II (ca. 2009–1959 BCE) defeated the forces of the north and united Egypt under the rule of Thebes.

Fig. 6

Battle axe
First Intermediate Period,
ca. 2118–1980 BCE
Bronze, wood, and leather
55 × 7.5 cm (21 5/8 × 2 15/16 in.)
The John Woodman Higgins Armory
Collection, 2014.344

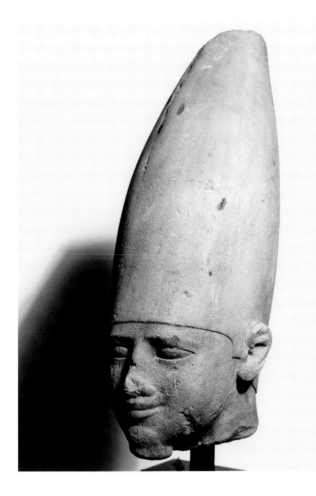

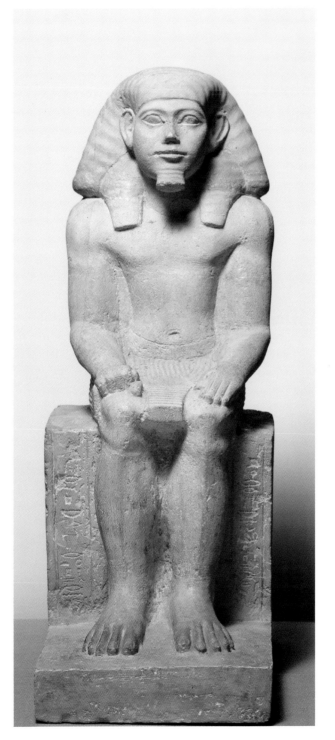

Fig. 7

Head of Mentuhotep III
Armant, Middle Kingdom, Post-
Conquest Dynasty 11, Reign of
Mentuhotep III, ca. 1980–1940 BCE
Limestone
61.6 × 21.3 × 31.8 cm
(24 ¼ × 8 ⅜ × 12 ½ in.)
Alexander H. Bullock Fund, 1971.28

After the internecine warfare of the
First Intermediate Period, Egypt
was reunified by local rulers of the
Theban area. Mentuhotep II founded
the Middle Kingdom and built a great
funerary temple in Western Thebes
in the bay of Deir el-Bahri. His son,
Mentuhotep III, constructed a temple
to the dynasty's titular god, Montu,
at Armant, just south of Thebes. This
head of Mentuhotep wearing the
White Crown of Upper Egypt is from
one of eight statues discovered that
depicted the king in the pose of the
mummified Osiris. The sculptures still
show the rather provincial style of the
First Intermediate Period. They were
later re-inscribed by King Merenptah
of the Nineteenth Dynasty and still
later were taken down and buried
beneath the floor of a temple built in
the Greco-Roman Period.

Fig. 8

Djefhapi
Middle Kingdom, Dynasty 12,
ca. 1939–1760 BCE
Limestone
52.4 cm (20 ⅝ in.)
Museum Purchase, 1938.9

In the Twelfth Dynasty the royal court
moved back to the Memphis area
and revived the classical styles of the
Old Kingdom. This statue of Djefhapi
shows him seated on a block seat in
a traditional pose found on earlier
statues, with one hand flat on his
lap and the other clenched in a fist,
and wearing a short, pleated kilt. His
broad, muscled body is also typical of
earlier statues. He wears a short beard
and an unusual hairstyle with lappets
protruding from under a flaring wig
typical of the Middle Kingdom. The
statue was carved of limestone but
faux-painted to look like granite.
Djefhapi served as a priest of Osiris
in the town of Assiut in Middle
Egypt, and this statue was probably
made for his tomb.

THE MIDDLE KINGDOM, POST-CONQUEST DYNASTY 11–DYNASTY 12 (CA. 1980–1760 BCE)

Mentuhotep's victory would establish Thebes as a principal city and its local god, Amun, as the state god, whose temple at Karnak would grow to become one of the largest religious centers the world would ever see. Mentuhotep built his funerary temple at a place called Deir el-Bahri on the west bank of the Nile across from Karnak and decorated it with beautiful painted sculptures and reliefs that still retain some of the style of the Intermediate Period (fig. 7).

During the Middle Kingdom, art and literature also reached great heights, and craftsmanship in everything from sculpture to jewelry was never equaled. The kings of the Twelfth Dynasty returned the capital to the north and revived Old Kingdom styles in art (fig. 8) and architecture, as seen in the pyramids they built at Sakkara, Dahshur, El Lahun, and Hawara. Thebes still continued to flourish as well, and became the most important religious center in the country. They also established control over Nubia to the south, with a string of frontier fortresses that were constructed to protect Egyptian trading interests and exploit the rich gold fields of the region.

Eventually, however, the kings again saw their power and prestige eroding, and the Thirteenth Dynasty witnessed a succession of weak, unrelated kings. Since foreign trade was in the hands of the central administration, the trade networks broke down, and itinerant traders from Cyprus and the area of Syria–Palestine migrated into the Delta and settled in the town of Avaris. They eventually became rich and powerful enough to establish their own kingdom and were called by the Egyptians the *heqa khasut* or Hyksos, meaning "rulers of foreign lands." They grew in power until they were able to take control of a significant portion of Lower Egypt; the country fragmented, with dynasties ruling at Abydos and at Thebes.

THE SECOND INTERMEDIATE PERIOD, DYNASTIES 13–17 (CA. 1759–1539 BCE)

During the Second Intermediate Period, a number of rival dynasties ruled concurrently in the Delta, Abydos, and Thebes. In the south, in Nubia, the Kingdom of Kush, centered at Kerma (fig. 9) at the Third Cataract, also grew to rival Egypt and eventually not only took over the string of frontier fortresses established in the Second Cataract, but actually attacked Egypt itself. The Theban kings, squeezed between the Hyksos in the north and the Kerma Nubians in the south and threatened by an alliance between the two enemy powers, mounted a number of campaigns to drive the Hyksos out of Egypt and subdue the Nubians. The Theban king Seqenenre Tao appears to have been

Fig. 9

Kerma beaker
Nubia or Egypt, Classic Kerma/Second Intermediate Period, 1759–1539 BCE
Ceramic
10.8 × 13.3 cm (4 ¼ × 5 ¼ in.)
Mrs. Kingsmill Marrs
Collection, 1925.304

The kings of the Middle Kingdom created a series of fortresses along the Nubian border to control the Nilotic trade and the rich gold fields in the area. However, with the weakening of Egypt's presence during the Second Intermediate Period, a powerful kingdom arose in the area of the Third Cataract. This kingdom, called Kush by the Egyptians and centered at the site of Kerma, eventually invaded Egypt itself and was only defeated by a series of military campaigns conducted by the kings of the early Eighteenth Dynasty. Finely made black-topped pottery beakers such as this were a hallmark of the Nubian Kerma culture. A number of them have also been found in Egypt, either in the graves of Nubians who brought them with them or as trade items.

Fig. 10

Erskine E. Nicol (Scottish, 1890–1926)
The Temple of Queen
Hatshepsut, Der El Bahri
1908
Watercolor
54.8 × 78.2 cm (21 9/16 × 30 13/16 in.)
Mrs. Kingsmill Marrs
Collection, 1925.477

The kings of the New Kingdom often married their sisters to strengthen their claim to the throne, particularly if they were not born of the principal queen, the "great royal wife." Thutmose II, who ruled ca. 1482–1480 BCE, was the son of King Thutmose I and a minor wife, and so married his half-sister Hatshepsut to secure his claim to the throne. He died, however, after a short reign and left Hatshepsut as regent for his young son Thutmose III, also by a minor wife.

After a period of about seven years as regent, Hatshepsut took the unprecedented step of elevating herself to co-ruler with the young Thutmose III; she referred to herself as king, and even depicted herself in the guise of a male ruler. To further legitimize herself, she built a splendid mortuary temple at Deir el-Bahri next to, and partly modeled on, the temple of Mentuhotep II, who was revered as the founder of the Middle Kingdom.

killed in battle with the Hyksos, but his successors Kamose and Ahmose were eventually able to reunite the country.

THE NEW KINGDOM, DYNASTIES 18–20 (CA. 1539–1077 BCE)

Ahmose ushered in the New Kingdom, Egypt's "Golden Age," which saw the creation of an empire that stretched from the Fourth Cataract in Nubia to Syria, with great wealth derived from foreign conquest. The pyramids, which may have been robbed in the turmoil of the Hyksos period, were no longer used as royal tombs, and instead the kings were buried in a remote location in Western Thebes now known as the Valley of the Kings. To keep their memory alive and maintain their funerary offerings, they built memorial temples along the edge of the cultivation in Western Thebes. One of the most beautiful was built by Queen Hatshepsut (fig. 10), who had ruled as regent for her young stepson Thutmose III but eventually took kingly titles herself, even being depicted as a male ruler. After ruling for twenty-two years, Hatshepsut died and Thutmose III became sole ruler, carrying out a series of military campaigns and stretching the Egyptian Empire to its greatest limits.

Thutmose III's grandson, Amenhotep III (fig. 11), was perhaps Egypt's most prolific builder, creating monuments the length of the Nile. He built a lavishly decorated palace at Malqata in Western Thebes for his jubilee festivals, the first of which marked thirty years of rule. Because the royal palace was so closely connected to the government, during the New Kingdom the word for palace—*pr a'a* or "pharaoh," meaning "the Great House"—came to be applied to the ruler of Egypt himself.

Soon after Amenhotep III's son Amenhotep IV acceded to the throne, he changed his name to Akhenaten, "the living spirit of Aten," to reflect his belief in a single god, Aten. Known as the "heretic pharaoh," Akhenaten not only changed the religion but also the art style, varying from a cartoonish mannerism to a sensuous naturalism. There have been many explanations for this radical departure, but most probably it was to counter the growing wealth

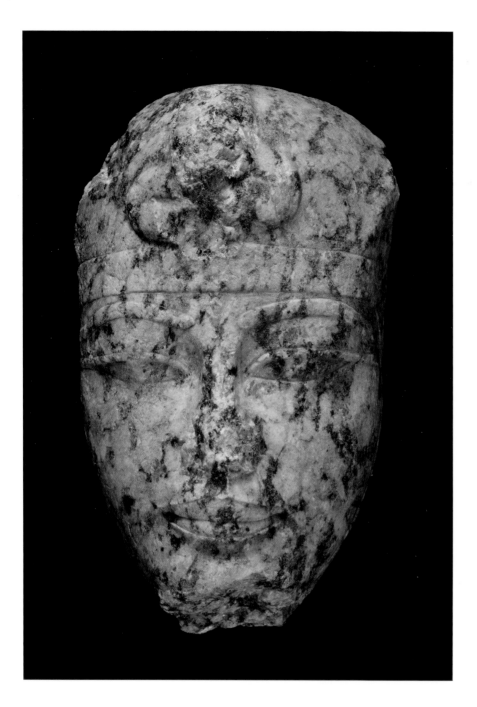

Fig. 11

Head of King Amenhotep III
New Kingdom, Dynasty 18, Reign of
Amenhotep III, ca. 1390–1353 BCE
Red granite
17.8 cm (7 in.)
Mrs. Kingsmill Marrs
Collection, 1925.606

Perhaps the greatest builder in
Egyptian history was Amenhotep III,
who constructed dozens of temples
and thousands of statues. This
beautiful portrait of the king depicts
him in the exotic style of his reign
with wide, arched brows, slanted
almond eyes, and full lips.

and power of the priesthood of Amun. Akhenaten and his queen, Nefertiti,
renounced the traditional religious beliefs and closed all the temples, even
going so far as to destroy images of Amun and hacking out the god's name.
He moved the capital from Thebes to Amarna in the middle of Egypt and built
a splendid city there with vast temple complexes, palaces, and housing for the
court and administration.

Akhenaten's reforms did not outlive him, and his immediate successors
began the process of restoring the old religion and bringing the court back
to Thebes. The process was finally accomplished by Tutankhamun, who was
originally named Tutankhaten, "the living image of Aten"—to reflect the
religious beliefs of his father—but who, upon assuming the throne, changed
his name to "Tutankhamun" to honor the old god Amun. After a brief reign,

Fig. 12

Ay as a Fan Bearer
New Kingdom, Dynasty 18, Reign of Akhenaten, 1353–1336 BCE
Plaster on limestone with polychrome
34.4 × 22.4 × 5.4 cm (13 9/16 × 8 13/16 × 2 1/8 in.)
Austin S. and Sarah C. Garver Fund, 1949.42

Ay was a favored courtier of the "heretic" pharaoh Akhenaten and would later become vizier under his successor Tutankhamun. This relief depicts him wearing an elaborately curled wig typical of the late Eighteenth Dynasty and holding a fan and a crook to mark him as a high official. The relief was originally part of his destroyed tomb at Akhenaten's capital city of Tell el-Amarna, but it was never used as afterwards the court returned to Thebes. When Tutankhamun died prematurely with no male heir, Ay claimed the throne by marrying the boy-king's widow, Ankhesenamun. Ay died after a brief rule and was buried in a large tomb, perhaps intended for Tutankhamun, in the western extension of the Valley of the Kings.

Fig. 13

Walter Frederick Roofe
Tyndale (British, 1835–1943)
The Temple of Seti I
ca. 1905
Watercolor on medium, smooth cream wove paper
26.5 × 36.9 cm (10 7/16 × 14 1/2 in.)
Mrs. Kingsmill Marrs
Collection, 1925.462

Seti I (ca. 1290–1279 BCE) constructed his mortuary temple facing eastwards towards the Temple of Karnak. The temple was originally surrounded by a large enclosure wall and fronted by two pylon gates, but they have all been destroyed and now only the hypostyle hall in the temple's center remains. It is decorated with graceful papyrus-bud columns and elegant reliefs, with chapels dedicated to the king and his father, Ramesses I, and a court for the solar cult.

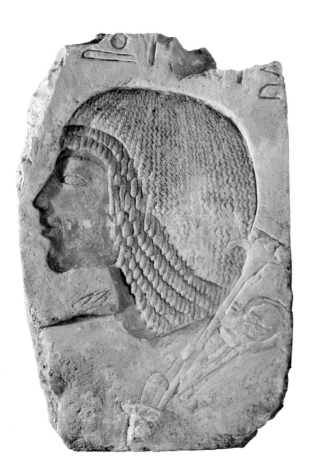

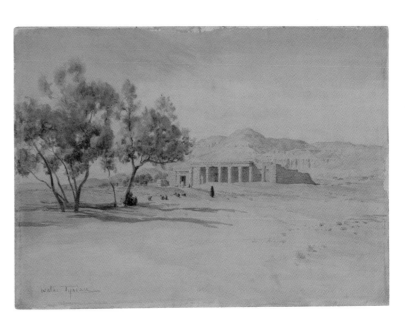

Fig. 14

Antonio Beato (Italian,
ca. 1825–ca. 1903)
Karnak, Middle Columns
ca. 1870
Albumen print from wet
collodion negative
25.4 × 38.1 cm (10 × 15 in.)
Gift of Mack and Paula Lee in honor of
David Acton, 2004.226

The temple complex at Karnak grew tremendously under the patronage of the Ramesside Period kings. In particular, the great hypostyle hall constructed largely by Seti I (ca. 1290–1279 BCE) and his son, Ramesses II (ca. 1279–1213 BCE) was an enormous construction covering an area of over 50,000 square feet with 134 columns in 16 rows reaching a height of 33 feet. This early photograph is taken from the rear of the hall looking west to the temple entrance. The columns at the back were never finished and clearly show the blocks they were made of that elsewhere had been smoothed down and carved with relief to look like monolithic columns. The clerestory windows that lit the hall can be seen bordering the central row of higher columns.

Tutankhamun died and was buried in a hastily finished, small tomb in the Valley of the Kings. After the heresy of his father, Tutankhamun and his family were erased from the official history, which helped conceal his tomb from later robbery until it was discovered by Howard Carter in 1922. The tomb contained over 5,000 objects, which had been made not only for Tutankhamun but for other members of the Amarna royal family.

Tutankamun died without a son and heir and was briefly succeeded by his vizier Ay (fig. 12), but eventually a new dynasty took control under the general Paramessu, who changed his name and ruled briefly as Ramesses I. His son, Seti I, built many beautiful temples (fig. 13) and the grandest of all the tombs in the Valley of the Kings. The son of Seti I, Ramesses II, also known as Ramesses the Great, undertook the construction of numerous temples throughout Egypt (fig. 14) and Nubia as well as conducting a number of military campaigns. Although the famous Battle of Kadesh between Ramesses II of Egypt and Muwatalli II of the Hittites was a draw, Ramesses trumpeted it as a great victory, and it led to the first peace treaty in recorded history. Ramesses II reigned for sixty-seven years, so long that he outlived thirteen of his sons. However, dynastic rivalry ended his line, and the following Twentieth Dynasty may have had little or no relation to the Ramessides. Despite that, the second king of the dynasty took his illustrious predecessor's name, and as Ramesses III tried to emulate his forebear in every way. Unfortunately, this was a bad time—a group of migrating pirates known as the "Sea Peoples" sailed the

Mediterranean, ravaging the old kingdoms along the coast. Egypt alone under Ramesses III was finally able to defeat them at the Battle of Xois in 1178 BCE. Ramesses also had trouble at home and was assassinated in a plot conceived by one of his minor wives to put her son on the throne. Ramesses III, like the other kings of the New Kingdom, had donated large tracts of land and great wealth to the temples, particularly that of Amun at Karnak. By the time of Ramesses XI, at the end of the Twentieth Dynasty, the priests of Amun had grown so powerful that they rivaled the throne.

THE THIRD INTERMEDIATE PERIOD, DYNASTIES 21–25 (CA. 1076–655 BCE)

Ramesses XI, the last king of the New Kingdom, had no male heir, and the priests of Amun at Thebes and a local dynasty at Tanis in the Delta both declared themselves his successors. The country again fractured between north and south. Civil war was averted, however, through a system of intermarriage between the kings ruling in Tanis and the priest-kings of Thebes. Other rival dynasties also sprang up in the Delta until the country was finally unified by a dynasty from Nubia.

In the vacuum of leadership in Nubia after the end of effective Egyptian control at the close of the New Kingdom, a local dynasty of kings appeared in the area of the Fourth Cataract, where the Egyptians had established the great temple complex of Gebel Barkal at the southern limit of their territory. The rival dynasties fighting for control in Egypt were vanquished under the Nubian king Piye, and Egypt experienced a renaissance. The Nubian kings ruled as the Twenty-fifth Dynasty from their home in the Fourth Cataract, building their own pyramid tombs in cemeteries around Gebel Barkal and installing their sisters to help rule in Egypt in the office of "God's Wife of Amun" at Thebes.

THE LATE PERIOD, DYNASTIES 26–31 (664–332 BCE)

The Nubian kings came to the aid of Hezekiah of Judah when he was threatened by an Assyrian invasion in 701 BCE. Although the Assyrians were defeated for a time under King Esarhaddon, the Assyrians returned, conquering Judah and Israel and beginning an invasion of Egypt, and finally conquering it by 666 BCE. They drove the Nubian kings back to their homeland, where they continued building pyramids and still called themselves "King of Upper and Lower Egypt" for over half a millennium (fig. 17). The Assyrians had relied on local rulers in the Delta to help with their conquest, but, with the Nubian forces out of the way, the vassals turned on the Assyrians and were able to restore Egyptian independence under the Twenty-sixth Dynasty, ruling from

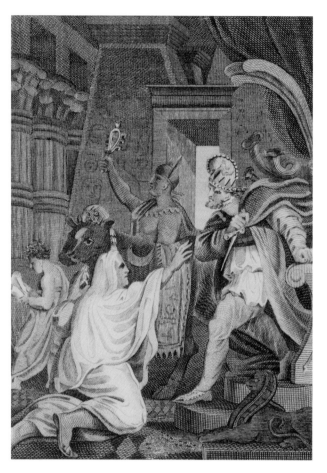

Fig. 15

John Scoles (American,
ca. 1772–1853) after Edward Francis
Burney (British, 1760–1848)
*Gambysis (Cambyses) Killing
the Egyptian Apis*
ca. 1800
Line engraving on copper printed on
cream wove paper
plate: 13.1 × 8.5 cm (5 ⅛ × 3 ⅜ in.)
sheet: 8.8 × 10.7 cm (3 ½ × 4 ¼ in.)
Charles E. Goodspeed
Collection, 1910.48.2785

Egypt was prey to foreign invasion
during the last centuries of dynastic
rule. The Persian king Cambyses
invaded the country in 525 BCE.
Although contemporary records show
him performing the traditional rites
of an Egyptian king, he is painted
as blasphemous in later histories.
In particular, he is reputed to have
killed the sacred Apis bull for which
he was then punished by madness,
killing his brother and his sister,
losing his empire, and dying from
the same fatal wound he inflicted on
the sacred animal.

Fig. 16

Tetradrachm
Greco-Roman Period,
Reign of Ptolemy I
310–305 BCE
Silver
3 cm (1 ³⁄₁₆ in.)
Gift of Emily Townsend and
Cornelius Vermeule in memory of
Francis Henry Taylor,
1999.449

After Alexander the Great's death,
Ptolemy, who distinguished himself
as a troop commander in Alexander's
campaigns, proposed that the
provinces of the huge empire be
divided among the Macedonian
army's generals. He became the ruler
of Egypt and eventually declared
himself to be a divine king and heir
to the pharaonic tradition. Coinage
had first appeared in the Greek world
and was adopted in Egypt at the end
of the dynastic period, but it was not
until after the conquest of Alexander
that it became common. On this
tetradrachm is depicted the diademed
head of the deified Alexander, shown
wearing an elephant-skin headdress
and the ram horns of the god Amun.

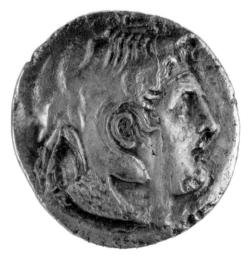
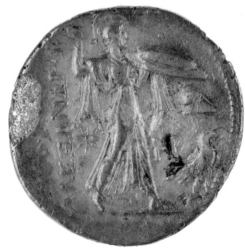

Fig. 17

**Prince Arikankharer Slaying
His Enemies**
Nubia, Meroitic Period
ca. 100 BCE
Sandstone
21.4 × 25.4 × 4.9 cm
(8 7/16 × 10 × 1 15/16 in.)
Museum Purchase, 1922.145

While in its latest dynasties Egypt
was subject to a series of foreign
invasions, to the south Nubian
civilization flourished. During the
Napatan (ca. 900–270 BCE) and later
Meriotic Periods (ca. 270 BCE–300 CE),
the land of Kush traded not only with
Egypt but also with Greece, Rome,
and peoples of the Near East. This
cosmopolitan civilization created
its own hybrid art style combining
all these influences along with
local traditions.

This relief is an outstanding example
of Meroitic art. It depicts Prince
Arikankharer, the son of two of the
most prolific builders in Meroitic
Nubia, King Natakamani and Queen
Amanitore. Although the crown prince
died before he could become king, he
was buried in a pyramid beside the
royal city of Meroë. He is depicted in
this relief smiting the enemies he is
holding by the hair in the same pose
as King Narmer three thousand years
before. Behind him floats a winged
female goddess fanning him, while
between his legs his hunting dog
bites a fallen enemy. On his head he
wears a royal diadem and his name
is written on a cartouche before a
block prepared for an inscription that
was never written.

Sais in the Delta. The Assyrians finally fell to a Persian invasion, which continued on into Egypt. Cambyses II of Persia (fig. 15) struck at the Delta city of Pelusium in 525 BCE. Although a number of Delta dynasties fought for independence, Egypt was again brought under Persian occupation until the conquest of Alexander the Great in 332 BCE.

THE GRECO-ROMAN PERIOD (332 BCE–642 CE)

Alexander was welcomed in Egypt as a liberator and proclaimed himself the son of Amun. Establishing the city of Alexandria in the Delta as his capital, he then advanced to conquer the rest of the Persian Empire and beyond. After Alexander's death in 323 BCE, his general, Ptolemy (fig. 16), brought his body back to Alexandria and founded the Ptolemaic Dynasty (305–30 BCE), the last ruler of which was Cleopatra VII, who had married both Julius Caesar and Mark Antony but was defeated by the Romans at the Battle of Actium (31 BCE) and committed suicide in 30 BCE. Egypt then became a province of Rome (30 BCE–476 CE) and was heavily taxed to support the Empire. When the Roman Empire was Christianized, the emperor Justinian ordered the closure of the temples in 537 CE. The Coptic Egyptian Church was founded with its own pope and language, a version of ancient Egyptian written with Greek letters. Egypt became part of the Byzantine Empire (ca. 527–642 CE) but was later conquered by the Arab Muslims under Caliph Umar in 642 CE, beginning the Islamic Period.

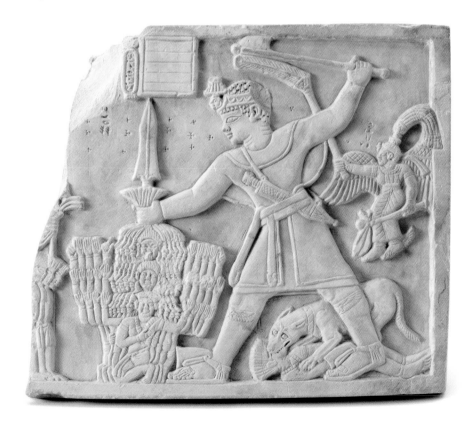

Medinet Habu

Oct: 25th

Dear Mr Mains

Just a line
that the drawing of
with her blue
makes I think
so please let
you would like me to send
till I have finished the one
If so the exact address you would like
to? I shall await your instruction
the Nile this Autumn to reach
still at a very high level —

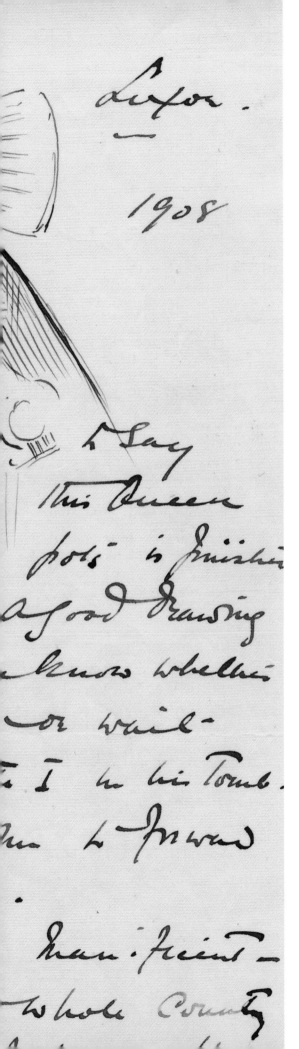

LAURA NORCROSS MARRS: TRAVELER, COLLECTOR, AND PHILANTHROPIST

Peter Lacovara

Laura Norcross (fig. 1) was born on March 11, 1845, in Boston, the daughter of a prominent Boston Brahmin family whose roots in Massachusetts extended back to 1636, when their ancestors settled in Salem and later in Watertown. Her father, Otis Norcross, Jr. (November 2, 1811–September 5, 1882), was the son of Otis Norcross, Sr. (1785–1827), a director of Norcross, Mellen & Company, established in 1810 as importers and retailers in china, glass, and pottery. Otis Jr. joined the firm as an apprentice at age fourteen and later took it over with his brothers, renaming it Otis Norcross & Co. In 1867 he was elected as the nineteenth mayor of Boston, but his term in office lasted only one year. He was described as having "brought to our service the sterling qualities which marked his whole character and career. He was a man of great intelligence, of remarkable firmness, and of the highest integrity, never weary in well-doing, and one whose counsel and co-operation, in all the concerns of this association and of the community in which he lived, were as highly valued as they were cheerfully and generously afforded."[1] These were rare things in Boston city government, so perhaps it was not remarkable he did not continue in office. Otis married his first cousin, Lucy Ann Lane (1816–1916) on December 9, 1835. They settled into a home at 249 Marlborough Street and later a palatial house at 9 Commonwealth Avenue in the Back Bay. Although the couple had eight children, only four of them survived into adulthood, Laura being the eldest surviving child.

There is little recorded about Laura Norcross's early life, but by 1886 she had begun to collect prints. Her first guide in collecting may have been her brother Grenville H. Norcross, for a bill of 1886, made out to him from a New York dealer, lists prints that are now in the Mrs. Kingsmill Marrs Collection at the Worcester Art Museum.[2] Soon after, however, the bills are made out to Laura Norcross, and in the next two years she purchased at least twenty-three prints from dealers in New York. It is not surprising that Laura had developed a

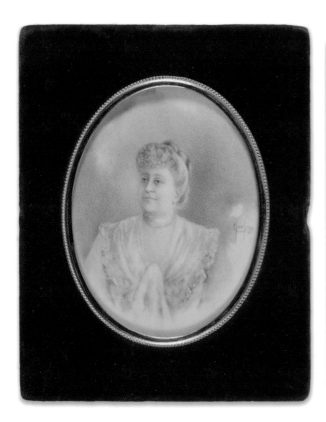 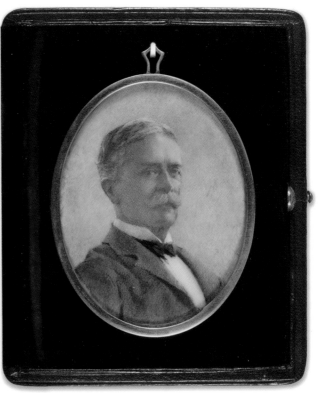

taste for art, her father's company importing the finest examples of European, Chinese, and Japanese ceramics and glassware, and being a relative through her grandmother of Winslow Homer.

Her father had also been a founding member of the Museum of Fine Arts in Boston. In 1889 Laura enrolled in a class being taught at the museum by Sylvester Rosa Koehler (1837–1900), its first curator of prints and drawings. Koehler became a mentor to Laura Norcross and helped guide her in creating a prodigious collection of prints and engravings.[3]

KINGSMILL MARRS

William Dana Kingsmill Marrs, known as Kingsmill (fig. 2), was born in February 1848, the son of Dana Francis Marrs and Jane Van Poelien of Canton, Massachusetts. Dana Marrs was an émigré from Ireland and was listed in census sources as "Boots" in 1850, presumably a shoemaker, and later as a machinist. By 1870, the family had moved to Boston and Kingsmill embarked on a career in business. His younger sister, Evangeline Marrs Simpson Whipple (1857–1930), married well and built a mansion in Wayland, Massachusetts.

Fig. 1

Robert Lee Keeling
(American, 1864–1941)
Laura Norcross Marrs
ca. 1916
Watercolor on ivory in green velvet frame with convex glass
12.5 × 10 × 1 cm (5 × 4 × 1/3 in.)
Massachusetts Historical Society, 03.116

Fig. 2

Carlota Saint-Gaudens
(American, 1884–1927)
Kingsmill Marrs
ca. 1910
Watercolor on ivory in gold locket
8.7 × 6.2 × 1 cm (3 1/2 × 2 1/2 × 1/3 in.)
Massachusetts Historical Society, 03.117

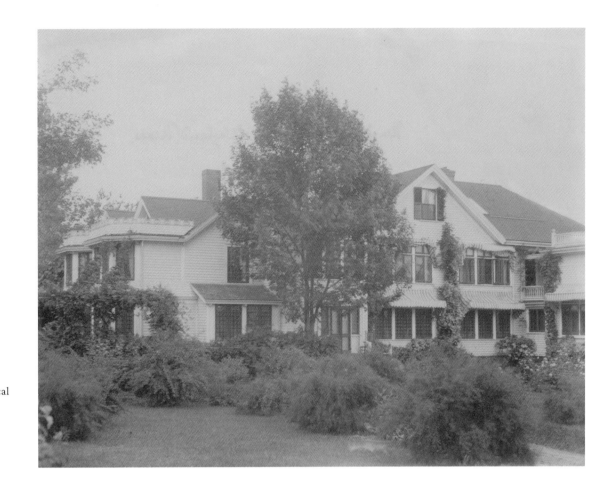

Figs. 3–4

Photographs of the exterior and interior (library) of "South Park" in Wayland, MA
Massachusetts Historical Society, Kingsmill Marrs Photographs, Photo. 165.88 (right) and 165.92 (below)

The view inside the mansion shows some of the Marrses' extensive collection of books and prints.

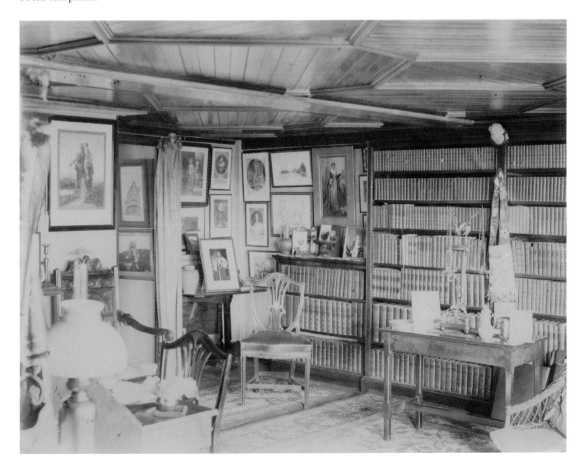

Kingsmill Marrs began a career as a merchant, traveling between England and Boston, and developed a passion for art, travel, and photography. In December of 1896 he married Laura Norcross, who shared his love of art, travel, and nature. From 1896 until 1905, they lived at "South Park," the home in Wayland that Evangeline had built (figs. 3–4). Evangeline's much older husband, Michael Hodge Simpson (1809–1884), had died shortly after its construction and as a widow traveled the world doing philanthropic work with her companion Rose Cleveland, the sister of the president.[4]

Laura and Kingsmill wintered in "Maitland Cottage" in Maitland, Florida, a fashionable suburb of Orlando popular with the affluent at the turn of the last century. Another visitor to Maitland was Evangeline, Kingsmill's sister, who had remarried. Her second husband, Bishop Henry B. Whipple (1822–1901), had founded a church in the town. Whipple was an advocate of many important causes, including Native American rights and conservation. He and many in his circle were appalled at the vast number of birds being slaughtered in Florida to provide plumage for ladies' hats. Laura and Kingsmill, along with other winter residents of Maitland, founded what would become the Florida Audubon Society,[5] with Laura becoming a leading advocate for conservation.

Fig. 5

Group of individuals in front of the Sphinx
Photograph taken by Mr. Dana Marrs, ca. 1896–1910, from Jane Van Poelien Marrs photograph album. Massachusetts Historical Society, Photo. 165.259

Fig. 6

Photograph of Kingsmill Marrs, Laura Norcross Marrs, and William Barker (left to right)
No date. Massachusetts Historical Society, Photo. 165.67

During their trip the Marrses and their friend William Barker posed for a comical portrait in the studio of Paul Dittrich in Cairo.

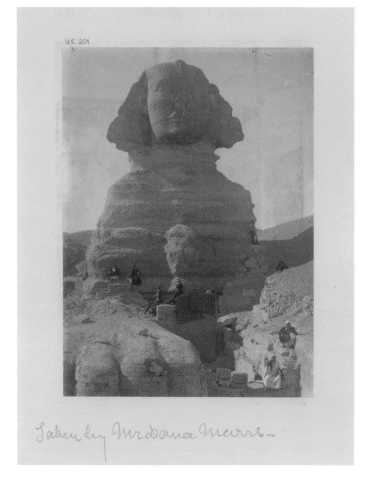

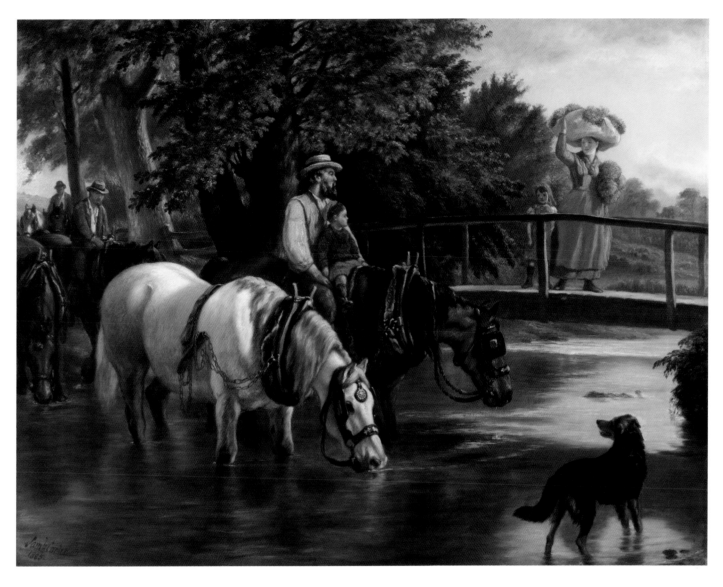

Fig. 7

Samuel John Carter
(British, 1835–1892)
***Self-Portrait with His Son
Howard on His Lap***
1885
Oil on canvas
70.5 × 91.5 cm (27 ¾ × 36 in.)
Anonymous Loan

EGYPT

In 1905 the couple bought the Villa Rangoni Machiavelli at Pozza di Maranello near Modena, Italy, and traveled through Europe and on to Egypt. The country and its antiquities fascinated them, and they seem to have enjoyed their trip immensely (fig. 5).

While in Cairo they stopped to have a comical souvenir photograph taken in the fashionable studio of Paul Dittrich (fig. 6),[6] along with their friend William Barker, who also shared a love of photography with Kingsmill. The group sailed down the Nile to Luxor, where they met Howard Carter, later to become famous as the discoverer of the tomb of Tutankhamun.

HOWARD CARTER

Howard Carter (fig. 7) was born on May 9, 1874, the last of eleven children born to Samuel Carter (1835–1892), a successful artist specializing in paintings of country life, and Martha Joyce Carter, née Sands (1837–?), who doted on her youngest son and imbued him with a fastidiousness that stood him well in later life. Howard was a sickly child, and had private home schooling,

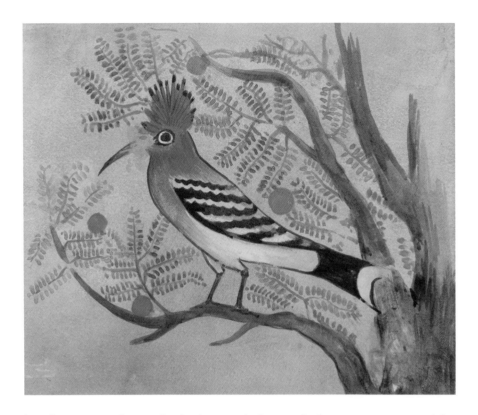

Fig. 8

Howard Carter (British, 1873–1939)
Hoopoe Facsimile from the Site
at Beni Hassan
ca. 1891
Watercolor on paper
44.2 × 30.1 cm (17 3/8 × 11 7/8 in.)
Egyptian Exploration Society, ART.211

Howard Carter made this
rendering of a hoopoe bird in
an acacia tree from the tomb of
Khnumhotep in Beni Hassan for the
publication of the tomb.

but from an early age he had an artistic streak that was encouraged by
his parents.[7]

Carter grew up in in Norfolk—100 miles northeast of London—and near
his home was Didlington Hall, which its owner Lord Amherst had filled with
his collection of Egyptian antiquities.[8] Amherst allowed the young Howard
Carter to visit frequently and to study and sketch his treasures. Noting the
young Carter's interest and ability, Amherst recommended him to his friend
Percy Newberry, an Egyptologist affiliated with the Egypt Exploration Fund,
a society based in London founded to do archaeological work in Egypt.[9] The
fund had been looking for an illustrator for their archaeological reports and,
following Amherst's recommendation, they engaged Carter.

Howard headed to Egypt in 1891, at the age of seventeen, where he was to
work on the fund's excavation of the Middle Kingdom tombs at Beni Hassan.
The tomb chapels had been painted with exquisite scenes of birds and ani-
mals (fig. 8), and Carter's accurate and evocative renderings of them secured
his position.[10]

The fund was working at a number of sites, and Carter was then sent
to work at the site of Tell el-Amarna—the capital of the "heretic pharaoh"
Akhenaten and his wife Nefertiti—under the direction of Sir William Matthew

Fig. 9

Unknown artist
Howard Carter at Deir el-Bahri
ca. 1893–94
Photograph
Egyptian Exploration Society,
DB-HAT.NEG.01.40

Howard Carter is shown on the left
supervising the clearing of debris
from the temple using a rail car.

Flinders Petrie; the tombs at Deir el-Bersheh; and the temples at Deir el-Bahri, Thebes (fig. 9).

Despite having trained as an artist rather than an archaeologist, Carter's diligence and ability in the field impressed the excavators he worked with, and he was recommended to the Egyptian Government Antiquities Service for the important post of Chief Inspector for Upper Egypt. In the next few years he made a number of important discoveries, including in the Valley of the Kings, where he worked under the patronage of Theodore M. Davis, a wealthy and somewhat irascible American amateur archaeologist.[11] Carter's achievements earned him a promotion to the Cairo office of the Antiquities Service in 1905, but soon after he found himself in the middle of an altercation between a group of drunken French tourists and the Egyptian site guards whom they were abusing. Carter properly sided with the Egyptians; however, complaints were made to the government by some of the French, and Carter lost his post.

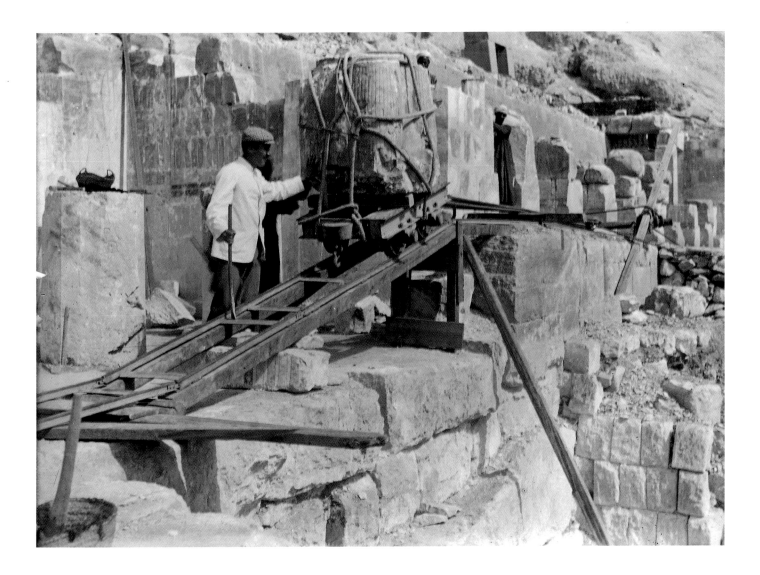

HOWARD CARTER AND LAURA MARRS

Carter was at loose ends and returned to his beloved Thebes, where he set himself up as a guide to the archaeological sites and sold watercolor paintings to supplement his income. In this capacity he was to meet Laura and Kingsmill Marrs on their arrival in Luxor.[12] They seem to have quickly struck up a friendship, with Carter not only touring them around but advising them on the purchase of antiquities and selling them a number of his watercolors. They also began a lively correspondence with Carter, who wrote a series of letters to them from October 1908 to June 1914.

His first letter, dated October 25, 1908, reads:

Dear Mr. Marrs

Just a line to say that the drawing of this Queen with her blue pots is finished & makes I think a Good drawing[.] Now please let me know whether you would like me to send it or wait till I have finished the one of Seti I in his Tomb. If so the exact address you would like me to forward it to? I shall await your instructions.

The Nile this Autumn is really manificent [sic]—still at a very high level—the whole country under water with only little patches of land appearing above the surface & carpeted in green, the villages standing clear as small islands under palms & mimosa trees—the latter covered covered [sic] with thousands of yellow balls, they being full in flowers. In the calm of the eve, it is really lovely, the sun just dipped below the horizon, the after glow flooding the place with colour—one is often puzzled to tell where the heavens & earth meet, the whole being lost in dreamy atmospheric colour giving the appearance of an enormous opal, picked out only here & there by a distant hill looming out of mystery like an amethyst, the flood full & stretching far away, rippled & bespeckled by pelicans, storks & heron, making in all a wonderment beyond imagination. In Luxor and Karnak temples, where you walked, you must now swim—the pavement now a mirror reflecting the columns. . .

Please tell Mrs. Marrs that I have received her nice letter & that I have not gone of late to Luxor—hard at work & cut off by the water—but will do so & write. . .

With every regard to all

Yours very sincerely,

Howard Carter[13]

Fig. 10

Letter from Howard Carter to Kingsmill Marrs
25 October 1908, page 1.
Massachusetts Historical
Society, Grenville H. Norcross
autograph collection

Carter illustrated this letter with
a sketch of Queen Nefertari for the
watercolor he was planning for Mrs.
Marrs (fig. 11)

Medinet Habou

Oct: 25th

Luxor.

1908

Dear Mr Mairs

Just a line
that the drawing of
with her blue
makes I think
So please let
you would like me to send
till I have finished the one

to say
this Queen
jots is finished
a good drawing
me know whether
it or wait-

of Seti I in his Tomb.
If so the Exact address you would like me to forward
To? I shall await your instructions.

The Nile this Autumn is really magnificent -
still at a very high level - the whole country
under water with only little patches of land appearing
above the surface & carpeted in green, the villages
standing clear as small islands under palms
& mimosa trees - the latter covered covered with
thousands of yellow balls, they being full in flower.
In the calm of the eve, it is really lovely, the
sun just dipped below the horizon, the after glow
flooding the place with colour - one is often puzzled

Fig. 11

Howard Carter (British, 1873–1939)
Queen Nefertari
1908
Watercolor over graphite on medium,
smooth cream wove paper
70.6 × 46.8 cm (27 13/16 × 18 7/16 in.)
Mrs. Kingsmill Marrs
Collection, 1925.144

The final rendering of the image
of the queen holding two offering
vessels from her tomb in the
Valley of the Queens.

Fig. 12

Howard Carter (British, 1873–1939)
*The Temple of Ramses III
at Medinet Habu*
1909
Watercolor over graphite on medium,
slightly textured off-white paper
59.8 × 42.7 cm (23 9/16 × 16 13/16 in.)
Mrs. Kingsmill Marrs
Collection, 1925.145

In this watercolor Carter expertly
evokes the somewhat battered
interior of the great temple.

The letter is also illustrated with a lovely sketch of the head of Queen Nefertari (fig. 10), to remind Mr. and Mrs. Marrs of the watercolor of the queen he was completing for them and that is now in the Worcester Art Museum (fig. 11). All in all, the Marrses purchased six watercolors by Carter, more than any other collector (figs. 12–16).[14]

Carter also took an active role in advising them on collecting. Writing to Laura in Florence in anticipation of her visit: "I trust seeing you all well installed in [Luxor] in late autumn – I shall have the place well salted with beads, scarabs, antiqas and etc. . . ."[15]

In addition to Carter, the Marrses were also advised on their purchases by Mohamed Mohassib, one of the principal antiquities dealers in Luxor (fig. 17).

Howard Carter
1909.

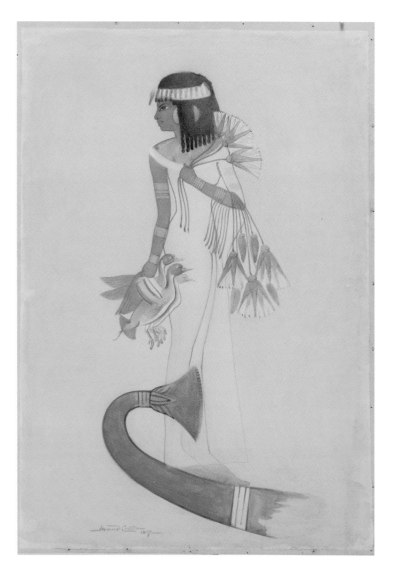

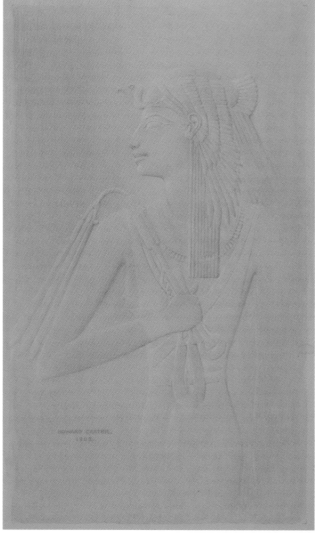

Fig. 13

Howard Carter (British, 1873–1939)
The Daughter of Menna
1907
Watercolor over graphite on medium,
slightly textured off-white wove paper
56.4 × 39.7 cm (22 3/16 × 15 5/8 in.)
Mrs. Kingsmill Marrs
Collection, 1925.143

The tomb of the official Menna
in Thebes is decorated with some
of the most beautiful and lively
paintings in all of Egypt and was a
favorite with visitors.

Fig. 14

Howard Carter (British, 1873–1939)
Queen Aahmes
1908
Watercolor over graphite on medium,
slightly textured cream paper
57.7 × 40.4 cm (22 11/16 × 15 7/8 in.)
Mrs. Kingsmill Marrs
Collection, 1925.142

Carter particularly liked this portrait
of Queen Hatshepsut's mother
Ahmose, from Hatshepsut's temple
at Deir el-Bahri, and made a number
of copies of it.

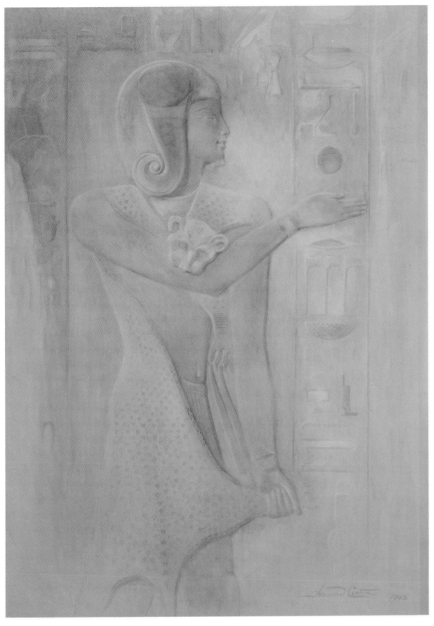

Fig. 15

Howard Carter (British, 1873–1939)
Iunmutef, Priest from the
Tomb of Seti I
1909
Watercolor over graphite on medium,
slightly textured off-white paper
53.5 × 47.7 cm (21 1/16 × 18 3/4 in.)
Mrs. Kingsmill Marrs
Collection, 1925.141

The tomb of King Seti I is undoubtedly
the most beautiful in the Valley of the
Kings, and this scene from it depicts
one of the priests dressed in his
ecclesiastical garb, attending to the
cult of the monarch.

Fig. 16

Howard Carter (British, 1873–1939)
Guests at a Banquet, from the
Tomb of Rahmose
1909
Watercolor over graphite on medium,
slightly textured off-white paper
38.2 × 49.4 cm (15 1/16 × 19 7/16 in.)
Mrs. Kingsmill Marrs
Collection, 1925.140

Another particularly beautiful
tomb, that of the vizier Ramose,
was decorated with stunning
reliefs carved into the fine white
limestone. Here, Carter renders two
of the guests depicted attending the
funerary banquet.

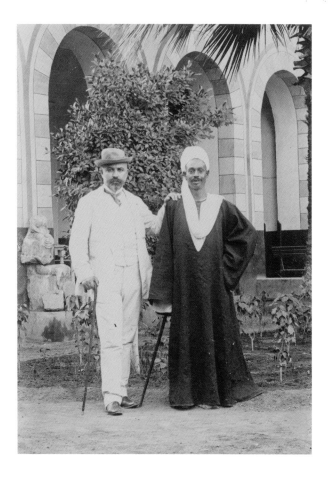

In those days, the trade in antiquities was legal but regulated by the government.[16] Mohassib and Laura kept up a voluminous correspondence;[17] writing from his shop at the Winter Palace Hotel he advised her on potential purchases and Egyptological subjects (fig. 18). She had a keen eye, not only for jewelry, but for small, precious things as well, and probably with Carter's approval acquired some pieces of exceptional interest.

As well as meeting the Marrses, at this point Carter made the acquaintance of Lord Carnarvon, a British aristocrat who was also interested in archaeology and agreed to hire Carter as his personal excavator.[18]

Carter's next letter written from Egypt is dated 1909:

Medinet Habu, Luxor, Jan 16th 1909

Dear Mrs. Marrs

So very many thanks for the photocards & the most excellent stuffed prunes. They arrived here today in good condition & I am already beginning to . . . Mr. Marrs' letter of the 22nd inst. reached me also today—I do so hope you received my letter also & also do. [ditto] for Mr. Marrs enclosing two small sketches in reply to his good thoughts for me.

What a wonderful place for vegetation & flowers yours must be—It makes me quite envious—the desert has its charms but I fear no flowers.

Fig. 17

Photograph of Kingsmill Marrs and the son of Mohamed Mohassib in Luxor
ca. 1908. Worcester Art Museum archives

Fig. 18

Invoice from Mohamed Mohassib
January 26, 1910. Worcester Art Museum archives

In this invoice on Winter Palace stationery Mohammed Mohassib lists some of the items for sale to the Marrses.

Luxor goes on as usual just passed through a spell of cloudy weather, ending yesterday in a small shower of rain, a sharp gust of wind & today bright, cold, & sunny—everything looking the better & clean after the washing by the rain. At the Tombs of the Kings Mr. Davis found a small tomb pit but nothing of great interest in it beyond some gold foil. Prof Petrie is pegging away on the north end of the necropolis but as yet not fortunate. I have just been offered an enormous fee by Lord Carnarvon to undertake a months excavation (February) at Drah abou'l Neggeh—a site no doubt you will remember, between Deir El Bahari & the mouth of the valley of the Tombs of the Kings—to try & find the Tombs of Amenhotep I & Aahmes Nefertari (the founders of the 18th Dynasty) which the Abbot[t] papyrus mentions to be in the neighbourhood—the circumstances being so good & such an interesting rest for a short time from ones work I have accepted & shall try & do my best. There are certainly possibilities of finding those tombs—but I'll say nothing towards probabillities [sic]—time will show. Can't you with your 3 spades come & assist—3 1/2 piastres per diem for all willing workers. I'll give 4 to Mr. Barker because he can photograph. I will let you know how things go.

Great preparations are being made for the Khedive & the Duke of Connaught who are coming up to open the Esneh Barrage just completed. Luxor is getting under bunting the natives shelling out with these splendours & discordant noises being made by band tuning accompanied by the donkies—Luxor is really happy as you will well imagine.

Before I forget Mr. Nicol—who is staying here wishes all his salaams to be sent to you all.

My household has increased by six fluffy yellow goslings & I hear suspicious noises from under the other geese but I dare not count before hatching. Mr. Tyndale is going to Japan to do a similar book of this country like last. He is now at Deir el Bahari & sends his regards. I do so hope that this summer you will come to England where I hope to be for a few months.

With every regard to yourself & all

Believe me yours very sincerely

Howard Carter[19]

Their visit engendered a keen interest in Egyptology in the Marrses, and, in a letter dated December 2, 1909,[20] Kingsmill wrote to the keeper of Egyptian and Assyrian antiquities at the British Museum, E. A. Wallis Budge, about the spelling of ancient Egyptian names, a jumble that confuses non-specialists

to this day. Budge promised to send a list of books but recommended above all his own guidebook to Egypt and the Sudan.[21] Carter responded to Laura, sending him a newspaper clipping with an article about the date of the Great Sphinx at Giza on June 23, 1911:

My dear Mrs. Marrs

It was so nice to hear once again from you & that Mr Marrs' health is improving. I have often wondered how you all have been & only wished you were in Egypt last winter.

The cuttings you enclosed are most interesting & the first I had heard of the new theory regarding the poor old Sphinx. The dating & still more the naming of an unnamed monument such as the Sphinx must always be a matter of vague conjecture—a possible reason why Herodotus ignored it altogether. And the so called "Riddle of the Sphinx" seems as great an invention of modern times as the Sphinx itself invented by the ancients. Reisner's theory [the accepted view that the sculpture is dated to the reign of Khafre] is very possibly a correct one, though one cannot help but think that the evidence for so emphatic a statement is small. Certainly it has great probabilities of being somewhere near the mark. For on that plateau we have nothing that is not purely mortuary & the mass of the stuff there pertaining to the Old Kingdom. Mr. Higgins contentions, who ever the man may be for I have not heard of him before & for the moment shall call him "Juggins", is as celestial as his starry hypothesis. However true his theory of the origin of the Sphinx formation may be, it gives no reason why any one king should not adopt the form when wishing to represent himself. The hundred and one monuments we have from the earliest to the very latest period of kings of Egypt representing themselves as human headed lions crushing their enemies—a common symbol of power used among the symbolical sculptures of the ancient Egyptians—is a fact Mr. Higgins seems either not to know or to have forgotten.

There can I think be little doubt that the Sphinx did represent some reigning monarch & most probably of the Old Kingdom. The topographical position is strongly in favour with Reisner's supposition but I think him most wrong in making his statement so emphatic.

I am so glad that you liked Miss Rathbone. Your statement was correct, but you see her height enabled her to look over my head. You ask whether we had finds this year. Yes we were certainly lucky & found a very large tomb of the Middle Empire, which had been reused as a hidding [sic] place for later burials ranging between the Hyksos Period and the early Eighteenth Dynasty. It was full of most interesting stuff having 64 separate & un-touched burials in it, the cache being made by some pious

officials of the necropolis for their safe keeping from the thieving workmen who disturbed them in making some alteration or when clearing the ground in constructing some new monuments. I am now occupied in getting out a publication of the three seasons results which will be fully illustrated & I hope in the course of the year to be able to send you a copy which will better describe to you the whole finds than I shall be able to do here. I think our pearls were a harp of the Hyksos time and a delightful little portrait figure of a boy in electrum of a period of Amenhetep Ist.

My chateau is built & awaiting you, and I am now home for a holiday of three months after a strenuous two years of painting, building and excavating. Please give my best wishes to all & with every kind regards to yourself

Yours most sincerely

Howard Carter

The Constitutional Club
Northumberland Avenue
will find me 'till Sept 15. Then the same old Luxor.

H.C.[22]

Carter recommends the work of George Andrew Reisner, who was at the time working at Giza, as the source for her questions about the Great Sphinx.[23] He also writes about his own excavations, for by this point he had received the patronage of Lord Carnarvon and was excavating in the Asasif, the area below the temples of Deir el-Bahri.[24] He also refers to the dig house he built in Western Thebes, now open as a museum.

In addition to excavating, Carter continued to paint, and his beautiful watercolors were much in demand. He wrote Laura on December 15, 1911: ". . .yes—I have been and am hard at painting since my Return from England the 5th of September and I think I have some good work very near completion. They are nearly all commissioned already and I find it difficult to keep up. . . ."[25]

Despite Carter's well wishes, Kingsmill Marrs died on May 20, 1912, and was buried in the Cimitero Evangelico degli Allori in Florence. Laura kept the house in Italy as her main residence. The last letter we have from Carter to Mrs. Marrs was written to her there shortly before the start of World War I:

June 12. 1914
Turf Club
Cairo

Dear Mrs. Kingsmill Marrs

Thank you so much for your two very kind letters. I have been long in answering them, but I have been moving about Egypt, letters have followed me & I have had really little chance of answering them.

Your kind invite to stop at Florence was most inviting but I must get straight back to England—I hope by next week's mail.

It has been abnormally hot this May & June, in fact the hottest experienced for many years, which naturally makes one long to get away from it.

I hope soon to have another publication out of our latter work including the discovery of the royal tomb of Amenhetep I. The latter discovery has been of great interest owing to the ancient records of the King's tomb in legal papyrus recording the ancient robberies. In years we have tried to find its where abouts from these early statements—but not until this last autumn were we successful.

With every kind wish & regards to both Mr. Barker & yourself

Yours most sincerely

Howard Carter[26]

Contrary to Carter's belief,[27] it turned out that he and Carnarvon had not actually found the tomb of Amenhotep I, but instead probably that of Ahmose-Nefertari, Amenhotep's mother.[28]

Carter joined the war effort, serving as a translator for the British armed forces. After the conflict ended, he and Lord Carnarvon applied for permission to dig in the Valley of the Kings. Eventually, after many false starts, Carter and Carnarvon were rewarded beyond their wildest dreams when, on November 4, 1922, Carter discovered the top step of a flight of stairs leading to a long corridor that ended with a door still sealed with the name of Tutankhamun.[29]

LAURA MARRS AND THE WORCESTER ART MUSEUM

After her husband's death, Laura eventually went back to Boston, returning to her family home at 9 Commonwealth Avenue, where she lived with her bachelor brother Grenville. In May of 1919, Mrs. Marrs gave the photographs and books she and Kingsmill had gathered during their life together to the

Massachusetts Historical Society in memory of her husband. The Marrs library comprises almost 1,000 titles and, in addition, the letters from Howard Carter.

Mrs. Marrs also donated a number of textiles to Boston's Museum of Fine Arts, and a collection of Native American artifacts to the Museo di Storia Naturale in Florence, Italy.

The Worcester Art Museum was particularly fortunate in receiving a vast number of gifts, including more than 1,400 prints and drawings, and the Marrses' Egyptian collection. Laura Marrs wrote to Benjamin Stone, the director of the Worcester Art Museum, on May 21, 1926: ". . .[I] shall come to Worcester and will bring some very unusual prized scarabs to add to your Egyptian Collection. They are Mr. Marrs' private collection of fine workmanship and semiprecious stones numbering around fifty which should make a very beautiful and rare addition to your Egyptian collection."[30]

Laura Norcross Marrs died on September 23, 1926, and was buried in Mount Auburn Cemetery in Cambridge, Massachusetts. She was remembered for her remarkable generosity in making bequests to a large number of charities and worthy causes.[31]

Endnotes

1. Winthrop 1883.
2. Worcester Art Museum archives.
3. Riggs 1977–78.
4. On the abandoned estate, see "Beautiful, but Deserted, Mansion at Saxonville," *Boston Globe*, Sunday, Nov. 1, 1903, 45.
5. Pool 2018.
6. Baillot de Guerville 1905, xiii.
7. Reeves and Taylor 1992.
8. Dawson and Uphill 1995, 14.
9. James 1982.
10. Carter et al. 1900.
11. Adams 2013.
12. James 1996, 415–28.
13. Massachusetts Historical Society Archive.
14. These are now all in the Worcester Art Museum (1925.140–145), a gift of Laura Marrs.
15. Excerpt of letter from Howard Carter to Laura Norcross Marrs, June 20 1908, Worcester Art Museum archives.
16. Hagen and Ryholt 2015.
17. Much of this correspondence, now preserved in the archives of the Worcester Art Museum, gives an important picture of not only the prices charged for these pieces but, in some instances, their archaeological provenance.
18. James 1992, 139ff.
19. Massachusetts Historical Society Archive.
20. Worcester Art Museum archives.
21. Budge 1906.
22. Massachusetts Historical Society Archive.
23. Reisner 1912, 4–13.
24. Carnarvon and Carter 1912.
25. Worcester Art Museum archives.
26. Massachusetts Historical Society Archive.
27. Carter 1916, 147–54.
28. Porter and Moss 1964, 599.
29. Carter and Mace 1923b, Vol. 1, 86–96.
30. Worcester Art Museum archive.
31. "Mrs. Marrs leaves Charity Thousands," *Boston Herald*, Wednesday, September 29, 1926.

JEWELS OF THE NILE

Yvonne J. Markowitz

Ancient Egypt—an African civilization that flourished along the Nile River during the third through the first millennium BCE—was once a preeminent presence in the Mediterranean world that was admired for its powerful leadership, military might, architectural wonders, imposing statuary, and sophisticated decorative arts. Many believed that this land, with its curious iconography and extensive literature, held the key to understanding the world's deepest mysteries. Even at the end of its glory years, its famed pyramids at Giza—one of the seven wonders of the ancient world—were designated a "must see" by Philo Mechanicus, a noted Greek writer who lived during the third century BCE.

Among the surviving artifacts from the Nile Valley that continue to captivate the public are the majestic jewels that once adorned the bodies of Egypt's leading citizens. Many of these extraordinary adornments are known from archaeological discoveries that were made during the late nineteenth to early twentieth centuries and promoted in popular publications such as the *Illustrated London News*. These finds represent a fraction of the jewelry produced and offer a mere glimpse into the rich and varied ornaments worn by both the living and the deceased—the latter as they embarked upon their journey into the afterlife.

The most prized Egyptian adornments recovered by archaeologists are those found in unplundered burials where the context in which the deceased was interred is well documented. This material offers a wealth of information on the various forms, styles, and uses of jewelry. It also provides valuable insights into ancient technologies, cross-cultural influences, and trade. This knowledge forms the basis for understanding the vast amount of jewelry found in private collections, including those amassed by Mrs. Laura Marrs under the guidance of British archaeologist Howard Carter (1874–1939).

Portrait of Woman with Pearl Jewelry
Early Roman Period, 2nd century CE
(detail)

HISTORICAL BACKGROUND

The creation and wearing of jewelry in the Nile Valley predate the unified state by nearly a hundred thousand years. These early ornaments, recently discovered along the Mediterranean coast, are largely fabricated from organic materials such as plant fiber and snail shells. Jewelry made from more durable substances, such as metal and hardstones, did not come into play until the Predynastic Period (before 2900 BCE) when Egypt was divided into autonomous communities that had mastered the cultivation of grains, the domestication of animals, and the construction of permanent structures. During this period, the dead were buried in cemeteries with a range of grave goods, including jewelry. By the end of the era, some of these items were made of gold and prized, imported materials, such as turquoise from the Sinai and lapis lazuli from northeast Afghanistan. Faience—a quartz-based ceramic with small amounts of lime and an alkali—was also introduced during this time and used extensively for beads and amulets.

It is rare for ancient jewelry to survive intact. This is especially the case when the ornament is composed of multiple elements joined together with degradable materials such as animal hair, leather, or linen thread. One group of adornments, a series of four bracelets composed of gold and hardstone beads of varying shapes that belonged to a queen of the First Dynasty ruler Djer (ca. 2870–2823 BCE), was discovered with its stringing intact (fig. 1). The jewels, hidden in a crevice in a brickwork wall inside the king's funerary complex, were secured to a detached arm by a series of linen wrappings that encapsulated the original order of the various components. The tomb, located within the sacred site of Abydos in Upper Egypt, was excavated in 1901 by British Egyptologist Sir Flinders Petrie (1853–1942), who postulated that the treasure was concealed by Eighteenth Dynasty laborers assigned to restore the tomb.[1] The bracelets are important as they represent complex constructions of mostly precious materials, and illustrate the Egyptian preference for gold and hardstones. As in many cultures, gold was valued because of its resistance to tarnish and decay, as well as its association with the life-giving sun. The hardstones, such as the carved turquoise beads used in the Djer treasure, were prized for their durability, rarity, and color. This notion of—you might say obsession with—permanence and the afterlife permeates Egypt's material culture and is the reason why so many objects have survived.

Significant jewelry was also recovered by George A. Reisner (1867–1942), an American archaeologist known for his excavations at Giza, a site that served as the burial place for Egypt's mighty Old Kingdom (ca. 2543–2118 BCE) rulers, functionaries, and officials. Reisner was one of the first in his field to apply scientific methodology to fieldwork, and his undertakings within the pyramid complexes of Giza provide invaluable information that informs our

Fig. 1

Bracelets
From Abydos
Archaic Period, Dynasty 1, Reign of Djer,
ca. 2870–2823 BCE
Gold, turquoise, lapis
lazuli, and amethyst
L: 7.4 cm (2.9 in.) to 15.6 cm (6.1 in.)
Egyptian Museum, Cairo, 52011,
52008, 52010, 52009

As early as the third millennium BCE,
ancient Egyptian craftsmen were
creating sophisticated adornments out
of materials they designated as precious.
Among them were native gold, turquoise
from the Sinai, lapis lazuli from
Afghanistan, and amethyst from deposits
in southern Egypt, east of Aswan.

understanding of the basic, standard features of Egyptian adornment. Among the artifacts his team unearthed were a number of woven, beadwork collars with matching wrist and ankle ornaments (fig. 2). Worn by both sexes as well as anthropomorphic deities, these objects are largely composed of stone or faience elements that serve as colorful additions to the near-white kilt that constituted men's attire and the plain, linen sheath favored by women (fig. 3). Broad collars appear frequently in Egyptian art and are even pictured on Middle Kingdom coffins along with other goods deemed essential in the next life.[2] Other forms that dominated the jewelry landscape during the Pyramid Age are diadems (circular head ornaments), girdles, decorative belts, strings of amulets, and stacked bangles—a fashion fad among elite ladies of the Fourth and Fifth Dynasties. For officials and their spouses, jewelry was typically arranged in a bilateral, symmetrical manner on the body. This penchant for balance and equilibrium, a cornerstone of Egyptian cosmology and an underlying principle of *maat*,[3] is also reflected in the design and composition of individual ornaments.

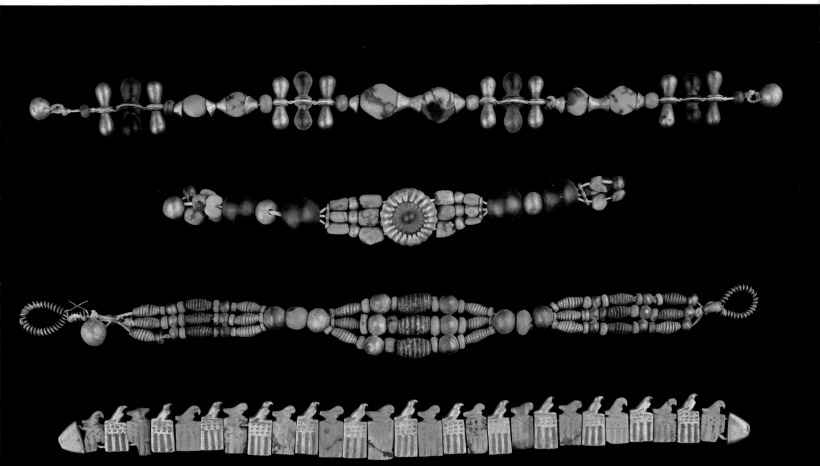

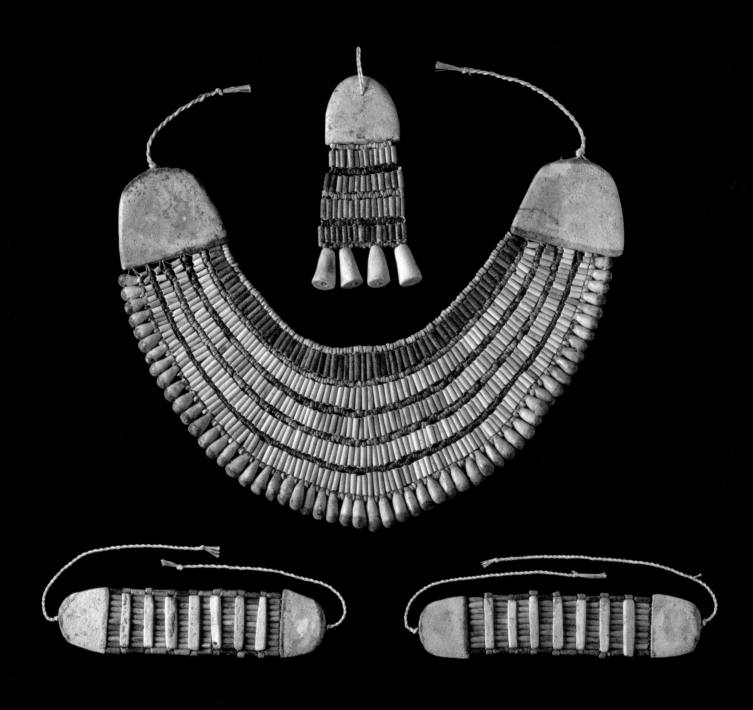

Fig. 2

Jewelry suite (broad collar, counterpoise, and wrist ornaments)
From Giza, tomb 2422D
Old Kingdom, Dynasty 5,
ca. 2435–2306 BCE
Faience
19 × 27 × 0.5 cm
(7 1/2 × 10 5/8 × 3/16 in.) [broad collar]
Museum of Fine Arts, Boston, Harvard University—Boston Museum of Fine Arts Expedition, 37.1311-13

Beaded broad collars with a matching counterpoise, wristlets, and occasionally anklets were standard adornments worn by Egypt's ruling class. The most common material used in their fabrication was faience, a quartz-based ceramic.

Fig. 3

Pair statue of Ptahkhenuwy and his wife
From Giza, tomb G 2004
Old Kingdom, Dynasty 5,
ca. 2435–2306 BCE
Painted limestone
H: 70.14 cm (27 5/8 in.)
Museum of Fine Arts, Boston, Harvard University—Boston Museum of Fine Arts Expedition, 06.1876

Our understanding of ancient jewelry forms and patterns of use is greatly enhanced by statuary depicting Egyptians wearing their finest and most prized ornaments.

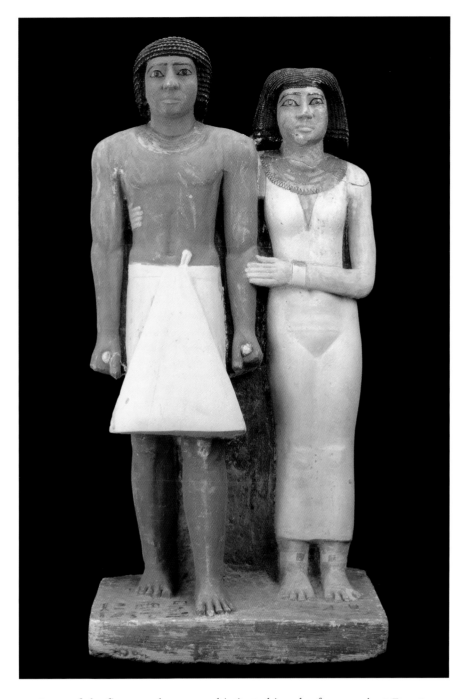

Some of the finest and most sophisticated jewelry from ancient Egypt was made during the Middle Kingdom (ca. 1980–1760 BCE), an era characterized by a strong central government; an expanded military; a series of foreign expeditions in search of new resources; the establishment of outlying, fortified posts; massive irrigation and hydraulic projects to improve agriculture; and the extension of Egypt's borders. In this stable and prosperous environment, art, architecture, and literature flourished. This was also the case with the decorative arts, as evidenced by the stunning jewels made for Sithathoryunet, a daughter of Senwosret II (ca. 1845–1837 BCE), a ruler who was buried at El Lahun in the Fayum, a region about sixty miles southwest of Cairo. Her tomb, which was located alongside that of her illustrious father, was plundered in antiquity and later excavated in 1914 by Petrie and archaeologist Guy Brunton

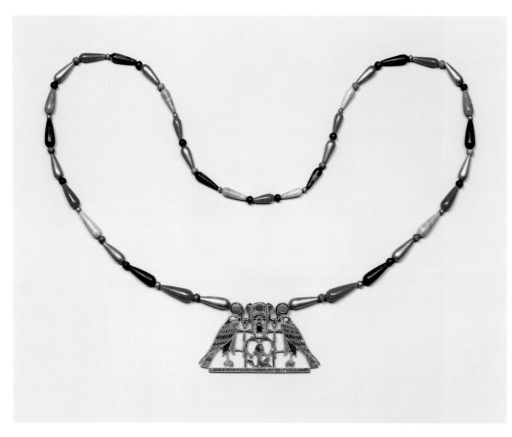

Fig. 4

Pectoral and necklace of Sithathoryunet
From El Lahun, tomb
of Sithathoryunet
Middle Kingdom, Dynasty 12, Reign
of Senwosret II–Amenemhat III, ca.
1887–ca. 1813 BCE
Gold, carnelian, lapis lazuli,
turquoise, and garnet
H × W: 4.5 × 8.2 cm
(1 ¾ × 3 ¼ in.) [pectoral]
L: 82 cm (32 ¼ in.) [necklace]
Metropolitan Museum of Art,
New York, purchase, Rogers Fund and
Henry Walters Gift, 1916, 16.1.3a,b

Elaborate chest ornaments (pectorals)
were worn by Egyptian elites during the
Middle Kingdom. Many incorporated
symbolic emblems and royal names and
were made of precious materials.

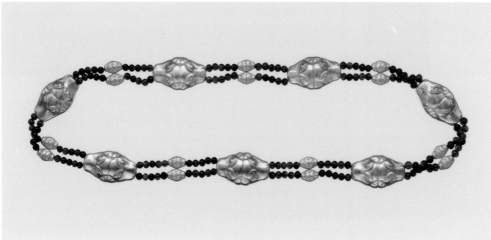

Fig. 5

Leopard-head girdle of Sithathoryunet
From El Lahun, tomb
of Sithathoryunet
Middle Kingdom, Dynasty 12, Reign
of Senwosret II–Amenemhat III,
ca. 1887–ca. 1813 BCE
Gold, amethyst, and diorite
pellets (inside)
Circumference: 81 cm (31 ⅞ in.)
Metropolitan Museum of Art, New
York, purchase, Rogers Fund and
Henry Walters Gift, 1916, 16.1.6

Girdles worn around the waist
sometimes incorporated hollow metal
elements—the pebbles contained
within them would create a sensual
sound upon movement.

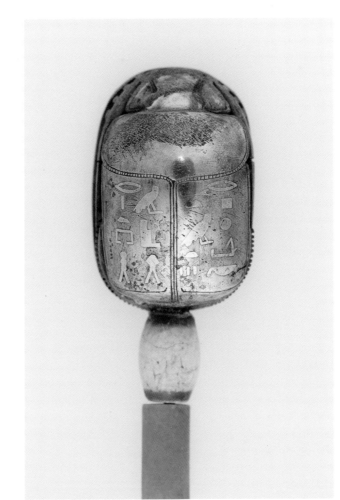

Fig. 6

Scarab of Wah
From Thebes, Tomb of Wah
Middle Kingdom, Dynasty 12, Reign of
Amenemhat I, ca. 1939–1910 BCE
Silver, electrum, glazed
steatite, and cord
2.5 × 3.9 cm (1 × 1 ½ in.)
Metropolitan Museum of Art,
New York, Rogers Fund and Edward
S. Harkness Gift, 1940, 40.3.12

One of the most important scarabs of
precious metal known to survive is
the inlaid silver beetle of the estate
manager Wah. Its construction,
size, and artistry are unique and an
example of the high skill level of the
Egyptian metalsmith.

(1878–1948). They discovered that hidden within a niche in the entranceway to the underground burial chamber was a marvelous cache of jewelry that included a diadem with rosettes and a central uraeus; two trapezoidal, gold pectorals inlaid with semiprecious stones (one bearing the name of Senwosret II (fig. 4), the other that of Amenemhat III); a girdle of hardstone and golden cowrie-shell beads; a girdle of amethyst ball beads and gold leopard-head elements (fig. 5); and a series of amuletic clasps with hieroglyphic signs and emblems.[4] The configuration of these clasps, which are concealed and incorporated into the ornament's overall design, is ingenious and unlike any other closure mechanism found in antiquity. It consists of a locking device made up of a T-shaped rod on the underside of the clasp and a grooved, decorative sleeve that slips over it. These sophisticated clasps were used on a variety of adornments, including necklaces, girdles, arm ornaments, and anklets.[5] Also fashionable during the Middle Kingdom were elaborate circlets for the head; hardstone, unicolor necklaces composed of spherical and lenticular-shaped beads; cylindrical amulet-case pendants with straight or fluted caps; fish pendants for the hair; oyster-shell pendants (some with royal names); bracelets with confronting, recumbent lions; scarab finger rings; and anklets with tiger-claw pendants. The period is also associated with advanced metalsmithing techniques, most notably fine filigree decoration; granulation, a technique in which tiny spheres of precious metal are fused by soldering to a metal substrate; and inlaid metalwork, a method in which one metal is inserted into

recesses carved into a metal of another color. A noted example of the latter is the large, silver scarab of the early Twelfth Dynasty estate manager Wah, whose name and titles are composed of electrum inlays set into the back of the beetle (fig. 6).[6]

Probably the most famous Egyptian jewels with a secure provenance are those of the boy-king Tutankhamun, who ruled briefly during Dynasty 18 of the New Kingdom (ca. 1539–1292 BCE). Known as Egypt's Golden Age, it was a period of international trade, military conquests, territorial expansion, monumental building projects, and wide-ranging influence. Under the succeeding, powerful Ramesside dynasties (19 and 20), Egypt became an imperial power that dominated parts of western Asia and Nubia (modern Sudan).

In 1922 Howard Carter, with funds provided by the British aristocrat and amateur Egyptologist Lord Carnarvon (1866–1923), discovered the late Eighteenth Dynasty tomb of Tutankhamun in the Valley of the Kings. Located on the west bank of the Nile across from the modern city of Luxor, the site served as the burial grounds for Egypt's mighty New Kingdom pharaohs and

Fig. 7

Corselet of Tutankhamun (front and back)
From Western Thebes, Valley of the Kings, Tomb KV62
New Kingdom, Dynasty 18, Reign of Tutankhamun, ca. 1333–1324 BCE
Gold, carnelian, lapis lazuli, turquoise, ivory, and glass
40 × 85 cm (15 ¾ × 33 ½ in.)
Egyptian Museum, Cairo, JE62627

This lavish corselet was most likely worn by the young king at his coronation. It is composed of two rectangular parts with a feather pattern, an elaborate collar, and a pair of decorative straps.

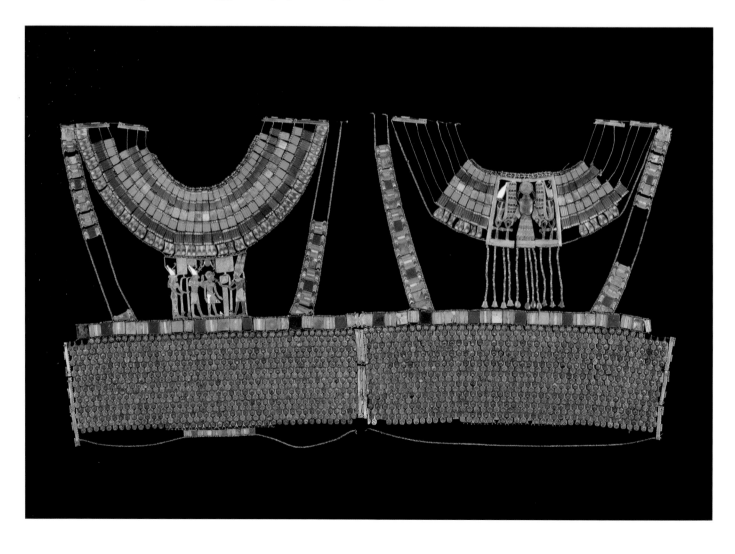

nobles. The contents of Tutankhamun's densely packed tomb, including the dazzling jewelry and funerary equipment, are testament to the grandeur of the age in which he reigned and the virtuosity of Egyptian craftsmen.

In comparison to the refined, delicate jewelry associated with Middle Kingdom royals, Tutankhamun's ornaments are bold, flamboyant, and opulent. Even Carter was stunned, exclaiming upon his first glimpse of the treasure that, as his "eyes accustomed to the light, details . . . emerged slowly from the mist . . . and gold—everywhere the glint of gold."[7] A seasoned excavator, the archaeologist describes being "struck dumb with amazement" by the wondrous objects before him—all for a teenage king whose reign is best known for his having rejected the monotheistic inclinations of his iconoclastic father, King Akhenaten (1353–1336 BCE), who broke with Egypt's age-old traditions and established a new capital city at the virgin site of Amarna, located on the east bank of the Nile about 300 miles south of Cairo.

Tutankhamun's marvelous jewels also stunned the world. In addition to his gold funerary mask,[8] Carter found a diadem with a central vulture's head and rearing cobra (symbols of the king's sovereignty over Upper and Lower Egypt); three different types of collars; an elaborate corselet most likely worn at the king's coronation when he was nine years old (fig. 7); twenty-six cloisonné pectorals; twenty-four bracelets; a sheet-gold belt; multiple beadwork garments; six pairs of earrings (stored in a cartouche-shaped jewelry box); finger rings in a variety of designs; two ceremonial daggers; and numerous amulets, including dozens of items placed in the king's mummy wrappings.[9] An examination of these ornaments suggests that some of the objects were worn in life as they show signs of wear and occasional repair.

During the New Kingdom, many jewelry forms were added to the repertoire of types found earlier. Earrings, for example, were largely absent prior to Egypt's era of empire and probably gained popularity as a result of Nubian influence. Finger rings, once composed of simple wires or a central scarab with a thin, wire shank, evolved into a fashionable adornment in a variety of shapes, including those with three-dimensional bezels; stirrup-shaped signets with flat, carved surfaces featuring hieroglyphs and sacred emblems; and metal rings with rectangular bezels on rigid, non-swivel shanks. Pectorals, large chest ornaments, once trapezoidal in shape, were sometimes frameless and composed of three-dimensional elements.

Military decorations befitting a global power also made their appearance during the New Kingdom. Most striking are the golden fly pendants that served as emblems of endurance, constancy, and valor. It has been suggested that these honorific ornaments originated in Nubia, where elite soldiers were distinguished by the large ivory and metal flies worn in pairs around the neck.[10] Another ornament, awarded by the king in recognition of outstanding

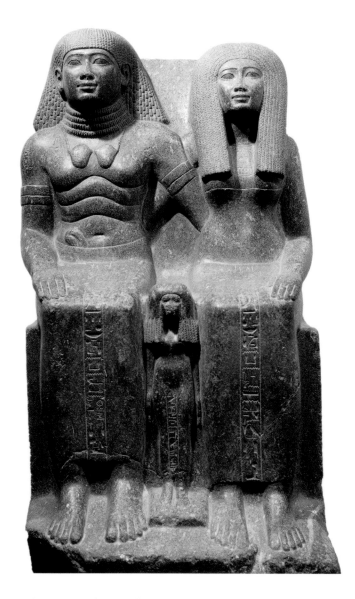

Fig. 8

**Double statue of Sennufer and
his wife Sentnay**
From West Thebes, TT 96
New Kingdom, Dynasty 18, Reign of
Amenhotep II, ca. 1425–1404 BCE
Granite
H: 120 cm (47 ¼ in.)
Egyptian Museum, Cairo,
JE 36574, CG 42126

Sennufer, who held numerous titles
including Mayor of Thebes, is shown
here wearing a *shebyu* collar, a double-
heart amulet, and *awaw* upper
armlets—all honorific awards.

merit, is the "gold of honor" collar composed of multiple strands of gold,
lenticular-shaped beads. Recipients of such distinguished rewards are also
sometimes depicted wearing matched pairs of *awaw*-armlets or the wide
mesketu-bangle—all crafted from glittering gold (fig. 8).

By the first millennium BCE, the might and influence of Egypt in the
ancient world had begun to wane. At first, power was divided between the
cities of Tanis in the north and Thebes in the south. However, after a series
of civil wars, a formidable new dynasty under the leadership of the Kushite
king Piankhy (Piye) (ca. 722–ca. 712 BCE) emerged in Nubia. After a series of
successful military campaigns northward, he became sole ruler of the entire
Nile Valley—an area that encompassed the land between the Mediterranean
Sea and Khartoum. Known as the Kushite or Twenty-fifth Dynasty, its rulers
adopted and adapted many traditional Egyptian beliefs, amalgamating age-old
customs with unique Nubian insignia, practices, and rules of governance.

Fig. 9

Hathor-headed crystal pendant
From el-Kurru, Tomb Ku 55
Nubian, Napatan Period, Reign of
Piankhy (Piye), ca. 743–712 BCE
Gold and rock crystal
5.3 × 3.3 cm (2 1/16 × 1 1/4 in.)
Museum of Fine Arts, Boston, 21.321

This extraordinary pendant is one of
several jewels composed of precious
metal and hardstone that were
recovered from the burial of one
of King Piankhy's queens. In this
example, the gold cylinder within the
crystal orb is hollow and may have
been designed to hold an amuletic
text or substance.

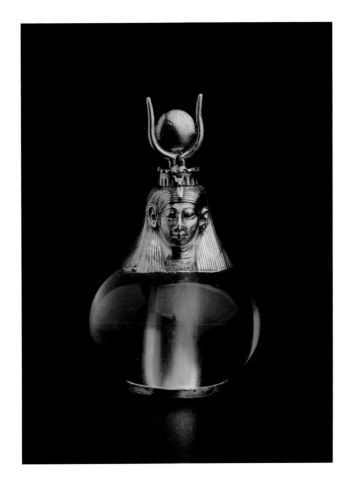

Although the capital of the Kushite kingdom was established at Napata (near modern Karima, Sudan) and its religious center located at nearby Gebel Barkal, it is likely that the dynasty's early rulers resided, at least part of the year, in Memphis, Egypt's ancient capital strategically located near the Giza plateau and the modern city of Cairo. They were buried, however, in pharaonic-style splendor in Egyptian-inspired pyramids at various sites in Nubia.

As with many aspects of Nubian culture, the jewelry recovered from excavations consists of forms borrowed from Egyptian sources, ornaments that incorporate repurposed Egyptian imports, and items that are uniquely Nubian in appearance, material, and construction. It has been suggested that some of the jewels found in the burial chambers of Piye's queens are, in fact, Egyptian jewels that were part of the booty acquired by the conqueror during his military campaigns as he made his way to the Nile Delta. Among them are a gold and rock crystal Hathor-headed pendant (fig. 9); a malachite and gilt silver pendant in the form of the goddess Maat; a dolomitic marble cat amulet; and

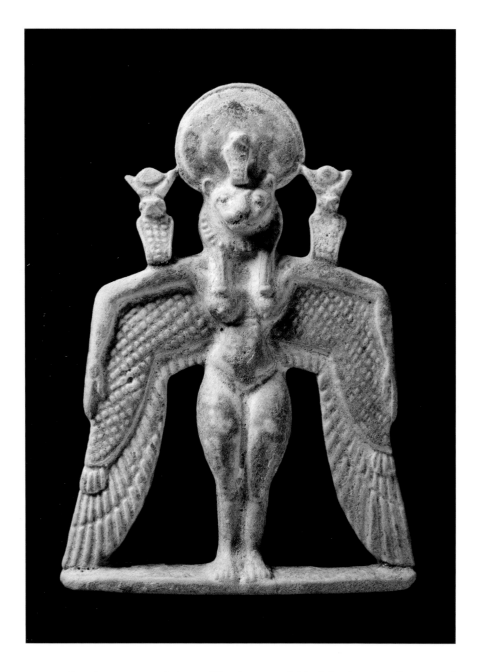

Fig. 10

Winged goddess pectoral
From el-Kurru, Tomb Ku 51
Nubian, Napatan Period, Reign of
Piankhy (Piye), ca. 743–712 BCE
Faience
8.5 × 6.2 cm (3 ⅜ × 2 ⁷⁄₁₆ in.)
Museum of Fine Arts, Boston, Harvard
University—Boston Museum of Fine
Arts Expedition, 24.616

This amulet features a goddess
whose body proportions represent
the Nubian ideal of female beauty.
As with many Kushite adornments, it
represents an amalgam of Egyptian
and Nubian aesthetics.

an amethystine quartz miniature libation vessel (situla). These hardstone and precious metal adornments would have appealed to the Nubians as they have a long history of crafting exotic stones into luxury products. However, they do not appear to have been influenced by the Egyptian reliance on specific hues associated with sacred stones nor the Egyptian preference for opaque, solid colors. They also created ornaments that represent a radical departure in the manner in which the female figure is depicted—images with pendulous breasts and heavy thighs (fig. 10).

COLOR SYMBOLISM

The color palette found in ancient Egyptian jewelry, especially those ornaments made in royal workshops, is universally appealing and based on color harmonies first noted by Renaissance writers. The scheme used by the Egyptians,

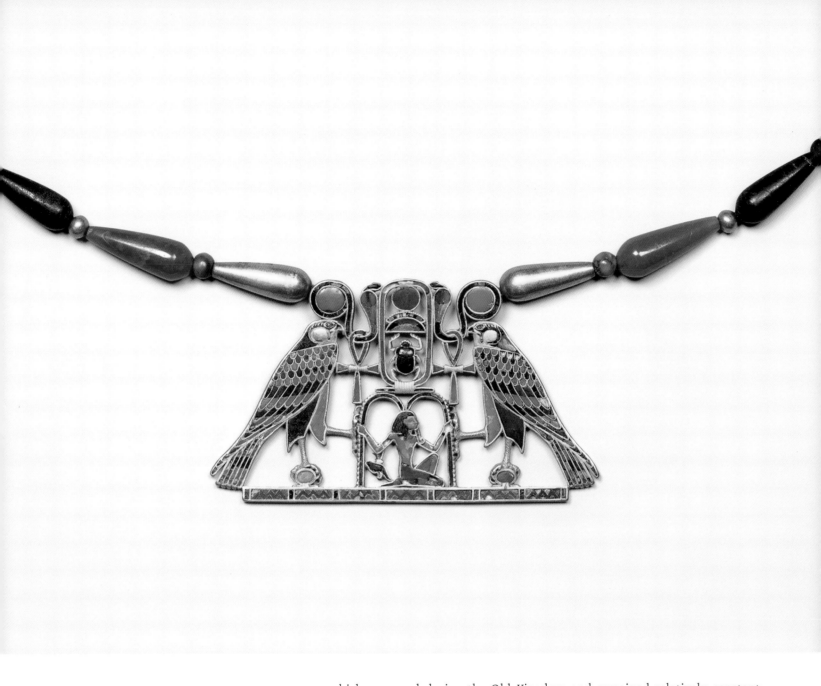

Fig. 11

Detail of fig. 4

which appeared during the Old Kingdom and remained relatively constant throughout dynastic history, is best described as a tetradic grouping of four colors arranged as complementary pairs.[11] These pairs—red-yellow (gold) and green-blue—represent a balance between warm and cold hues that is visually pleasing and harmonious (fig. 11). For the ancient Egyptians, however, the use of certain colors was more than an aesthetic consideration. It was a reflection of a system of beliefs in which color symbolized the essence of all that exists, including objects associated with daily life as well as goods designed to accompany and sustain the deceased in the afterworld. The colors used in the creation of these objects reflected these ideas, providing order, stability, and meaning in a universe fraught with malevolent and unpredictable forces. Red, the color of life-sustaining blood; yellow (gold), the embodiment of the regenerative sun; green, a sign of vegetation, renewal, and health; and blue, the vibrant hue of both the sky and the Nile River, were chosen because each

Fig. 12

Color symbolism illustration
The color scheme used by the
Egyptians is best described as a
tetradic one: a grouping of four
colors arranged as complementary
pairs. These pairs, often found in
royal jewelry, represent a balance
between warm and cool hues that are
aesthetically pleasing.

played a vital role in insuring the well-being of the individual and the community (fig. 12). It is interesting to note that tints or shades—colors created by mixing primary, secondary, or tertiary colors with white or black—rarely appear in Egyptian jewelry. The same is true of the secondary colors with the exception of purple, a color fashionable during the Middle Kingdom (ca. 1980–1760 BCE) and Ptolemaic times (305–30 BCE) when it was often used alone or in combination with gold (fig. 13). Color perspective—a technique in which warm colors are used to make objects appear in the foreground while cool colors fill receding areas—was also of no interest to the Egyptians as flat, uniform color represented a realism based on fixed and enduring aspects of nature.

MATERIALS AND TECHNIQUES: METALS

Ancient Egyptian metalsmiths used a number of local and imported metals when exercising their craft. The most prized were gold and silver, two of the three noble metals found in the earth's crust that have been exploited by civilizations around the globe for millennia. The third metal—platinum—has a melting point so high (3,215°F) that it was rarely used in the decorative arts until the invention of the oxyhydrogen torch in the mid-1800s.

Egypt was fortunate in that various regions of the Nile Valley and its Eastern Desert were a source of both alluvial and lode (ore) deposits of gold. In

Fig. 13

Claw anklets of Sithathoryunet
From El Lahun, Tomb
of Sithathoryunet
Middle Kingdom, Dynasty 12, Reign
of Senwosret II–Amenemhat III,
ca. 1887–ca. 1813 BCE
Gold and amethyst
L: 15 cm (5 ⁷⁄₈ in.) each
Metropolitan Museum of Art, New
York, purchase, Rogers Fund and
Henry Walters Gift, 1916, 16.1.7a,b

During the Middle Kingdom, women
sometimes wore matched anklets
with claw-shaped pendants. It has
been suggested that they represent
bird claws, as some examples
are embellished by bejeweled
feather patterns.

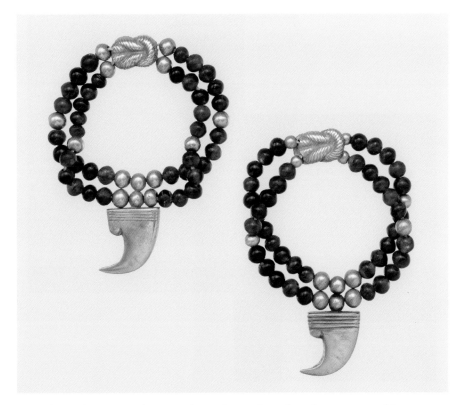

describing this asset, the Egyptians often referred to three geographic sources. From southeastern Egypt, including the elevated regions parallel to the Red Sea, came the "gold of Koptos," while northern or Lower Nubia supplied the "gold of Wawat," an area that was particularly rich in gold ore. Finally, the "gold of Kush," which encompassed the gold-belt region south of the Second Cataract in the area of Napata in ancient Nubia, included riverine alluvial deposits as well as auriferous tracts that stretched eastward across the desert. There is evidence that these areas of gold-bearing ores were extensively worked in antiquity by shallow surface mining and that the extracted gold ranged in purity from about 80 to 99 percent.[12] Analyses of samples from placer (alluvial) deposits are higher in gold content than mined ores whose silver composition may account for more than 20 percent of any given sample. Silver-rich gold (less than 75 percent gold), called electrum, is pale in color and can darken when exposed to an environment that contains sulfur. Sources of this "white gold" included ancient Nubia, Punt (located southeast of Egypt in northeast Ethiopia), and the mountainous regions of the Eastern Desert.

In pure form, gold is a bright-yellow, glowing metal that does not decay or oxidize (tarnish) over time. In ancient Egypt, it was a symbol of everlasting life and the powerful deity Ra. For the metalworker, it is a superior substance

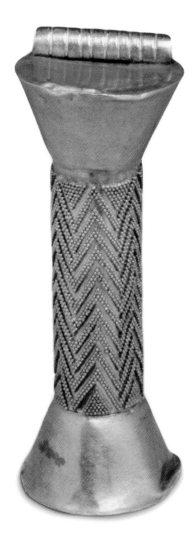

Fig. 14

**Cylindrical amulet-
case pendant**
Provenance unknown
Middle Kingdom, ca. 1980–1760 BCE
Gold
7.6 × 2.7 cm (2.9 × 1.1 in.)
British Museum, London, EA24774

Cylindrical amulet-case pendants were worn exclusively by women during the Middle Kingdom. One example is known to have contained garnet pebbles. Some of the finest examples are decorated with tiny gold balls arranged in triangular or zig-zag patterns.

because it is malleable and readily hammered into thin sheets that can be cut into various shapes and assembled mechanically or by soldering. The metal can also be stamped with dies, a method used when repetitive shapes are part of the design. Surface embellishments, such as chasing (indented designs made with a hammer and chisel), repoussé (relief designs formed by pressing the metal forward from the underside), and filigree (wire decoration made by strip-twisting narrow bands of sheet metal), were also among the many metalsmithing techniques employed by Egyptian artisans. Probably the most difficult decorative device employed was granulation, a technique in which minute spheres of metal are attached or fused to a substrate to produce a delicate, raised pattern. Ornaments with granulated surfaces appear during the

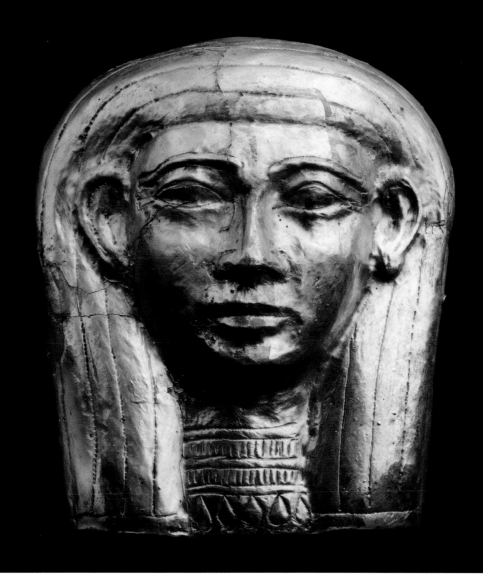

Fig. 15

Mask of Queen Malakaye
From Nuri, Pyramid 59
Nubian, Napatan Period, Reign of
Tanwetamani, 644–653 BCE
Gilt silver
13 × 11.5 × 3.9 cm (5 ⅛ × 4 ½ × 1 ½ in.)
Museum of Fine Arts,
Boston, 20.1059a

Gilt-silver mummy masks once
adorned royal mummies in ancient
Egypt and Nubia. They are made of
hammered sheet metal with chased
ornamentation on the surface.

Middle Kingdom and then sparingly until Hellenistic times when it became a hallmark feature of Greek jewelry (fig. 14). Finally, gold was sometimes cast in molds or through the lost-wax process into three-dimensional adornments—a technique infrequently used as it is wasteful of metal. The ancients were more likely to cover a non-precious core in the desired shape with thin, metal sheet.[13]

Unlike gold, the silver used in Egyptian jewelry was most likely acquired from outside sources such as northern Greece, Anatolia (modern Turkey), and Syria where it was extracted by cupellation[14] from argentiferous, lead-ore deposits. At first, it was used sparingly for small, precious objects. By the first millennium BCE, silver was more commonly used, as demonstrated by the silver coffin of the Tanite[15] pharaoh Psusennes I (ca. 1051–1006 BCE), and the numerous gilt-silver objects found among the burial goods of Twenty-fifth Dynasty (ca. 722–655 BCE) ruling elites (fig. 15). Like gold, silver had important symbolic meanings: it was associated with the moon and the god Thoth; represented ritual purity and cleanliness; and was considered the "bones of the gods." The techniques used in fabricating silver objects were the same as those used in crafting gold items.

MATERIALS: THE STONES

The hardstones used by the ancient Egyptians are described as "semiprecious" materials in modern, Western culture. They are largely opaque minerals of intense hue rather than transparent gems that reflect light when faceted. The most prized stones by today's standard—diamond, ruby, sapphire, and emerald—rank high on the Mohs scale of hardness[16] and would have been difficult to carve even if available. In the case of emerald, an Egyptian source in the Eastern Desert was known in pharaonic times but not used until Ptolemaic rule. Even then, jewelers typically used the mineral in its natural, crystalline form with a central, drilled hole to facilitate stringing or mounting on wire. Softer stones, such as amazonite (microcline) and turquoise, were the minerals of choice when a green hue was desired. In addition to their color, stones were valued for their rarity, durability, and resistance to decay. The most frequently used were:

Amazonite (1) – a blue-green, opaque mineral that is a variety of microcline feldspar. Found in pegmatite veins in gneiss deposits located in the Eastern Desert, the Red Sea region, and the Libyan mountains, this shimmering stone is sometimes confused with beryl or turquoise. It was used in the manufacture of beads, amulets, inlays, and small three-dimensional objects.

Amethyst (2) – a translucent form of microcrystalline quartz whose violet color is due to small amounts of ferric oxide. The most important source in Egypt was the Wadi el-Hudi region of the Eastern Desert where there are signs of Middle Kingdom mining activities. A pale, violet form of the mineral with white streaks, known as amethystine quartz, was also employed. In addition to making beads and amulets, the stone was sometimes used to carve small vessels and statuettes.

Carnelian (3) – a translucent, brownish-red or reddish-orange form of chalcedony (silicon dioxide) with numerous sources in the Eastern Desert and Nubia. It was used in the manufacture of beads, amulets, inlays, finger rings, and earrings.

Chalcedony (4) – a translucent, bluish-white, microcrystalline form of quartz. There are many varieties including agate, carnelian, jasper, onyx, and sardonyx. Found in several locations, including the Eastern Desert, the Fayum, and Nubia.

Garnet (5) – part of a family of silicate-based minerals with similar physical properties but different chemical compositions. The variety used in Egypt is the pinkish-red almandine/pyrope series found in the Eastern Desert where the specimens are small, dark, and brittle. Used sparingly in jewelry until Classical times, when different sources of higher caliber became available.

Hematite (6) – an opaque, black form of iron oxide found in various rock formations in the Eastern Desert, the Aswan region, and the Sinai. Used in the manufacture of beads and amulets, especially the head-rest and carpenter's square.

Jasper (7) – a red, green, or yellow form of chalcedony found in the Eastern Desert; used in jewelry production (beads, amulets, and inlays), heart scarabs, and statuary.

Lapis lazuli (8) – an opaque, brilliant-blue feldspar silicate that sometimes presents with white calcite veins or glittering crystals of pyrite. The only source in ancient times was Badakhshan in northern Afghanistan.

Malachite (9) – an opaque, green mineral (copper carbonate hydroxide) found in the Eastern Desert and the Sinai peninsula; used occasionally in jewelry manufacture; commonly ground up for use as a pigment and eye makeup.

Obsidian (10) – a natural, dark volcanic glass similar in composition to granite in that it is formed by the rapid solidification of cooling lava. It is believed to have been imported from Ethiopia or parts of Asia. Used in crafting cosmetic vessels, small models, eye inlays, and parts of sculptures.

Olivine (11) – any of a group of magnesium silicates that occurs in olive-green to gray-green masses; commonly known as peridot; found on St. John's Island situated in the Red Sea and used during Predynastic times in the manufacture of beads and pendants. Sometimes confused with green beryl.

Rock crystal (12) – a colorless, transparent form of quartz found in the Eastern and Western Deserts as well as the Sinai; used in the fabrication of beads, amulets, small vessels, and sculptures.

Serpentine (13) – a dark green, black, or spotted magnesium silicate used in the fabrication of beads, amulets, small vessels, and other decorative objects.

Steatite (14) – a form of the mineral talc, a soft substance (Mohs 1) that was typically heated and glazed to increase its hardness and resistance to wear. Found in the central and southern regions of the Eastern Desert, the rock was used in the fabrication of beads (especially scarabs), amulets, vessels, and small sculptures.

Turquoise (15) – an opaque, blue-green mineral that is a hydrated phosphate of copper and aluminum; extracted from veins in sandstone outcrops at the Wadi Maghara and Serabit el-Khadim in the Sinai; used to make beads, amulets, and inlays.

MATERIALS: FAIENCE

Faience is a quartz-based, non-clay ceramic with small amounts of lime and either plant ash or natron (a salt mineral). It has a vitreous, alkaline glaze that can exhibit a range of hues when mineral oxide colorants are added to the glazing mixture. In ancient Egypt, the glassy surface was achieved through a number of processes, including the heating of a glaze slurry applied to the surface of the object; the addition of the glazing material to the ground quartz and alkalis of the body which then "effloresces" or migrates to the surface; and the immersion of the body in a glazing powder that then chemically fuses to the underlying object when heated (cementation).[17]

Faience production has a long history in Egypt, and numerous examples of small adornments dating to the Predynastic Period have been found in

Fig. 16

Shabti of Lady Sati
New Kingdom, Dynasty 18,
ca. 1539–1292 BCE
Polychrome faience
26 × 8.9 cm (10 ¼ × 3 ½ in.)
Brooklyn Museum, Charles Edwin
Wilbour Fund, 37.124E

The New Kingdom is known for the wide range of colors used in faience and glass manufacture. This emphasis on polychromy is evident in decorative arts objects as well as funerary equipment, including shabtis.

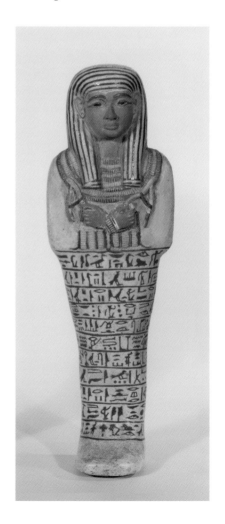

cemeteries at Naqada and Badari. With the introduction of the beaded broad collar during the Old Kingdom, it became a mainstay among jewelers who utilized massive amounts of beads and small amulets for an increasing number of elites. At first, the colors used were limited to blue-green and then later expanded to include black, white, red, yellow, purple, and marbleized hues (fig. 16). Faience production reached the height of artistry during the New Kingdom when vibrant, polychrome objects in the form of personal adornments, vessels, small sculptures, inlays, tiles, and ritual artifacts were part of everyday life.[18] In addition to the symbolic powers inherent in the various colors used in faience production, it has been suggested that the process itself was imbued with mystical properties as the white-toned faience body appeared to magically transform into a bright, dazzling object upon heating.

MATERIALS: GLASS AND ENAMEL

Glass production in ancient Egypt was a natural extension of the faience industry in that the raw materials—silica (desert sand), soda, and lime—are common to both substances. It was not until the New Kingdom, however, that it appears as a fully developed art form. The lack of evidence of prior experimentation with glass formulas and firing techniques has prompted some scholars to speculate that it was a technology imported from western Asia where glass manufacture was well underway by the mid-second millennium BCE. Documents dating to the reign of Thutmose III (ca. 1479–ca. 1425 BCE) indicate that ingots of worked glass were imported from Mitanni, a Mesopotamian power that flourished around 1500 BCE. These specimens would then have been melted and manipulated into a wide range of objects in varying hues.[19] Among the wares created were personal adornments in the form of beads, amulets, earrings, rings, and inlays.[20] Although we now regard glass as an inexpensive substitute for more precious materials, it was considered a luxury good by the Egyptians whose glassworkers were among the most talented artisans in antiquity. A testament to its elevated status is its limited use and association with royalty. A spectacular example is the funerary mask of King Tutankhamun (ca. 1333–ca. 1323 BCE), a marvel of goldsmithing that features intense-blue glass inlays set into recesses made in the beard and striped, royal headcloth. In addition to inlays, glass was also used to create three-dimensional, sculptural components (fig. 17), vessels, beads, amulets, and pendants. Around 1100 BCE, glass as a decorative arts medium disappeared for a period of time in Egypt, only to resurface three hundred years later when a limited number of objects were produced using casting or core-forming methods.[21] Glass was also a material popular among the Phoenicians (ca. 1500–ca. 300 BCE), a maritime people along the Mediterranean coast who were prodigious traders skilled in the art

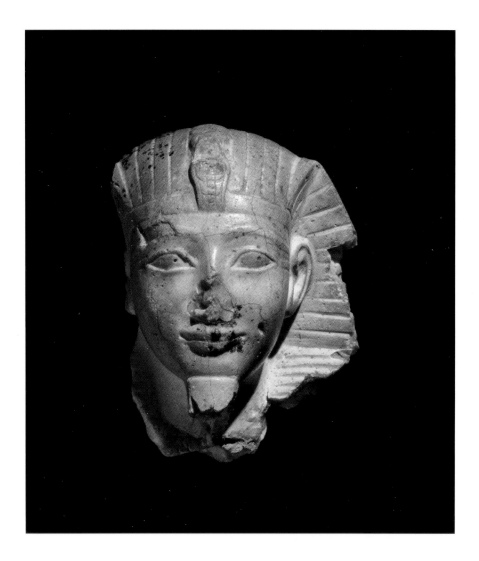

Fig. 17

Head of Amenhotep II
New Kingdom, Dynasty 18, Reign of
Amenhotep II, ca. 1425–1404 BCE
Cast glass
4 × 2.9 × 3.4 cm (1 9/16 × 1 1/8 × 1 5/16 in.)
Corning Museum of Glass, 70.1.4

Glass sculpting in the round appears
in Egypt during the New Kingdom and
was a prized material restricted to
royal workshops. This example is one
of the earliest known glass portraits.

of glassmaking. One of their specialties was the glass eye-bead, an ornament prized in many regions of the ancient Near East.[22] It was the Romans, however, who introduced glass blowing and the manufacture of glass wares on a large scale, including clear glass vessels for daily use as well as elaborate containers to house precious substances (fig. 18).

Enameling, an offshoot of glass technology, is a process where ground glass and metallic oxide colorants are heat-fused to a metal, glass, or ceramic substrate to produce a smooth, vitreous coating. Although a few examples are known from the Third Intermediate Period, enamel does not appear on a large scale in Egypt until Ptolemaic times.[23]

Fig. 18

Bottle
Romano-Egyptian, ca. 100–200 CE
Glass
H: 3.5 cm (1 ⅜ in.)
Mrs. Kingsmill Marrs
Collection, 1925.327

By the end of the first century
BCE, the Romans had introduced
glass blowing, replacing cast and
core-formed vessels with a less
labor-intensive technology. As
a result, glass containers were
affordable and acquired by a wide
range of consumers.

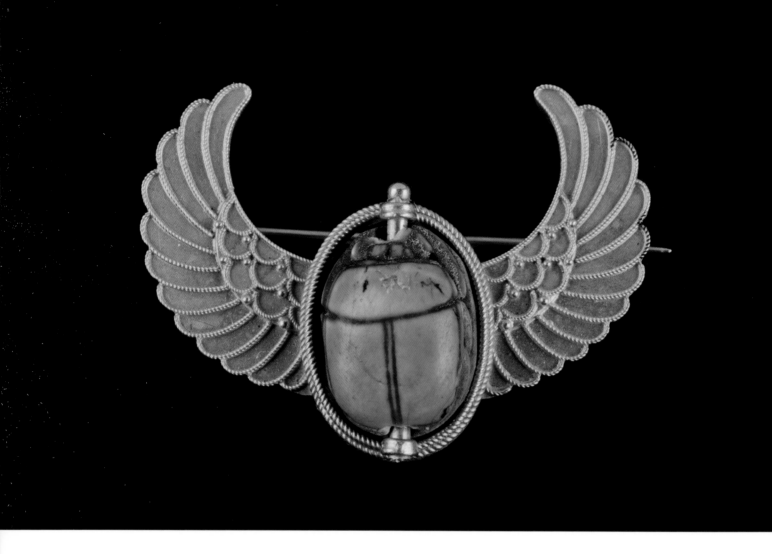

EGYPTIAN REVIVAL JEWELRY

For centuries, the West has been attracted to the exotic lands of the East and the cultures of ancient civilizations. It began in earnest during the Renaissance, a time characterized by a renewed interest in the Classical world, especially the thoughts and views expressed in Greek and Roman literature. By the eighteenth century, travelers, scholars, and artists had expanded their fascination with the historic past to include Egypt, a Mediterranean power that in its time was respected, revered, and sometimes feared. It was home to grand marvels of architecture; possessed majestic monuments decorated with curious imagery; and boasted a strange written language that was not deciphered until the early nineteenth century.[24]

Kingsmill and Laura Marrs were among a coterie of late nineteenth-century Americans who fell under Egypt's allure. Like many who traveled to the mysterious lands of the East, they collected a range of antiquities that they brought back home to be admired, displayed, and sometimes worn. Among the latter were personal adornments composed of small antiquities that were either set in precious metal mounts by Egyptian craftsmen or later adapted into stylish ornaments by Western jewelers. Howard Carter proved invaluable in the acquisition of these small treasures as a lively trade in forgeries was already

Fig. 19

Brooch featuring an ancient scarab on a winged mount
New Kingdom, ca. 1539–1077 BCE (scarab); late 19th–early 20th century (mount)
Gold and glazed steatite
2.6 × 3.6 × 1.5 cm (1 × 1 7/16 × 9/16 in.)
Mrs. Kingsmill Marrs
Collection, 1926.86

A popular motif among revivalist jewelers was the scarab. These small, sacred beetles were powerful amulets in their day and represented the power, mystery, and glory of ancient Egypt to nineteenth- and twentieth-century travelers to the ancient Near East. Many acquired these portable antiquities during their journey and had them set in decorative gold mounts at home.

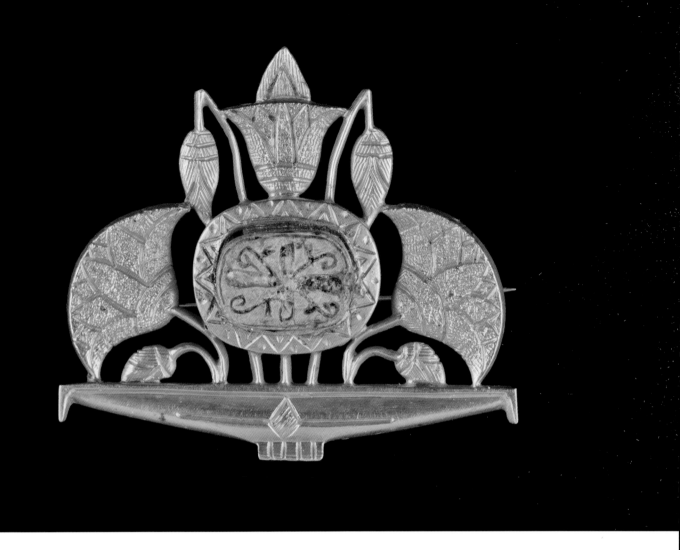

Fig. 20

**Brooch featuring a skiff
with blossoms and an
ancient plaquette**
New Kingdom, ca. 1539–1077 BCE
(plaquette); late 19th–early 20th
century (mount)
Gold and glazed steatite
3.2 × 3.7 cm (1 ¼ × 1 ⁷⁄₁₆ in.)
Gift of Mrs. E.D. Buffington, 1914.2

The gold mount for this ancient
Egyptian plaquette consists of a skiff
with lotus blossoms and buds in a
bilateral, symmetrical arrangement.
The lotus was a popular decorative
motif in antiquity and one that was
also fashionable among revivalist
jewelers. The surface of the metal
in this ornament is finely textured
in a manner reminiscent of fine
Etruscan granulation.

established in Egypt by the late nineteenth century. It was his expertise that
guided the Marrses to purchase artifacts that were authentic, finely crafted, and
representative of Egyptian forms and materials. An example in the collection is a
winged scarab brooch composed of a blue-glazed, steatite scarab set in an early
twentieth-century gold mount (fig. 19). The wings of this ornament are curved
upwards in a manner reminiscent of several inlaid pectorals found in the tomb
of Tutankhamun, the boy-king whose discovery by Carter in 1922 created an
Egyptian craze that far surpassed prior and subsequent Egyptomanias.

Egyptian revival jewelry made during the pre-Tutankhamun period (roughly
1870–1922) falls into three categories—pieces based on Egyptian symbols
and themes; ornaments designed to incorporate small antiquities; and jew-
elry with stylized elements suggestive of ancient Egypt (fig. 20). For affluent
ladies traveling in Europe during the second half of the nineteenth century,
the house of Castellani (1814–1930), founded by Fortunato Pio Castellani and
located in Rome's Piazza di Trevi, was a favorite stop. The firm, known for
its gold, enamel, and micromosaic adornments closely modeled on ancient
Greek and Italian originals, appealed to members of the new industrial class
with the means to acquire objects they identified as symbolic of an illustri-
ous, romantic past.

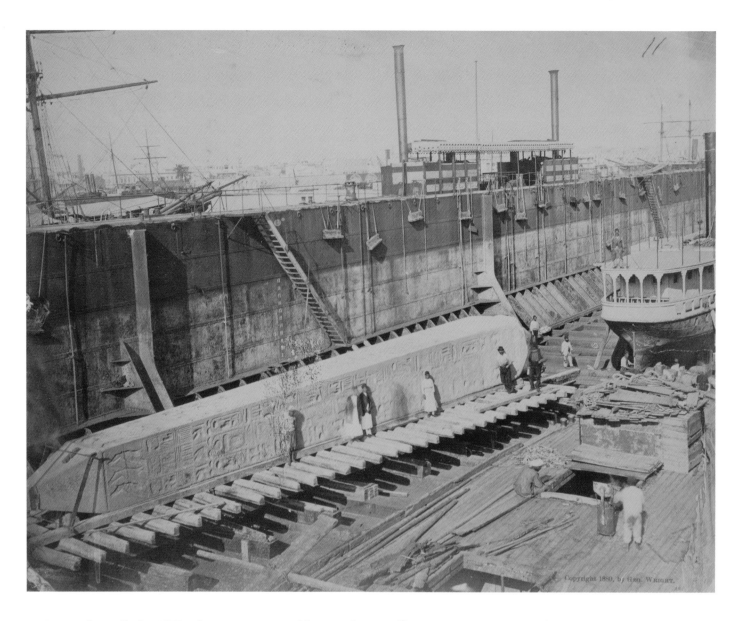

Copyright 1880, by Geo. Wright.

It wasn't until the 1870s that ornaments with Egyptian motifs appear, reflecting the excitement generated by the opening of the Suez Canal (1869), a series of international expositions, and the publicity surrounding archaeological discoveries at ancient sites. For Americans, the arrival in 1880 of an imposing Egyptian obelisk (Cleopatra's Needle) that was later installed in Central Park near the Metropolitan Museum of Art further stimulated an interest in all things Egyptian (fig. 21). Leading designers and merchandisers took notice. By the late 1870s, Tiffany & Co. (1837–present), America's premier retailer of high-style jewelry, was offering Egyptian-inspired adornments made of precious materials to their well-heeled clientele. Among them was a brooch depicting the head of an Egyptian queen, possibly the ill-fated Cleopatra.[25] The ornament is composed of a carved citrine head, a stylized vulture headdress set with diamonds and sapphires, a diamond-studded choker and necklace, and a lower band of pavé-set rubies (fig. 22). Drawings preserved in the Tiffany & Co. Archives indicate that other bejeweled objects, including bracelets, watch fobs, stick pins, rings, and purse mounts were also part of their wares. Even the talented and prodigious G. Paulding Farnham (1859–1927), who

Fig. 21

Vintage photo of Cleopatra's Needle (obelisk) arriving in New York
1880, unknown photographer. New York Public Library, 5239571.

Cleopatra's Needle in New York City is an ancient Egyptian obelisk that was erected in Central Park, west of the Metropolitan Museum of Art, in January 1881. Although the monument is associated with the name of Cleopatra in popular culture, it was originally created during the reign of the Eighteenth Dynasty ruler Thutmose III (ca. 1479–1425 BCE).

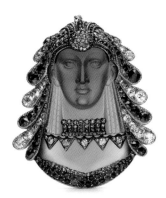

Fig. 22

Brooch
Tiffany & Co.
(American, founded 1837)
1870–80
Gold, diamonds, sapphires,
rubies, and citrine
4.8 × 4.1 cm (1 ⁷⁄₈ × 1 ⁵⁄₈ in.)
Tiffany Archives, A2002.18

This revivalist brooch consists of a
carved citrine head in the form of
a goddess or queen with a stylized
vulture headdress. It is one of the
earliest examples of the Egyptian
style in America and, in keeping
with Tiffany & Co.'s reputation
as the premier retailer of gem-set
jewelry, is decorated with diamonds,
sapphires, and rubies.

Fig. 23

Brooch
Tiffany & Co.
(American, founded 1837)
1889–1901
Gold, platinum, diamond,
pearl, and enamel
3.9 × 4.0 cm (1 ⁹⁄₁₆ × 1 ⁹⁄₁₆ in.)
Tiffany Archives, A1998.04

This brooch was created in the Tiffany
& Co. workshop during a period
when the firm held center-stage at
the international expositions. Like
many of its European competitors, the
firm created jewelry in the popular
archaeological revival style. Some
ornaments, including this circular
brooch made of precious materials,
incorporate motifs that are subtle
references to Egypt. In this case,
there are five stylized lotus blossoms
separated by natural pearls.

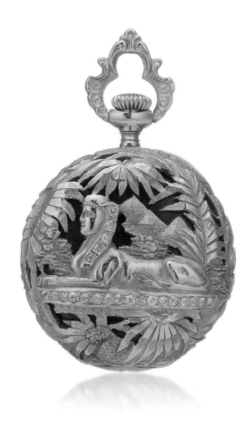

Fig. 24

Tiffany & Co.
(American, founded 1837)
Pocket watch
ca. 1899
Gold, diamonds, enamel, and crystal
4.2 × 2.8 cm (1 ⅝ × 1 ⅛ in.)
Tiffany Archives, G2000.03

Pocket watches are portable
timepieces meant to be carried in a
pocket or suspended from a chain
or ribbon worn around the neck.
They were popular adornments
during the nineteenth century and
were decorated with a wide range of
motifs, including designs inspired by
ancient Egypt. A perennial favorite
among jewelry and watch designers
was the sphinx set among the
pyramids of Giza.

Fig. 25

Louis Comfort Tiffany
(American, 1848–1933)
On the Way between Old and
New Cairo, Citadel Mosque of
Mohammed Ali, and the Tombs
of the Mamelukes
1872
Oil on canvas
105.1 × 172.9 cm (41 ⅜ × 68 ¹⁄₁₆ in.)
Brooklyn Museum, 06.329

Louis Comfort Tiffany, son of
Tiffany & Co. founder Charles Lewis
Tiffany (1812–1902), traveled to the
Middle East in 1870 where he was
influenced by Islamic architecture
and metalwork. This influence is
evidenced in his early paintings and
later decorative arts.

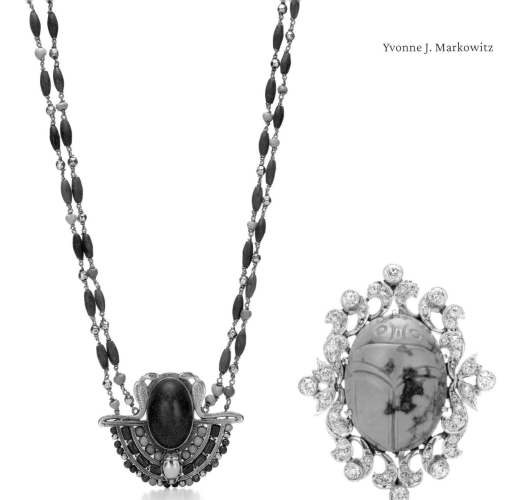

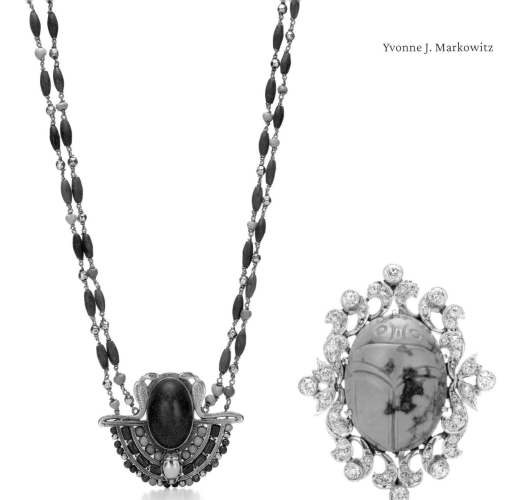

Fig. 26

Louis Comfort Tiffany (1848–1933)
for Tiffany & Co.
(American, founded 1837)
Necklace
ca. 1913
Gold, lapis lazuli,
turquoise, and carnelian
L: 24.5 cm (9 ⁵⁄₈ in.)
Tiffany Archives, A2008.27

Although Louis Comfort Tiffany is
known for his naturalistic approach
to jewelry design and appreciation
of arts & crafts and art nouveau
decorative arts, his Egyptian-themed
glass and jewelry inspired by ancient
Egyptian adornment illustrate
a lifelong interest in the land
of the pharaohs.

Fig. 27

Tiffany & Co.
(American, founded 1837)
Brooch
1893–1909
Gold, platinum,
diamonds, and turquoise
3.4 × 4 × 2.7 cm
(1 ⁵⁄₁₆ × 1 ⁹⁄₁₆ × 1 ¹⁄₁₆ in.)
Tiffany Archives, A2003.42

This brooch, created in the Edwardian
style, incorporates a contemporary
scarab of turquoise most likely
sourced from mines in the American
Southwest. It's unusual in that
Edwardian jewelry rarely references
the past, preferring the all-white look
of platinum and diamond. Charles
Tiffany, however, was enamored
with American colored stones,
setting a standard for jewelers in
the United States.

would become design director of the jewelry department at Tiffany's in 1891, fell under Egypt's spell. Among his credits are a gold, enamel, diamond, and pearl brooch with stylized lotus blossoms created around the time of the 1889 Exposition Universelle in Paris (fig. 23) and a gold and enamel watch with a central, diamond-studded sphinx amid the pyramids of Giza and a surround of stylized palm fronds (fig. 24).[26]

In 1902 Louis Comfort Tiffany (1848–1933), son of Tiffany founder Charles Lewis Tiffany (1812–1902), became vice-president and art director of the firm. Early in his career, he had traveled extensively throughout the Middle East where he was influenced by Islamic metalwork and architecture (fig. 25). His fascination with Egypt, in particular, was on display during the lavish Egyptian fête he hosted at the Tiffany Studios' showroom in 1913. Dressed as an Egyptian pasha, he orchestrated an extravagant pageant dramatizing Mark Antony's return to Cleopatra in Alexandria. The gala, which was widely reported in the press, included professional dancers, waterworks, a philharmonic orchestra, and more than three hundred costumed guests.[27] That same year, his elite "Tiffany Art Jewelry" division created an elegant necklace based on an ancient pectoral incorporating Egyptian forms (scarab, uraei, and broad collar) and materials (fig. 26).[28] The firm also retailed Egyptian-themed ornaments made of traditional, high-end materials, including a platinum and diamond

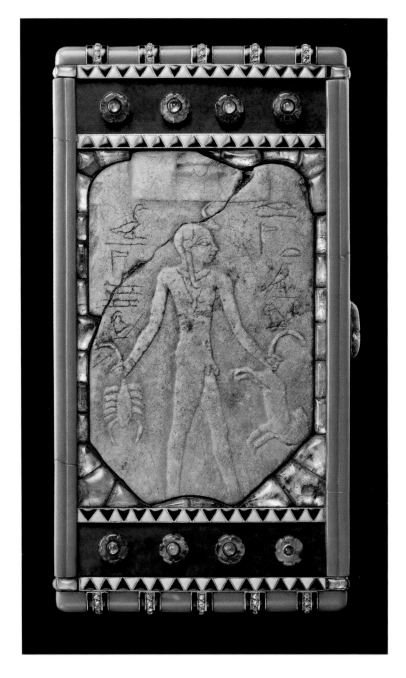

Fig. 28

Cartier Paris
Egyptian vanity case
1927
Calibré-cut emeralds, carved buff-
top emeralds and emerald matrix
cabochons, coral, lapis lazuli,
turquoise, and black enamel
H. ca. 10.2 cm (4 in.)
Cartier Collection, VC 65 A27

In addition to jewelry, Cartier created
high-style decorative arts items
that included vanity cases, smoking
paraphernalia, cosmetic cases, and
table clocks. More than any other
European firm, they were known
for designing around small artifacts
that they acquired from antiquities
dealers. Their finest Egyptian-
inspired objects were made during
the 1920s and purchased by European
royals and American celebrities.

Fig. 29

Designed by André Boeuf for
Trifari (1925–1999)
Egyptian revival Osiris brooch
1973
Gold plate and silver
4 1/4 × 2 3/4 in.
Private collection

Costume jewelry makers in America
created Egyptian-themed jewelry
during the popular Tutankhamun
exhibition tour of the early 1970s.
One of the most successful firms to
capitalize on the craze for all things
Egyptian in that period was Trifari, a
Rhode Island company known for its
innovative, whimsical adornments.

brooch with a central, carved turquoise scarab that was made in the popular
Edwardian style (fig. 27).

The discovery of Tutankhamun's tomb coincided with a new aesthetic
in the visual arts that originated in France around the First World War and
quickly spread throughout Europe and the United States. Known as art deco,
the movement was characterized by rectilinear, geometric shapes that were
flat and contained. In this respect, it shared many attributes with ancient
Egyptian jewelry, including an emphasis on bilateral symmetry and bold, con-
trasting colors. During this period, which lasted nearly two decades, jewelers
produced fewer ornaments incorporating small artifacts. One notable excep-
tion is the house of Cartier (1847–present), a French firm that had established
a lucrative satellite shop on Fifth Avenue not far from Tiffany & Co. Their
Egyptian-inspired jewels (fig. 28), owned by celebrities and dignitaries such

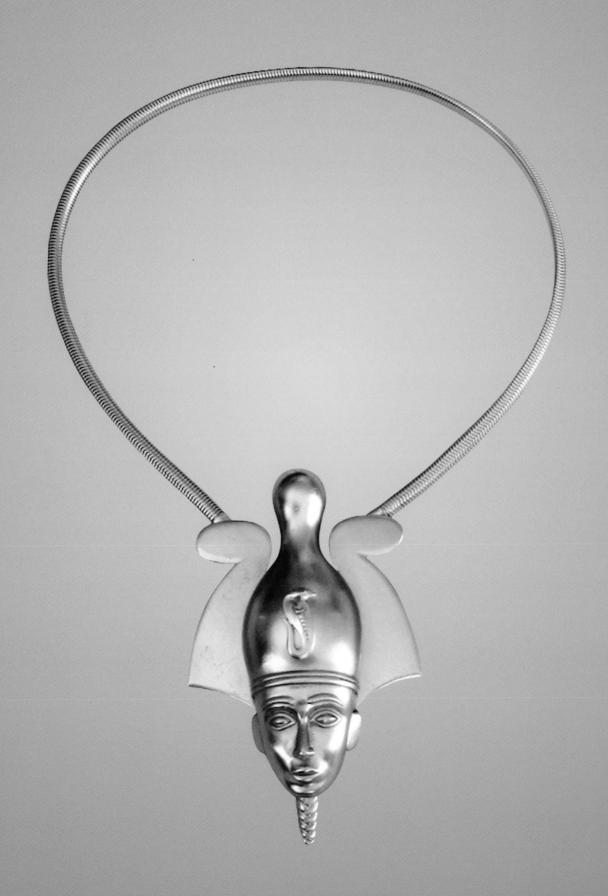

as Ambassador Ira Nelson Morris (1875–1942), were often designed around amulets and fragments of artifacts purchased from a number of antiquities dealers in Paris.[29] Set in platinum and diamond mounts that were embellished by classic Egyptian stones, these glamorous objects represented the epitome of deco fashion. More important, they were worn by international personalities and appeared in high-fashion magazines such as *Vogue* and *Town & Country*. As a result of this exposure, Egyptian-themed jewelry spawned numerous reiterations in the world of couture and costume jewelry.

Throughout the remainder of the twentieth century, identifiable emblems of Egypt—pyramids, sphinxes, obelisks, mummies, scarabs, hieroglyphs (real and nonsensical), and pharaohs' heads—became an important part of the lexicon of Egyptian design elements used by jewelers.[30] This was the case during the blockbuster museum tour of treasures from the tomb of Tutankhamun during the 1970s.[31] This exhibition marked the first time objects from the tomb had left Egypt. Hundreds of thousands of visitors waited in long lines to see the jewels and mask of the mysterious boy-king. Museum shops had record sales of trinkets while several costume jewelry manufacturers capitalized on the buzz (fig. 29). No doubt, future Egyptomanias lie ahead.

Endnotes

1. Petrie 1901, 16–17.
2. Freed et al. 2009, 121–22.
3. *Maat*, depicted as a woman wearing an ostrich plume headdress, symbolized the Egyptian concept of balance, order, truth, and justice. See Watterson 1984, 59–60.
4. For a more complete listing of the jewelry discovered, see Winlock 1934.
5. For a discussion and diagrams of Middle Kingdom clasps, see Wilkinson 1971, 58–60.
6. Andrews 1990, 177.
7. Carter and Mace 1923a, 141.
8. It has been suggested that the original owner of the mask was Queen Nefertiti, wife of King Akhenaten. See Reeves 2015, 511–26.
9. For a pictorial survey of the treasure, see Edwards 1976–77.
10. Lacovara and Markowitz 2019, 85–86.
11. It has been noted that the ancient Egyptians also relied on a tricolor scheme—red, green, and blue—in the decorative arts as well as painting, sculpture, and architecture. See Wilkinson 1994, 104–25.
12. Ogden 2000, 161–62.
13. For a more detailed discussion of metal techniques used in ancient Egypt and Nubia, see Gänsicke and Newman 2014, 143–47.
14. A metallurgical refining process where ores are separated into noble metals from base metals.
15. The Tanite kings ruled from the Egyptian Delta city of Tanis during Dynasties 21–22 (ca. 1076–746 BCE).
16. An ordinal scale for measuring the relative hardness of a mineral as determined by its ability to withstand scratching, as opposed to its ability to withstand blows. It was developed in 1812 by the Austrian mineralogist Friederich Mohs (1773–1839) and consists of a qualitative scale based on the ability of harder materials to scratch softer substances.
17. Nicholson 2000.
18. Friedman 1998.
19. Nicholson and Henderson 2000.
20. For an understanding of early glassmaking in ancient Egypt, see Lilyquist and Brill 1995.
21. Hess and Wight, ix.
22. Glass eye-beads remain a popular ornament in the Middle East, especially among brides, pregnant women, and children who are considered particularly vulnerable to the malevolent intentions of others.
23. Two objects have been identified among the burial goods of General Wendjebauendjed, a high official during the reign of King Psusennes I, who ruled from the Delta town of Tanis. See Ogden 1990–91.
24. The breakthrough in understanding Egyptian language was accomplished by the French orientalist Jean-François Champollion (1790–1832), a scholar known for his decipherment of the Rosetta Stone in the 1820s. For more information on this exciting discovery, see Champollion 2001.
25. Phillips 2006, 136.
26. Loring 2004, 118–19.
27. For a more detailed description of the event, see Loring 2002, 12–13.
28. The relatively small number of gold, enamel, and semiprecious stone ornaments created in this workshop was purchased primarily by customers with avant-garde tastes. Jewelry made of platinum and precious gems continued to be the stock-in-trade at Tiffany's during the early decades of the twentieth century.
29. Among the dealers were the Kalebdjian brothers located at 12 Rue de la Paix and Dikran Kelekian at Place Vendôme. See Young-Sanchez 2014, 77–86.
30. For a discussion of common motifs found in Egyptian revival jewelry, see Nicholls 2006, 47–108.
31. Hindley 2015.

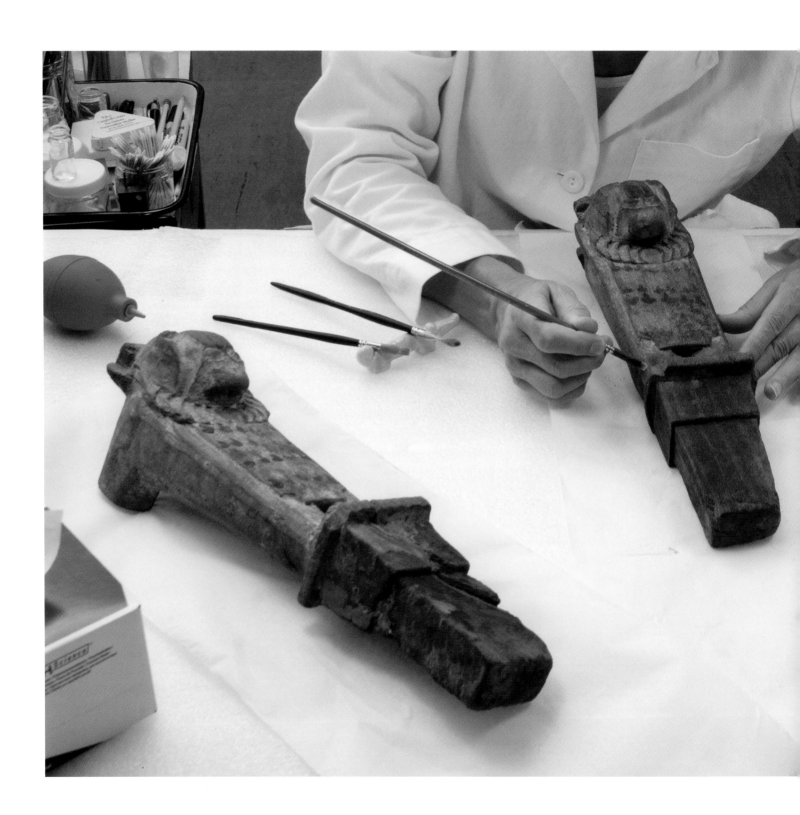

CONSERVATION, TECHNIQUE, AND RESEARCH

Paula Artal-Isbrand

INTRODUCTION

The opportunity to study and conserve the exquisite objects from the Mrs. Kingsmill Marrs Collection was hugely stimulating for me as the Worcester Art Museum's objects conservator (fig. 1). These beautiful and mesmerizing objects—fabricated from a vast range of materials, and shaped and decorated using elaborate techniques—made this year-long project extremely exciting and instructive. As I examined, studied, and conserved these treasures in the Museum's conservation laboratory using microscopes, high-resolution cameras, and other scientific equipment, I was in awe over and over again at the high level of sophistication of the Egyptian artists and craftsmen who made them. Although there is no known provenance for any one of these objects, one can safely assert that they were all either excavated, or found in tomb chambers. Numerous intriguing discoveries were made during the meticulous conservation campaign that helped to better understand many of the artifacts that are part of Mrs. Marrs's generous gift to the Museum. For instance, the unusual appearance of several unfinished items allowed us to learn about their manufacturing process.

This essay consists of two parts. In the first part, I have selected representative aspects of the conservation treatment process; in the second, which also includes scientific research, I share compelling observations and insights gained during the conservation campaign.

CONSERVATION TREATMENT

The conservation treatment of the extraordinary Marrs collection has made it possible to display many of the items for the first time. The majority of the treatment time was devoted to three activities: restringing the necklaces and armlets, cleaning, and restoring broken and deteriorated objects (fig. 1).

Detail of fig. 1

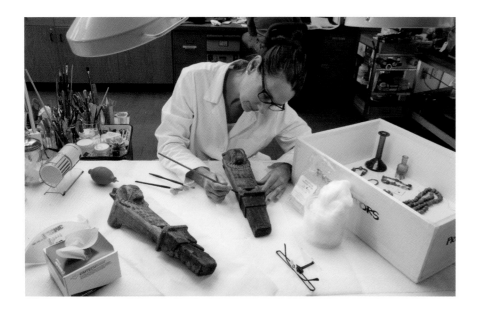

Fig. 1

Objects conservator Paula Artal-Isbrand cleaning a pair of polychrome wooden lion legs from a funerary bier (1925.410)

All materials used during this conservation campaign have been extensively researched for conservation purposes—the materials are inert and reversible, and will only minimally change color and consistency over time.

Restringing

Egypt's contribution to the art of jewelry was the introduction of beads.[1] The wide range of materials, shapes, and techniques that can be observed on the necklaces, collars, armlets, and anklets in this catalogue attest to this. Made primarily of metal, precious and semiprecious stones, glass, and faience, Egypt was the largest producer of beads in antiquity.[2]

The profession of jeweler in Egypt was highly specialized, depending on the material used and the task performed.[3] The highest rank was occupied by the goldsmith, the *nuby*, followed by the precious stone worker, the *neshdy*. Then there was the *iru weshbet*, the bead maker who worked with faience and glass and probably with other materials as well. Fig. 2 depicts a detail of a New Kingdom tomb painting of a busy jewelry workshop.[4] One can observe jewelers polishing or drilling holes in stone beads using bow drilling equipment (right) and threading beads for a broad collar (left). The quest by Egyptian craftsmen to produce a man-made material that was more readily available and easier to work into artifacts reminiscent of stone led to the discovery of faience and subsequently glass. It is therefore not surprising that the Egyptian word for glass literally translates as "melted stone."[5] Both these materials—faience and glass—were considered to be artificial precious stones, making them a highly valued commodity before the Eighteenth Dynasty. They were certainly not a

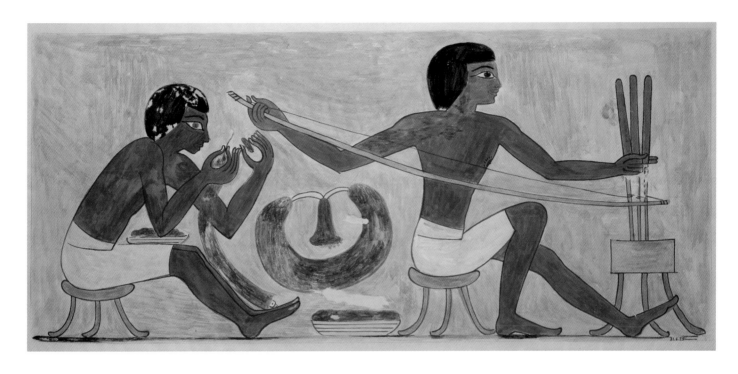

Fig. 2

Nina de Garis Davies (1881–1965)
Tomb of Rekhmire **(facsimile)**
Tempera paint and ink on paper
27.5 × 62.5 cm (10 $^{13}/_{16}$ × 24 $^{5}/_{8}$ in.)
Metropolitan Museum of Art, Rogers
Fund, 1931; 31.6.25

Bead workshop showing jewelers
stringing and drilling beads.

Fig. 3

Objects conservator Paula
Artal-Isbrand stringing newly
assembled necklaces

cheap substitute.[6] The *setro* was specialized in making strung necklaces. The literature reports that ancient threading material has occasionally survived in dry burial environments in Egypt including threads made of flax (linen)— the fibers were typically spun into threads of three or more twisted strands from as early as the fourth millennium.[7] An interesting fact is that cotton was unknown in Egypt until the Roman Period.[8]

While most of the beads from the Marrs collection were ancient, none of the necklaces, armlets, chokers, or anklets were ancient assemblages. In addition to modern string, modern clasps, and modern beads, they even incorporated mummy wrapping components. In close consultation with the curators, most items were restrung to accurately represent ancient Egyptian taste based on evidence from scientifically excavated jewelry. Some pieces, however, were left as Mrs. Marrs had purchased them during her travels to convey the unique tastes of the early twentieth century and of the widespread Egyptomania movement.

The restringing of items in the Marrs collection began in 2000 when Peter Lacovara, then Curator of Egyptian, Nubian, and Near Eastern Art at the Michael C. Carlos Museum of Emory University in Atlanta, requested a selection of these objects for a long-term loan (September 2001–August 2005) for Atlanta through the Museum Loan Network. Lawrence Becker, Chief Conservator at the Worcester Art Museum at the time, undertook the conservation for this loan with the help and advice from expert volunteer Sheila Shear.

The Marrs jewelry was restrung (fig. 3) with modern linen thread that was coated with beeswax using three different assemblage categories: unchanged assemblages; unchanged assemblages but without modern clasps or modern beads; entirely new assemblages with components of one or more items based on stringing patterns of ancient parallels. Finally, some items were entirely disassembled and their components displayed as individual objects. The decision for the latter approach was taken for various reasons—either because the components merited being shown individually or because not enough components were extant to produce a meaningful new strung assemblage.

The necklace in fig. 4 was entirely disassembled and its faience mummy beads were incorporated into the newly strung necklace in fig. 5 along with a faience lioness head and two tassel-like faience end beads.

The necklace in fig. 6 (1925.635) was taken apart because its assemblage of faience beads and a pendant was incorrect—it was a pastiche of elements from various items of ancient ornaments. Parts of it were restrung to produce the necklace in fig. 7 (2019.31), which consists of turquoise Hathor beads and plain beads. The remainder—consisting of multi-colored faience beads representing various fruit, grains, and vegetables (dates, clusters of grapes, cornflowers, poppy pods) and the pendant—were left unstrung. They will be displayed individually. The modern clasp was not reused.

Fig. 4

This faience mummy bead necklace with one modern glass bead (1925.550) was entirely disassembled.

Fig. 5

Newly strung necklace (2019.30) consisting of components from various objects including the ancient beads of the necklace in fig. 4 (1925.550)

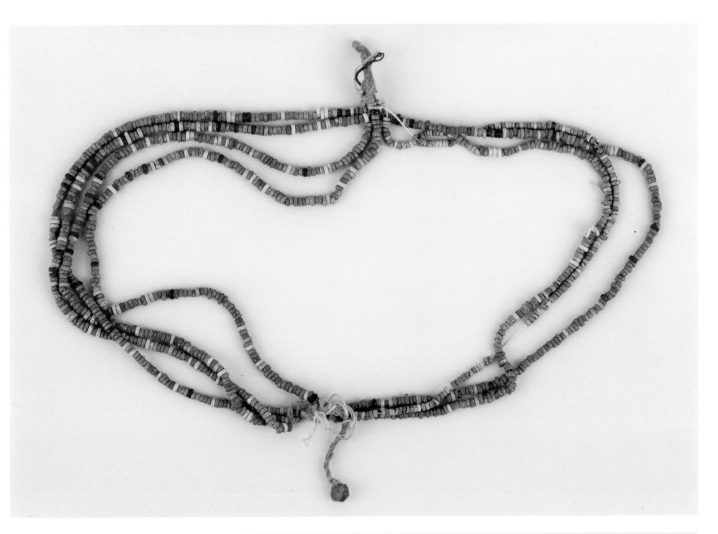

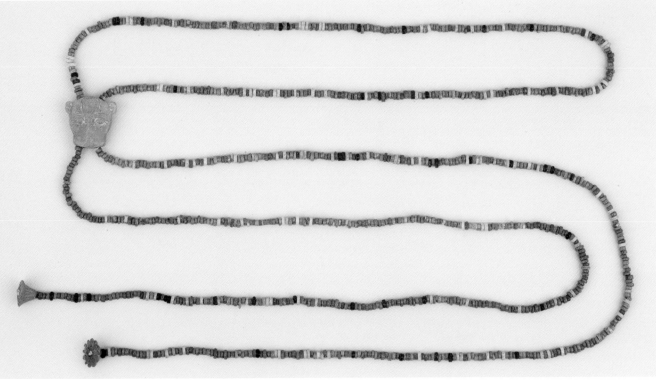

89

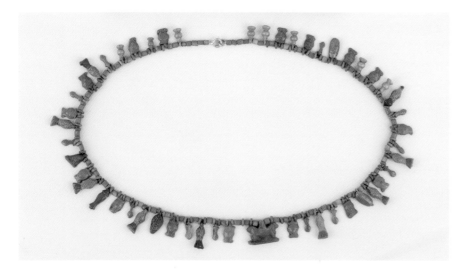

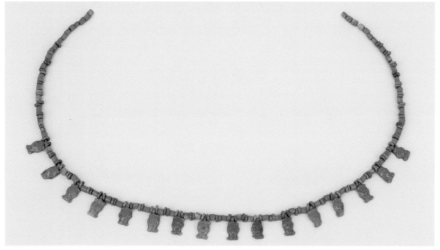

Fig. 6

This necklace (1925.635)—a modern-day creation made of faience beads, a faience pendant, and a modern gold clasp—was disassembled.

Fig. 7

The newly strung necklace (2019.31) made from parts of the necklace in fig. 6 (1925.635)

Fig. 8

Objects conservator Paula Artal-Isbrand cleaning the red granite head of Amenhotep III (1925.606) (top left); Head of Amenhotep III, during cleaning (top right); Cleaning of the four-legged "Egyptian alabaster" kohl pot (1925.357) (bottom left); Content residues inside an anhydrite vessel (1925.342) (bottom right)

Cleaning

All objects in the exhibition received a light cleaning with soft brushes and, if needed, also with cotton swabs dampened in ethanol or deionized water. It is important to mention that only the exterior parts were cleaned, leaving the interior parts and the bead holes intact to preserve possible traces of ancient substances or archaeological soil for analysis.

Some objects, however, needed a more thorough cleaning. Predominantly made of stone, they had a thick layer of dirt and grime on their surfaces that required attention. The exquisite cosmetic vessels and implements made of "Egyptian alabaster" (travertine) and anhydrite were in the worst condition. The translucency, softness, and light color of these stone objects make them

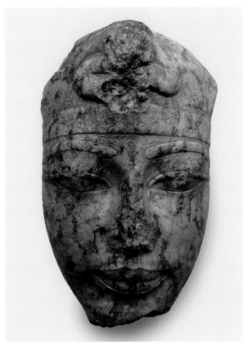

quite vulnerable to getting dirty not only from ancient use and exposure to archaeological soil but also from handling during and after excavation by excavators, antiquities dealers, Mrs. Marrs herself, and other individuals who left their mark on their surfaces. Some of these vessels retain content residues, likely remains of ancient cosmetic potions (fig. 8). Where extant, the author started a preliminary analytical study of the contents, which at the time of this publication was limited to testing for lead, which was indeed present in several samples.[9] The natural white mineral cerussite, a lead carbonate, is known to be an ingredient of ancient cosmetics from Egypt.[10]

The particularly beautiful head of Amenhotep III, made of red granite, also needed cleaning. During careful examination of its surface, the conservator noticed that the black color of the hornblende grains of the granite had been accentuated by overpainting with black paint. It was important to investigate if this paint was ancient or modern before cleaning of the surface could commence. If it was ancient, it would have been preserved. Paint analysis by conservation scientist Erin Mysak identified the black pigment to be bone black, which was not commonly used in ancient Egypt. It was removed with Shellsol D-38:ethanol, 1:1 on cotton swabs.[11]

A custom cleaning system was designed to dissolve the thick layer of dirt and grime on this group of stone objects. It consisted of chemicals mixed into a gel which was applied to the surface with a brush, left for a short time, and then removed along with the dissolved dirt and grime with a brush and lint-free cotton wipes.[12] Fig. 8 shows this cleaning process. To prevent absorption of the gel with the dissolved dirt and grime into the stone surface, the surface was first saturated with an inert slow-evaporating solvent before the gel application. This solvent was also used to remove any residues of the gel afterwards. A number of Egyptian alabaster containers displaying losses were restored with a putty made of acrylic resin, a bulking agent, and inorganic pigments.[13]

Restoration of glass

Egyptian craftsmen produced among the highest quality glass in antiquity.[14] The origins of glassmaking in Egypt are hard to trace. Though glass was made before the Eighteenth Dynasty (ca. 1539–1292 BCE), it is probable that it was initially produced accidentally while making faience. Then from 1500 BCE onwards glass was fabricated in Egypt on a regular basis, although it is important to note that its sudden extraordinarily high quality has led scholars to surmise that the glassmaking technology was likely introduced by foreigners and only manufactured by Egyptians once the knowhow had been established.[15]

A number of glass objects in the Marrs collection required a partial reconstruction in preparation for the exhibition. Two were selected for this essay— each one representing a unique glassmaking technique.

Fig. 9

Two ancient techniques of shaping glass—casting in a mold (left) and free-blowing (right) (drawings by Paula Artal-Isbrand)

Fig. 10

Four-legged glass vessel (1925.338), before (left), during (center), and after conservation (right)

The four-legged vessel (1925.338) in fig. 10, with losses to three of its legs, was fabricated by casting, probably in a two-piece clay mold (fig. 9).[16] Upon cooling, the surface was cold-worked and decorated with sharp tools and abrasives.[17]

The second item (fig. 11) is a tall dark green bottle with a long neck and a wide rim—a large part of the rim was lost. It is a free-blown vessel, formed by blowing air into molten glass using a blow pipe and then shaping the hot glass with specialty tools (fig. 9). Not an Egyptian invention but developed in Syria during the Roman Period in the first century BCE, this technique revolutionized the glass-making industry, allowing for the mass production of glass vessels due to the speed with which they could be made.

Both these vessels were restored using modern glass-conservation techniques which involve making molds from materials borrowed from dentistry and a conservation-grade epoxy colored with dyes as a fill material.[18] For the restoration of the legs of the four-legged vessel, a direct casting technique

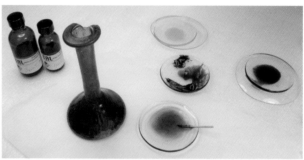

was used: a mold made of dental wax sheet stock was shaped by pressing it around the intact leg, and then placing it around the stumps of each broken leg—one at a time—and filling it with Hxtal NYL-1 epoxy (fig. 10). The epoxy was tinted with Orasol dyes to simulate the color of the ancient glass. A thick layer of acrylic resin[19] served as a barrier layer between the ancient glass object and the epoxy fills to facilitate its removal in the future should this be necessary.

For the restoration of the broken rim on the tall green vase, a two-step casting approach was used (fig. 11). This produced a "detachable" epoxy fill, which was adhered in place with adhesive.[20] The two-step restoration of the rim was done as follows. First an intermediate plaster of Paris (Garreco plaster of Paris) prototype was fabricated that was cast in a silicone mold (Coltene President) taken from an intact portion of the rim. This plaster cast was finished with scalpels and sandpaper before a second high-precision silicone mold was prepared from it, which was used for the final cast made of Hxtal NYL-1 epoxy and tinted with Orasol dyes to resemble the original glass. Even though a more time-consuming technique, the advantage of this approach is that all the casting, molding, and finishing work is done away from the ancient object. This technique is recommended when the shape of a loss is complex, and ample finishing work is required.

Fig. 11

The two-step restoration process of a loss along the rim of a free-blown glass vessel (1925.339). First a plaster cast of the loss was produced, followed by a colored epoxy cast (made in the same mold), which was adhered to the broken rim.

RESEARCH

The first step of the conservation campaign consisted in assessing the condition of all the objects proposed for exhibition to determine which ones needed treatment so that they could be displayed. During this period of scrutinized looking, as well as during the conservation treatment phase itself, some fascinating discoveries were made. Some of the findings, which clearly point to the highly sophisticated jewelry-making technology and material knowledge of the Egyptians, are discussed next.

An unfinished jasper amulet depicting Hathor

The fragmentary and unfinished amulet (1925.629) made of jasper on the left in fig. 12 most likely depicts the goddess Hathor—with her distinctive triangular head, elongated eyes, and characteristically pointy and protruding cow's ears. The image on the right in fig. 12 is a detail of a well-preserved column capital at the Metropolitan Museum of Art depicting the goddess Hathor for comparison. At first, the Marrs amulet does not stand out as being beautiful or remarkable, especially because of its deplorable condition, though closer examination reveals why this object is broken and was left unfinished. The clue lies on the top edge (fig. 13, left) of the artifact, where it is possible to see the remains of two drilling holes that originate from opposite sides. The artist's intention was clearly that these holes meet up in the middle—but they did not. Instead, the object snapped because the walls on either side of the holes had gotten too thin. So the work on the amulet was abandoned.

This amulet offers a unique glimpse into the sophisticated technique of cutting and drilling stone in ancient Egypt. With a Mohs hardness of Hm7.0, jasper is a very hard stone like quartz and rock crystal, and harder than granite (Hm6–6.5)—with diamond being the hardest mineral of all (Hm10).[21]

Carving, cutting, and drilling holes into an artifact made of a hard stone was therefore a challenge that the Egyptians learned to overcome by using tools made of harder materials. To drill holes in beads or amulets made from stone with a Mohs hardness Hm3–Hm7 they used flint point-borers which produced a V-shaped perforation.[22] The flint points were fitted into a wooden holder. Flint can cut stone with a hardness of up to Hm7.0, which includes most members of the quartz family.[23] In his publication *Jewellery of the Ancient World* Jack Ogden discusses the fascinating discovery of a flint drill found within a partially drilled hole in a granite bead.[24]

The V-shaped feature at the beginning of a hole in a bead or amulet like this Hathor amulet is indicative that this technique was used. The amethyst scarab in fig. 13, also in the Marrs collection, has a hole—still containing archaeological residues of sand or soil and most visible from the underside—that was made in this fashion. Belonging to the quartz family, amethyst also

 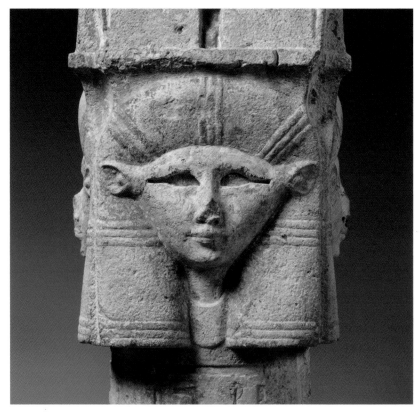

has a Mohs hardness of Hm7.0.[25] One can observe in the photograph that the two slightly conical-shaped holes drilled from opposite sides meet in the middle as intended. The reasons for drilling from two sides were likely twofold: the first was to avoid having a hole with a larger diameter on one side than the other,[26] and the second was to better control the directionality of the hole and avoid it wandering off its intended axis.[27] The existence of cone-shaped holes on either side of a bead or amulet is often used as a visual confirmation for authentication purposes, though the practice is also common in many modern-day bead-making centers.

A *neshdy*, the jeweler specialized in stone, likely carved the Hathor amulet and the amethyst scarab[28] and used a bow drill to make the holes. A bow drill is a simple rotational hand-operated tool of prehistoric origin first used to create heat and subsequently a fire through friction at the bottom of a quickly rotating shaft (fig. 14, right). The Egyptian bow drill evolved from this tool and operates by the same principle. It is constructed from a bow and a string, with the string wrapped around a wooden shaft to which a drill bit made of metal or a hard stone (typically flint) is fitted. When the operator

Fig. 12

Unfinished amulet made of jasper depicting Hathor (1539–1077 BCE) (1925.629) (left); column with Hathor, Egypt, Late Period, Dynasty 30, 380–343 BCE, limestone, paint, 102 × 34.3 × 34. 3 cm (40 3/16 × 13 1/2 × 13 1/2 in.), Metropolitan Museum of Art, Gift of Edward S. Harkness, 1928 28.9.7 (right)

Fig. 13

Top view of the amulet in fig. 12 showing two conical drilling holes originating on opposite sides that do not meet in the middle (top); underside of an amethyst scarab bead (1926.41) showing through the translucent stone that two drilling holes from opposite sides meet in the middle (middle); side-view of the scarab bead (bottom)

Fig. 14

A bow drill is a simple rotational hand-operated tool of prehistoric origin to create a fire through friction at the bottom of a quickly rotating shaft. Operating on the same principle, it later evolved into a tool for drilling holes into hard materials. Egyptians used bow drills for drilling holes into stones. (drawing by Paula Artal-Isbrand)

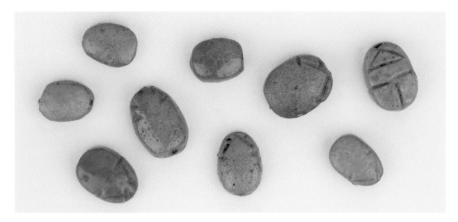

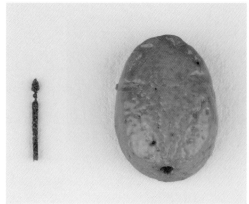

Fig. 15

Group of faience scarab beads
(1925.611) (left); an iron rod inside
the hole of one bead fell out during
treatment (right)

moves the bow horizontally in a back-and-forth motion, it causes the shaft
to turn on its axis at a high speed, and while pressing down onto the shaft a
hole is drilled. Egyptian jewelers also used multiple bow drill set-ups to drill
holes into several artifacts at once, by wrapping the string around several drill-
ing shafts—each one drilling a hole in a different bead. This operation can be
observed in the painting of a tomb wall on the right in fig. 2.

The discovery of iron rods inside a group of faience beads

A group of nine faience scarab beads (fig. 15) in the Marrs collection dating
to the Third Intermediate Period (ca. 1076–655 BCE) were not strung, but
stored loosely in a plastic specimen box. During examination the conservator
discovered that, with the exception of one bead, all holes were obstructed
with what at first seemed to be archaeological soil or sand. However, during
cleaning near the hole of one scarab, a compact little rod-like item suddenly
fell out of the hole. It was soon determined that the obstructed holes of all
the beads had iron rods inside because the beads were "magnetic" (fig. 16).

Scanning electron microscopy/energy dispersive X-ray spectroscopy (SEM/
EDS) analysis[29] of the small rod that had fallen out of the bead revealed that
it is composed of iron with a small amount of tin (fig. 17). The obvious ques-
tion the conservator posed herself was, are these little rods part of the man-
ufacturing process?

While the labor that went into the manufacture of stone jewelry (and drill-
ing holes into it) was strenuous and time-consuming, for man-made materials
like faience this was different. Egyptian faience is made up of crushed quartz or
sand, small amounts of lime, natron or plant ash, and metal oxides for color.[30]
Once the components are mixed into a thick paste by adding water, an arti-
fact is ready to be shaped—either free-hand or by pressing into a mold. The
mold technique was faster compared to shaping an artifact free-hand. Once

Fig. 16

Faience bead with iron rod inside the hole is "magnetic"

Fig. 17

SEM with energy-dispersive X-ray spectroscopy (EDS) spectrum of the metal rod in fig. 15 shows elemental iron (Fe) and tin (Sn) peaks

dry, the artifact was ready for firing. Two specialists worked with faience in ancient Egypt: the *baba* made earrings, bangles, finger rings, and openwork items like the eye of Horus in the Marrs collection while the *iru weshbet* exclusively made beads.[31]

This group of scarab beads were likely made in a mold like the ones depicted in fig. 18, which not only incorporate the design of the bead but also the depressions for the placement of a material that would create the hole.[32] These photos show one part of a two-piece mold. The material that was placed in these molds to create the hole in the bead was typically thick thread made of an organic material that would burn out during firing. This approach involved much less labor compared to having to make the hole mechanically after the bead was shaped by perforating the unfired bead with a hard, needle-like wire.[33]

The fact that the iron rods are magnetic is quite remarkable since iron artifacts typically fully corrode in an archaeological setting, especially if the iron item is small and thin. Corroded iron is not magnetic—only pure iron is—suggesting that these little rods have metallic iron cores. Certainly the sheltered placement inside the beads' holes helps to shield the iron from oxygen and preserve it.

In discussing this find with the exhibition curators as well as other scholars and experts in Egyptian faience beads all admitted never having seen faience beads with iron remains in their holes and all were surprised by this discovery.

In this context it is important to discuss iron production in ancient Egypt. Ogden writes that while the production of iron had increased dramatically in the ancient Middle East by the middle of the first millennium BCE, it had not increased in Egypt though.[34] He also states that although iron ore and meteoric

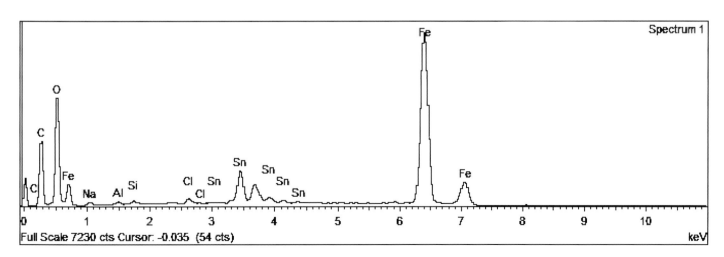

iron existed in Egypt all along, it did not provide a reliable source of supply for manufacturing iron objects in early Egypt.[35] In fact the advent of the Iron Age in Egypt was so late that the supremacy of iron weapons over the copper alloy weapons still used by the Egyptians has been seen as a major factor in the conquest of Egypt by the Persians around 600 BCE.[36] The discovery of iron wire in these beads therefore raises some obvious questions. If these beads were made in Egypt and the iron rods within them is part of their manufacture they would have to fall within the Iron Age in Egypt, which would not be before the Late Period (664–332 BCE). So are they possibly modern forgeries? Or is it also conceivable that the little rods are remains of wire that was inserted at a later date and had nothing to do with the manufacturing process?

These beads are most likely not modern-day forgeries because faience technology and its fabrication process was not rediscovered until the 1930s, according to Riccardelli—which is later than the date when Mrs. Marrs collected these items.[37] The beads are also not made from another material—such as glazed ceramic—because of the characteristic surface of ancient faience incorporating small cementitious deposits.

Since tin was found in the metal rod during analysis, the most likely scenario is that we indeed have remains of modern tin-coated iron wire inside the beads. The technology of tinning iron to prevent rusting dates to the seventeenth century.[38] We can therefore quite definitively assert that these little rods were not part of the manufacturing process but that the beads were strung with tin-coated iron wire at some point in time after excavation. The exposed sections rusted away over time but the sheltered sections inside the holes of the beads survived.

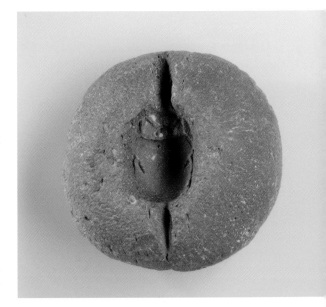

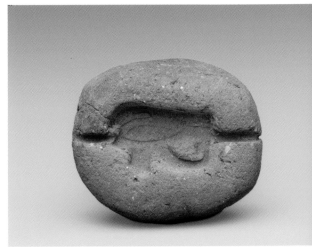

Fig. 18

Mold for a scarab (top)
New Kingdom, Dynasty 18, Reign of
Amenhotep III, ca. 1390–1353 BCE
Pottery
Diam. 2.8 cm (1 ⅛ in.), H. 1.6 cm (⅝ in.)
Metropolitan Museum of Art, Rogers
Fund, 1911, 11.215.684 (top)

Mold for making beads (bottom)
New Kingdom, ca. 1539–1077 BCE
Terracotta
Diam. 2.8 cm (1 ⅛ in.), H. 1.6 cm (⅝ in.)
Detroit Institute of Arts, Gift of Frederick
Stearns, 90.1S14827 (bottom)

Endnotes

1. Aldred 1971, 115.
2. Aldred 1971, 115.
3. Aldred 1971, 65–69.
4. Aldred 1971, 66.
5. Aldred 1971, 45.
6. Nicholson and Shaw 2000, 195.
7. Ogden 1982, 122.
8. Ogden 1982, 122.
9. See conservation treatment reports of cosmetic vessels in the Worcester Art Museum conservation files.
10. Beck et al. 2018.
11. Mysak, 2019.
12. The gel cleaning system was designed by conservation scientist Richard Wolbers (mix 10 g of Xanthan in 500 ml deionized water; in a separate container mix 1.5 g citric acid in 250 ml deionized water, add 1.5 g diethylenetriaminepentaacetic acid (DTPA) and adjust the solution to pH 6.0 with NaOH (3.0 M); then mix both solutions together in the proportion 2:1 (v/v), and add 37.5 g Benzyl alcohol). To avoid absorption of the gel into the surface, it was pre-wetted with cyclo-2244 D5 cyclomethicone. The latter was also used to clear the surface of any gel residues after cleaning. All chemicals from Sigma-Aldrich.
13. The restorations of the Egyptian alabaster losses were made by bulking up Paraloid B-72, 50% in acetone:ethanol, 3:1, with white onyx powder (distributed by Tiranti, London), and inorganic pigments (Kremer Pigmente).
14. Nicholson and Shaw 2000, 195.
15. Nicholson and Shaw 2000, 195.
16. Ogden 1982, 131, 133.
17. Ogden 1982, 132, 144.
18. Koob 2006, 75–106. The brand of materials that differ from the ones in the Koob publication appear in the text narrative in parenthesis.
19. The barrier or isolating layer consisted of Paraloid B-72, 30% in acetone:ethanol, 3:1, manufactured by Rohm & Haas.
20. Koob 2006, 95–101. The adhesive was Paraloid B-72, 50% in acetone:ethanol, 3:1, manufactured by Rohm & Haas.
21. https://www.gemrockauctions.com/learn/technical-information-on-gemstones/mohs-hardness-scale-for-gemstones.
22. Ogden 1982, 146.
23. Ogden 1982, 144.
24. Ogden 1982, 146–47.
25. Nicholson and Shaw 2000, 50.
26. Ogden 1982, 149.
27. Aldred 1971, 116.
28. Aldred 1971, 65–66.
29. Mysak, 2019.
30. Nicholson and Shaw 2000, 186.
31. Aldred 1971, 66.
32. Ogden 1982, 125.
33. Aldred 1971, 125.
34. Ogden 2000, 168.
35. Ogden 2000, 168.
36. Ogden 2000, 168.
37. Riccardelli 2001, 8.
38. https://en.wikipedia.org/wiki/Tinning.

CATALOGUE

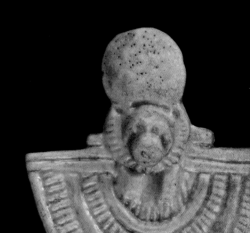

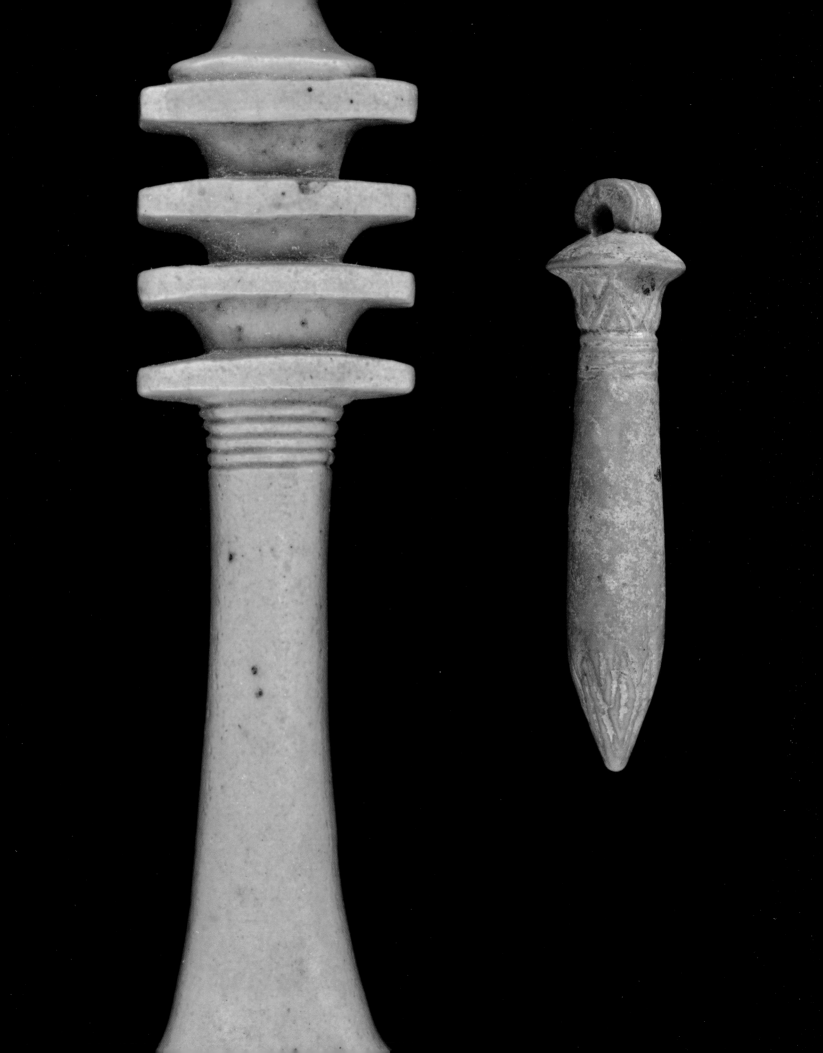

Amulets

Some of the earliest body ornaments were magical charms believed to possess supernatural abilities to protect, heal, or ensure the well-being of the wearer. These small objects, worn at all levels of society, are the essential building blocks of ancient Egyptian adornment. Even beads, by virtue of their unique shapes and the materials used in their manufacture, are often imbued with mystical significance.

Our understanding of the appearance, meaning, and use of these vital adornments is based on information drawn from sculpture, wall reliefs, paintings, and artifacts recovered during archaeological excavations. Amulets are also the subject of ancient texts, including a visual list of seventy-five charms recorded in a first-century BCE funerary papyrus and a detailed inscription naming dozens of charms and their materials located on the roof of a Ptolemaic temple at Dendera.

Ancient Egyptian amulets exist in many forms, including representations of gods, goddesses, and sacred animals; protective symbols meant to ward off danger; amulets of assimilation that embody attributes magically conferred on the wearer; and talismans in the form of inanimate objects symbolic of authority and power. Some of the most common in these categories are the scarab beetle (symbol of rebirth and renewal); the sacred eye of Horus or *wedjat* (provides protection and healing); the *ankh* (safeguards life); the *djed* pillar (confers endurance and stability); the *tyet* or knot of Isis (safeguards the body in the afterlife); the frog (promotes regeneration and fertility); the papyrus column (protects the limbs against injury); the rearing cobra or *uraeus* (symbolic of the protective goddess of Lower Egypt); the batensoda fish (prevents drowning); the oyster shell (promises good health for the wearer); the leonine-dwarf god Bes (household deity protective of children); the cat goddess Bastet (protector of women and the home); the four sons of the falcon-headed sky god Horus (protector of mummified internal organs); the goddess Hathor (the embodiment of fertility, dance, and music), and the dwarf-god Pataikos (fierce protector against malevolent forces).

Amulets are made of a wide range of materials, including precious metal, semiprecious stones, glazed steatite, and faience. In many cases, particular materials are sanctioned in written texts and spells. For example, the ideal substance used in the fabrication of heart scarabs is a hard, dark stone such as green jasper, serpentine, or basalt, while sacred eyes (*wedjats*) are ideally composed of a green-hued material. The positioning of amulets on select parts of the body was also believed to enhance the potency of certain charms, especially those that were placed on the mummy. Among them are the *tyet* talisman placed in the neck region; the *djed* pillar positioned on the central chest above the spinal column; and the headrest amulet located behind the head.

The use of amulets for both the living and the dead is well documented throughout the course of Egyptian history, although their popularity peaked during the Late Period (664–332 BCE), with some forms exclusively funerary in nature.

Faience Amulets of Gods and Goddesses
Full object information on p. 200

1. 1925.649 Khnum
2. 1925.652 Horus and Isis
3. 1925.650 Khonsu
4. 1925.651 Sekhmet
5. 1925.589 Horus

Many deities in ancient Egypt were depicted as miniature animal-headed humans that were worn as pendants or placed on the body of the deceased. Each deity was associated with specific magical powers that would have been transferred to the wearer. Popular examples include the ram-headed creator god Khnum and the falcon-headed deity Horus. Other gods and goddesses, such as the goddess Isis nursing her son Horus, were commonly shown in human form.

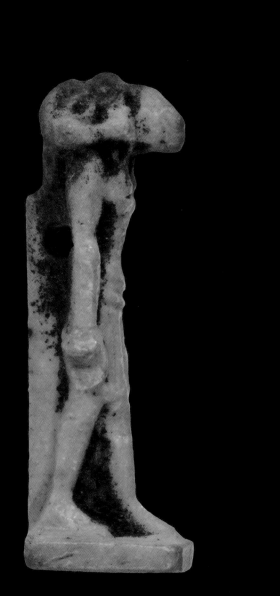

1

2

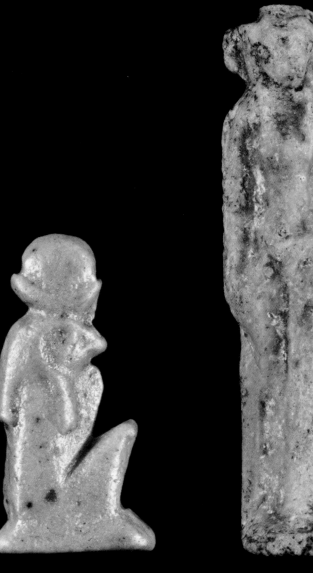

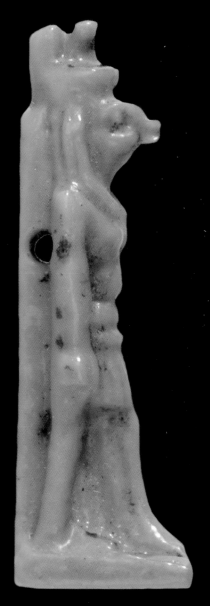

3 4 5

Amulets of Sacred Animals
Full object information on p. 200

1. 1925.614 Baboon
2. 1925.585 Ibis
3. 1925.646 Cobra (Wadjet)
 wearing Red Crown
4. 1925.647 Falcon
5. 1925.648 Baboon

Ancient Egyptian amulets sometimes take the form of sacred animals that are associated with deities. Examples include the baboon (Thoth), the falcon (Horus), the rearing cobra with Red Crown (Wadjet), and the ibis (Thoth).

Seated Cat Amulets
Full object information on p. 200

1. 1925.534 Seated cat amulets
 with mummy beads
2. 1925.586 Seated cat
3. 1925.626 Seated cat
4. 1926.124 Bastet with kittens

Several amulet forms represent feline goddesses. One of the most popular is the goddess Bastet, a festive fertility figure. She is often depicted as a slender, seated cat with kittens that lean against her front paws.

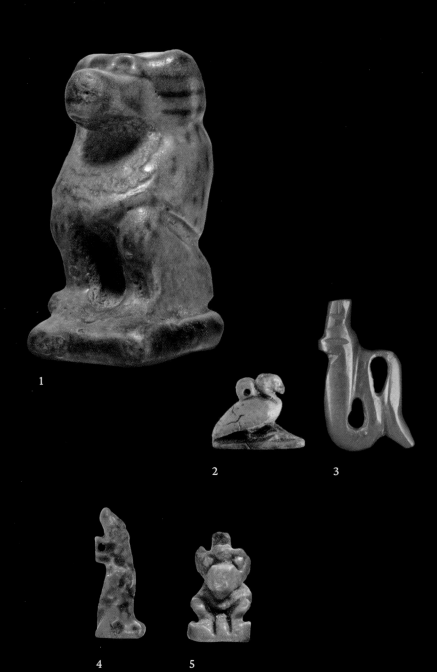

1

2

3

4

5

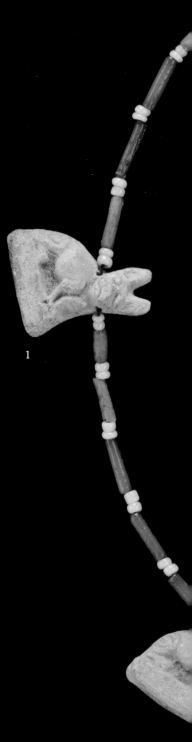

1

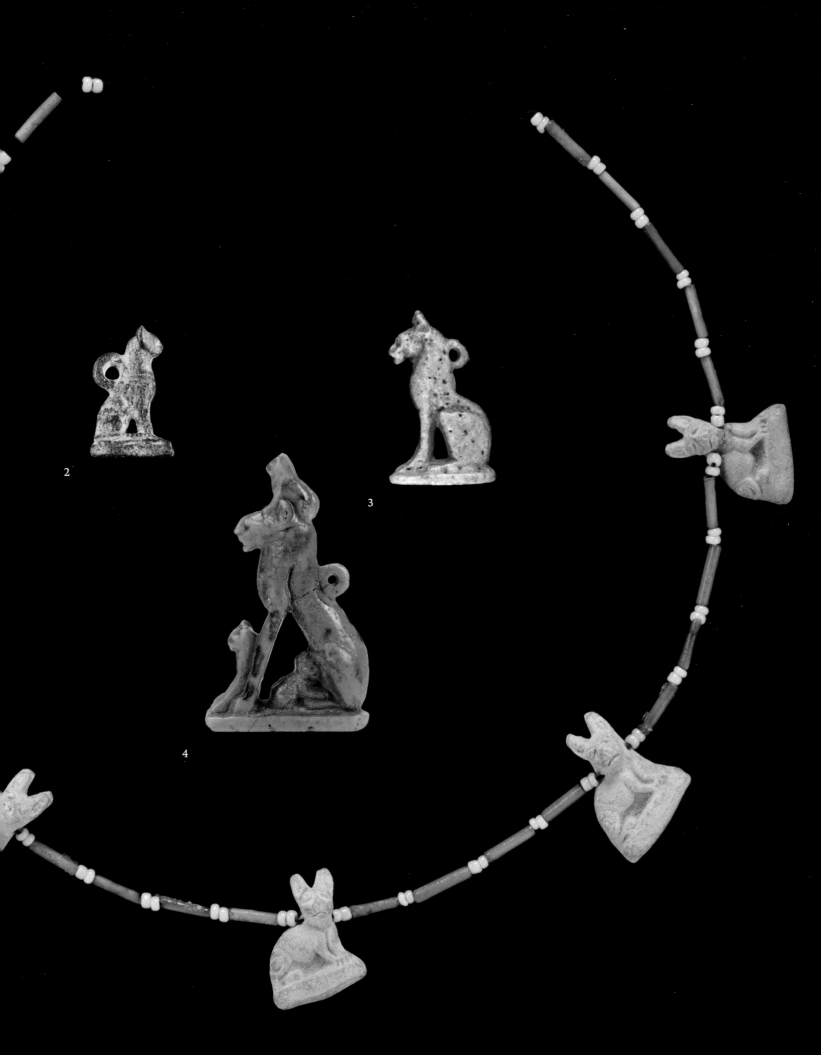

2

3

4

Amulets Providing Protection
Full object information on pp. 200–201

1. 1925.653 Pataikos
2. 1925.584 Pataikos
3. 1925.630 Pataikos amulets
 with ball beads

Pataikos is a protective deity who is often depicted as a short, bow-legged dwarf whose hands rest on his hips. A powerful entity that emerged during the first millennium BCE, he is capable of repelling menacing, destructive forces in both this life and the next. He was also a popular god among the Phoenicians and other neighboring cultures.

4. 1926.123 Bes
5. 1925.665 Bes head
6. 1926.113 Bes

Bes is a protective deity who is depicted with a full-faced, ferocious head, a feathered crown, a lion's mane and tail, and dwarf-like legs. He sometimes carries a shield and brandishes a sword. One of the household gods, Bes protects children, women in childbirth, and the home.

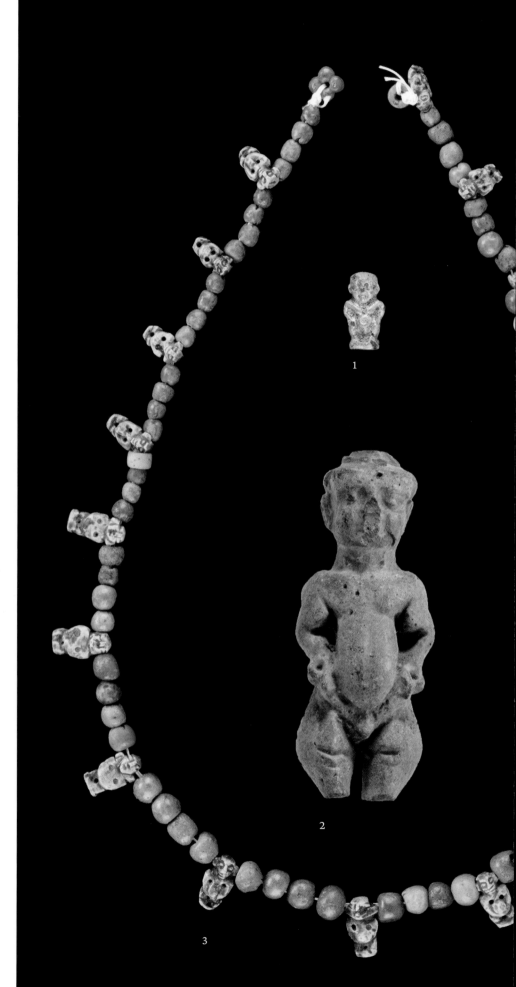

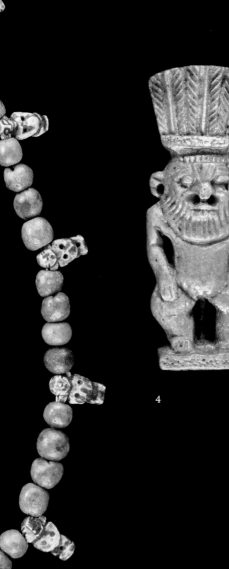

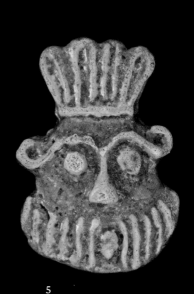

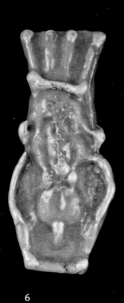

4

5

6

7. 1925.620 Son of Horus – Qebehsenuef
8. 1925.619 Son of Horus – Imsety
9. 1925.673 Son of Horus – possibly Hapi

The Four Sons of Horus—the baboon-headed Hapi, the falcon-headed Qebehsenuef, the human-headed Imsety, and the jackal-headed Duamutef (not shown here)—are protectors of the mummified internal organs of the deceased.

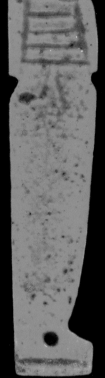
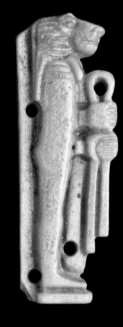

7

8

9

10. 2001.126 Heart
11. 1925.601 Heart
12. 1925.602 Heart
13. 1926.109 Heart

The ancient Egyptians believed that the heart not only pumped blood throughout the body but was the seat of thought, feelings, and actions. It was not removed from the body during mummification and was one of the most important funerary amulets. Most examples date to the New Kingdom or later and are made of red-hued materials.

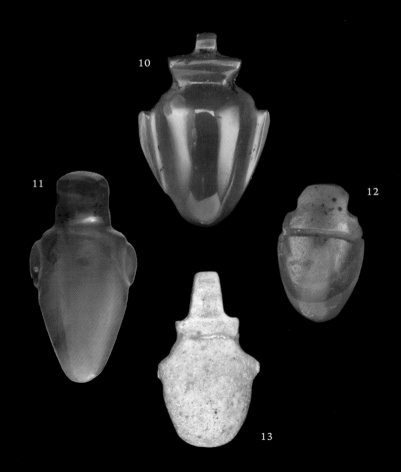

10

11

12

13

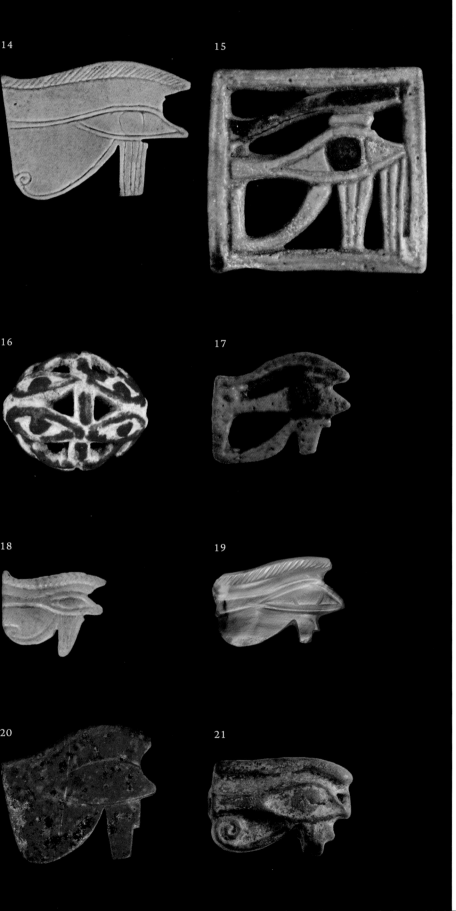

14. 1925.672 *Wedjat*
15. 1925.675 Openwork *wedjat*
16. 1925.609 Multiple eye
17. 1925.590 *Wedjat*
18. 2001.125 *Wedjat*
19. 1925.599 *Wedjat*
20. 1925.644 *Wedjat*
21. 1925.587 *Wedjat*

The *wedjat* or sacred eye represents the healed eye of the god Horus and was believed to provide regenerative and protective powers. Next to the scarab, it was Egypt's most popular amulet and was made in a range of materials and forms including inlaid and openwork constructions. During the first millennium BCE, the heyday of amulet production, amulets with multiple eyes were worn for optimum protection.

22. **1925.582 Aegis**
23. **1925.386 Isis knot**

Aegis amulets in the form of a wide,
beadwork collar surmounted by the head of
a god or goddess (in this case the goddess
Tefnut) had broad protective powers.
The Isis knot (*tyet*) is more specific in
that it places the wearer under the direct
protection of one of ancient Egypt's most
revered goddesses.

22

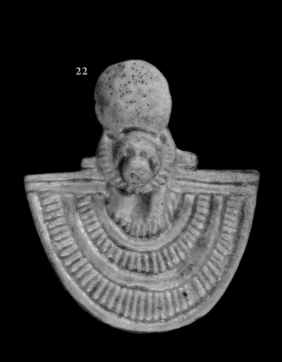

23

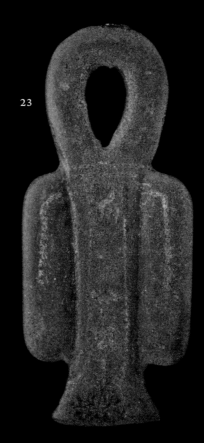

Amulets of Power, Assimilation, and Fertility
Full object information on p. 201

1. 1925.645 Lapis *djed*
2. 1925.562 Faience *djed*
3. 1925.674 Papyrus column

Amulets in the form of inanimate objects were sometimes imbued with magical powers and authority. One of the most common is the papyrus column, which is shown in the round and often made of green-toned materials such as amazonite or copper-glazed steatite. Another example is the *djed* pillar, a tall shaft with horizontal bars at the top that symbolized stability and endurance.

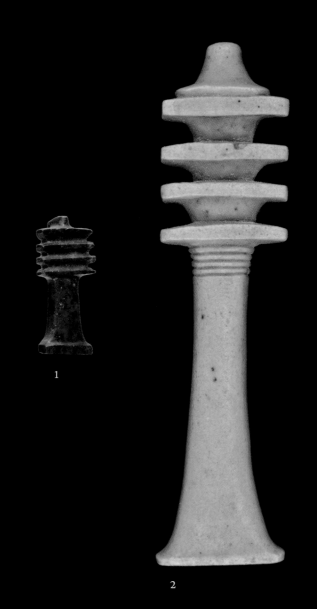

1

2

3

1.123 Monkey
.594 Frog
1.124 Monkey

monkeys were symbols of fertility
ual fulfillment in ancient Egypt.
s in the form of monkeys were
 during the Middle and New
ns and were made in a range
rials. Frogs were also fecundity
 and representations in the round
metimes mounted in finger
orn by women.

4

5

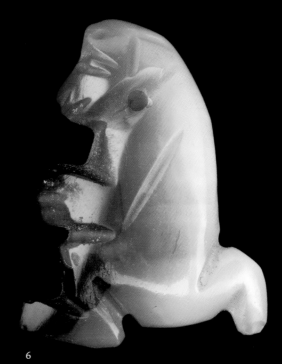

6

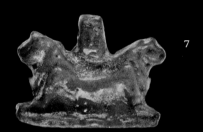

7

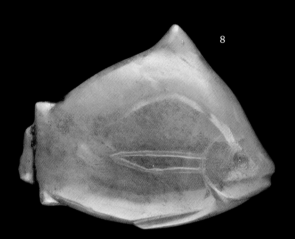

8

7. 2019.99.1 Double lion
8. 1926.122 *Bolti* fish

Tilapia or *bolti* fish amulets guaranteed long life and rebirth and were worn as pendants in the round or as decorative elements on scaraboids. Less common are double-lion figures representing the god Aker, guardian of the regenerative sunrise and sunset.

Amulets Mounted as Modern Scarf/ Cravat Pins
Full object information on p. 202

1. 1926.100 Baboon
2. 1926.98 *Wedjat*
3. 1926.99 *Wedjat*

In addition to scarabs, small amulets and fragments of artifacts were mounted in gold settings and worn as cravat pins. Some of the antiquities were made into wearable adornments in Egypt, where they were purchased by tourists, while others were mounted by Western jewelers once the travelers returned home.

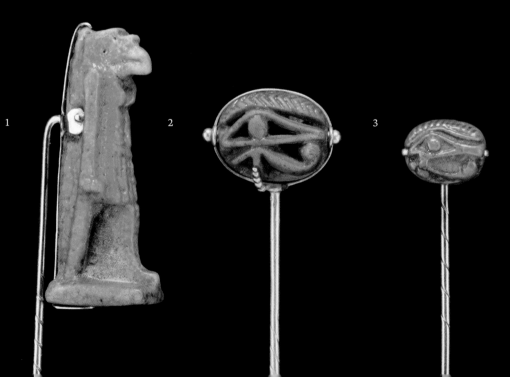

1 2 3

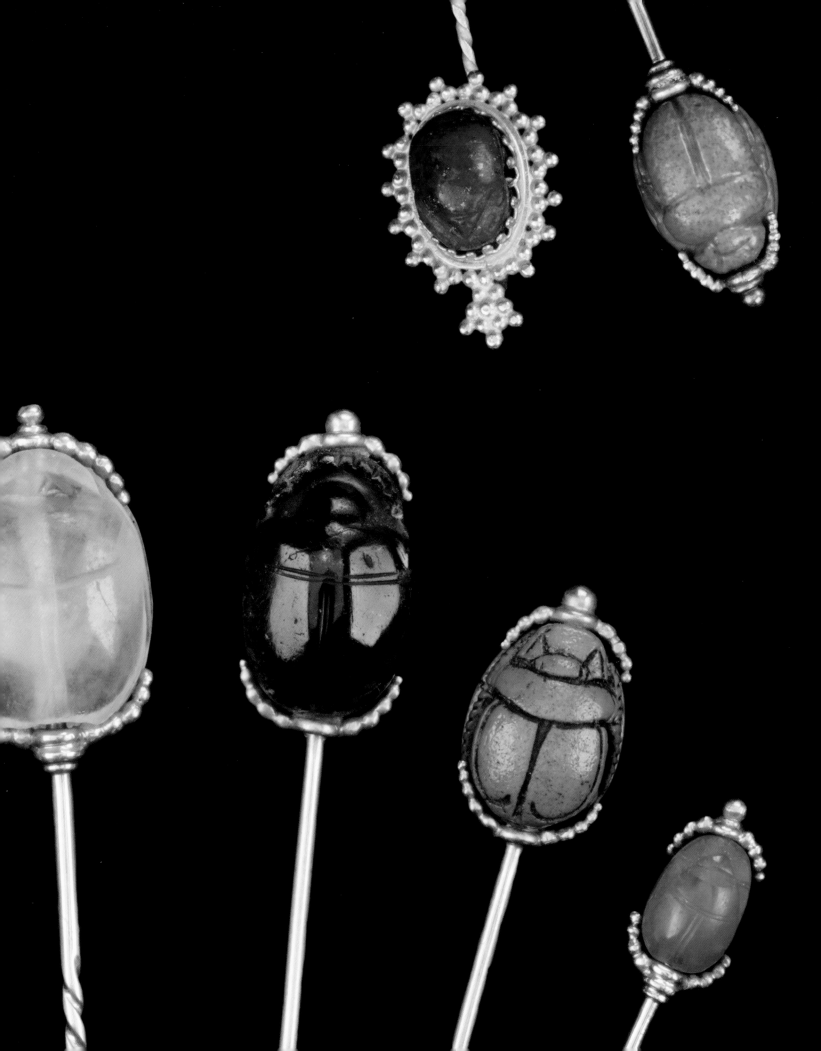

The Sacred Beetle

In ancient Egypt several species of beetle were imbued with magical, talismanic properties. An early example is the round-bodied urchin beetle (*Prionotheca coronata*), whose thorny, preserved carcasses have been discovered in Predynastic burials. Other insects (family Buprestidae), named "jewel" beetles because of their shiny, iridescent colors, were immortalized and transformed into golden pendants worn by Old Kingdom nobles. However, it is one particular species of dung beetle—the sacred scarab, *Scarabaeus sacer*—that is most closely aligned with Egypt. It appears in amuletic form around 2000 BCE and remained popular among all strata of society over the course of dynastic history. It was also a form borrowed and adapted by neighboring cultures and later resurrected by revivalist artists inspired by Egypt's illustrious past.

The reason for the scarab beetle's popularity in Egypt is rooted in its behavior. Keen observers of the natural world, the Egyptians were fascinated by the insect's unusual reproductive and feeding habits. In one instance, the female beetle lays an egg in a pear-shaped ball of animal dung buried underground. As the egg hatches, the young beetle emerges live from the sand as if magically self-created. In a second type of dung ball, the scarab rolls the ball across the sand where it is eventually hidden and consumed. The Egyptians saw these actions as the embodiment of the creator god Khepri, the force responsible for the emergence of the sun from the underworld as it begins its westward journey across the sky. This symbolic movement represented the ultimate act of renewal—a cosmic ritual reenacted daily.

Three-dimensional representations of scarab beetles were made in vast numbers in ancient Egypt, offering renewed life and protection to both the living and the dead. Their power lies not only in their beetle form but in the magical inscriptions, emblems, and pictorial images that were often added to their flat bases. Some scarabs, especially those dating from the first half of the second millennium BCE that bear the names and titles of their owners, also served as functional seals to "seal" or protect valuable property from theft. Evidence of their use exists in the many surviving mud-seal impressions associated with doors, boxes, and jars containing wine or precious oils. Other scarabs, found exclusively in funerary contexts, were designed to benefit the dead. The most important are the large, unpierced beetles of dark stone that were placed within the mummy wrappings over the heart of the deceased. These artifacts are typically inscribed with a verse from the Book of the Dead meant to ensure the owner's safe passage during the perilous journey to everlasting life. Most important was the scarab's ability to bind the heart to silence during the all-important weighing of the deceased's heart when it was pitted against the feather of truth.

Most scarabs are small (less than an inch) and were worn as adornments on the body. Although some have uninscribed bases, the majority are decorated with a range of motifs that include symmetrically arranged designs, images of the gods, kings' names in cartouches, good wishes, and protective mottos. The most prized examples are made of precious metal (rare) and semiprecious hardstones such as carnelian, amazonite, amethyst, rock crystal, hematite, and lapis lazuli. Others are made of glazed steatite or faience, a quartz-based ceramic with a vitreous coating.

Scarab (front and back)
Possibly New Kingdom,
ca. 1539–1077 BCE
Gold
0.9 × 0.6 × 0.5 cm (5/16 × 1/4 × 3/16 in.)
Mrs. Kingsmill Marrs Collection, 1926.66

Scarabs made of precious metal are rare
in ancient Egypt. The few that survive are
typically made of an assemblage of sheet
metal parts joined by soldering.

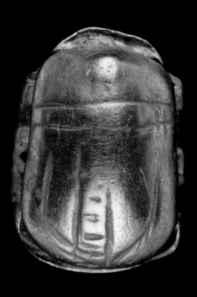

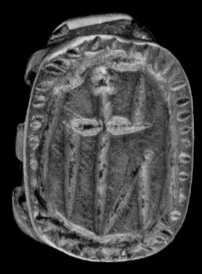

Hardstone Scarabs (backs only)
Full object information on pp. 202–204

1. 1926.31 Carnelian
2. 1926.30 Carnelian
3. 1926.28 Carnelian
4. 1926.29 Carnelian
5. 2001.122 Carnelian
6. 1926.33 Carnelian
7. 1926.32 Carnelian
8. 1926.76 Carnelian
9. 1926.73 Carnelian
10. 1925.603 Carnelian
11. 1926.41 Amethyst
12. 1926.39 Amethyst
13. 1926.72 Amethyst
14. 1926.40 Amethyst
15. 1926.38 Amethyst
16. 1926.37 Amazonite
17. 1926.69 Amazonite
18. 1926.36 Amazonite
19. 1926.35 Amazonite
20. 1926.34 Amazonite
21. 1926.77 Rock crystal
22. 1926.67 Amazonite
23. 1926.42 Rock crystal
24. 1926.43 Sapphire
25. 1926.71 Lapis lazuli
26. 1926.70 Hematite
27. 1926.74 Hematite
28. 1926.75 Hematite

Scarabs made of semiprecious hardstones
were highly prized talismans because
of their rarity, durability, and aesthetic
qualities. Stones were also imbued with
magical properties, protecting the owner
from malevolent forces, disease, and the
ill intentions of others. While many of the
stones used in fabrication were locally
available (for example, carnelian, amethyst,
and amazonite), other minerals such as
turquoise and lapis lazuli were imported.

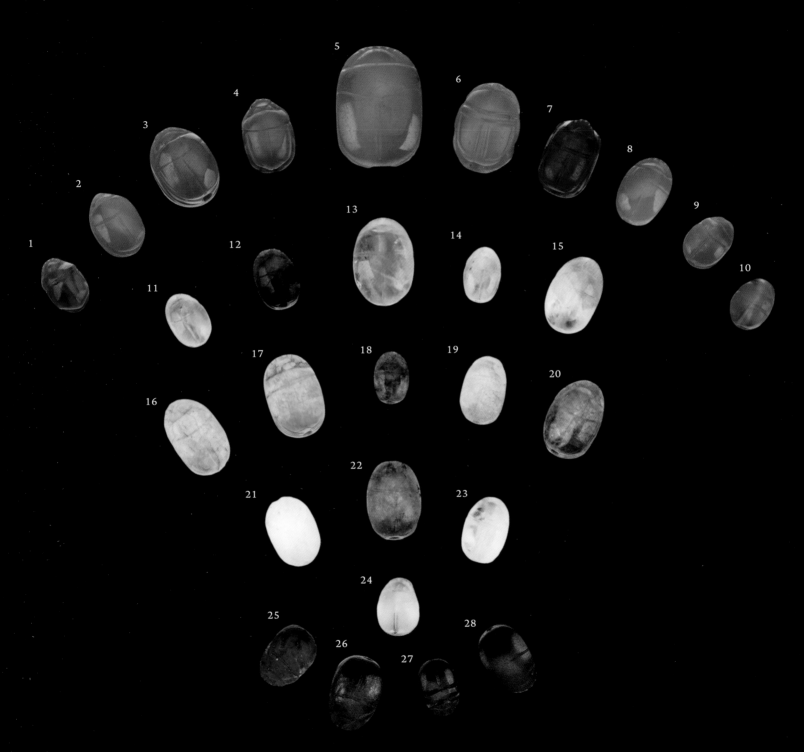

Glazed Steatite/Faience Scarabs
Full object information on pp. 204–205

1. 1926.58 Steatite
2. 1926.61 Faience
3. 1926.53 Steatite
4. 1926.50 Steatite
5. 1926.45 Steatite
6. 1926.54 Faience
7. 1926.78 Steatite
8. 1926.59 Faience
9. 1926.68 Faience
10. 1926.51 Faience
11. 1926.56 Faience
12. 1926.52 Steatite
13. 1926.49 Steatite
14. 1926.47 Steatite
15. 1926.63 Steatite
16. 1926.48 Faience
17. 1926.46 Steatite
18. 1926.64 Faience
19. 1926.65 Faience
20. 1925.618 Faience (winged
 scarab in 3 parts)

The majority of Egyptian scarabs were made of carved, glazed steatite or faience, a quartz-based ceramic with a vitreous, colored glaze. The latter were mass-produced and accessible to all strata of society. Small, lightweight, and believed to possess supernatural powers, scarabs were also popular in neighboring lands. Many have undersides (bases) decorated with hieroglyphs, emblems, symbols, and figures of deities, kings, or sacred objects.

Glass Scarabs
Full object information on p. 205

1. 1926.55
2. 1926.57
3. 1926.44
4. 1926.62

Glass was a high-value material when first introduced into Egypt during the early New Kingdom. Once the product of royal workshops, it later became an affordable substitute for more precious materials. It also possessed unique features in that the substance can have dappled, marbleized, or patterned designs.

1

2

3

4

Scarabs Mounted as Modern Rings

Full object information on p. 205

1. 1926.79 Lapis lazuli
2. 1926.83 Faience
3. 1926.80 Carnelian
4. 1926.81 Faience
5. 1926.82 Amethyst
6. 1926.85 Carnelian (with human face)
7. 1926.84 Faience

Some ancient scarabs were set in precious metal mounts designed to be worn as jewelry, especially finger rings. This was also the case during the nineteenth and early twentieth centuries, when jewelers were commissioned to fabricate jewelry settings for tourists and collectors who acquired small antiquities in Egypt or through dealers. Often the metal mounts were similar in style and construction to ancient forms; in other instances, the designs were fanciful recreations that were "egyptianizing."

Scarabs Mounted as Modern Scarf/ Cravat Pins

Full object information on p. 205

1. 1926.90 Lapis lazuli
2. 1926.88 Faience
3. 1926.92 Rock crystal
4. 1926.91 Amethyst
5. 1926.87 Steatite
6. 1926.89 Amazonite

Scarabs acquired during the late nineteenth and early twentieth centuries were sometimes mounted in gold stick-pin settings designed to be worn as scarf or cravat ornaments. These pins were functional neckwear-controlling devices favored by fashionable nineteenth-century gentlemen.

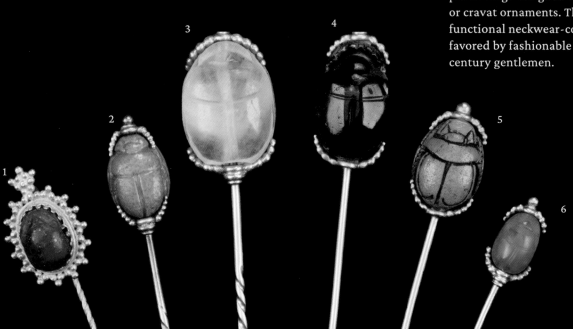

Scaraboids and Design Amulets
Full object information on pp. 205 & 207

1. 1926.107 Duck with reversed head
2. 1926.111 Circular design with scarab
 beetles and flies
3. 1926.93 Cowroid
4. 1926.94 Fish

In addition to scarabs, the ancient Egyptians
created small amulets inspired by the scarab
shape. However, the backs of these objects
represent a wide range of popular motifs
including fish, ducks, cowry shells, flies,
felines, and frogs. Like scarabs, many have
text and designs on the underside (base).

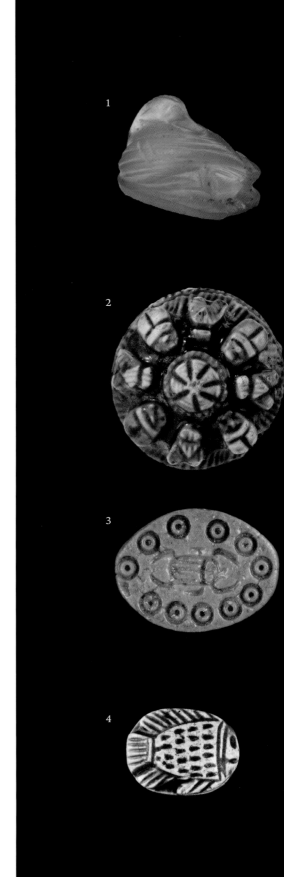

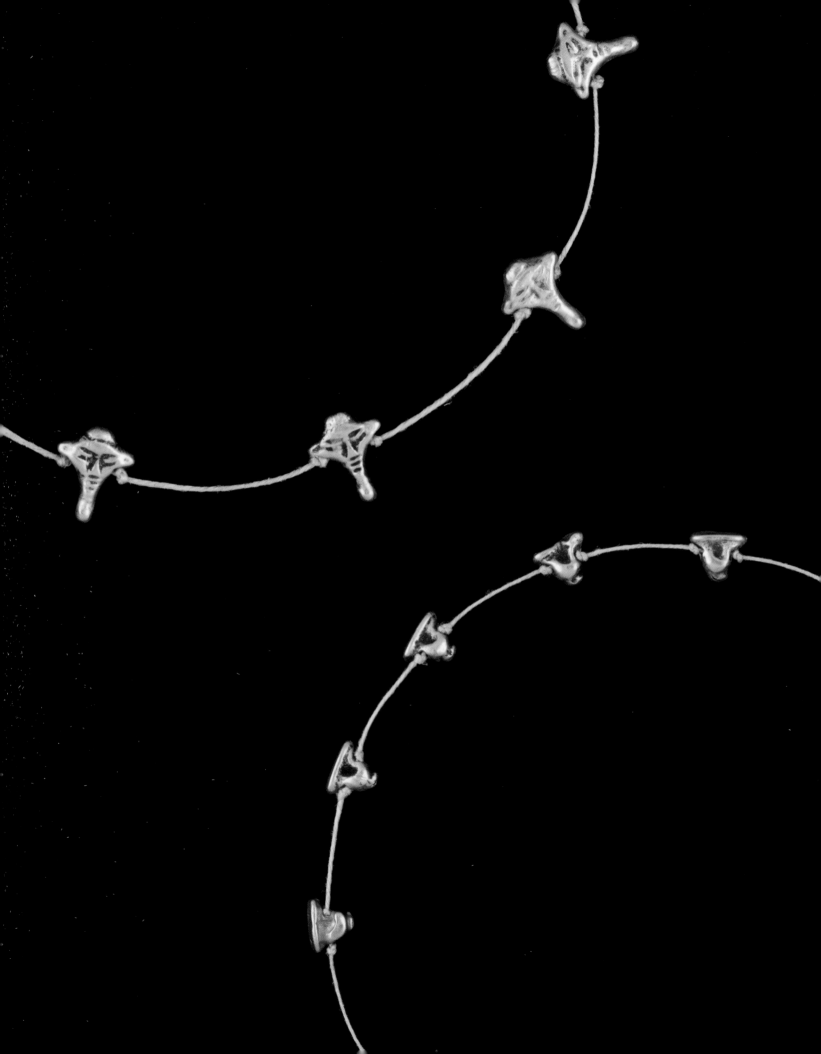

Ancient Egyptian Jewelry

Jewelry in ancient Egypt was worn by people from all levels of society, reflecting the identities and beliefs of the individuals who wore it, the technical capabilities and skills of the artisans who crafted it, and the international trade that fostered it. At its most basic, it fulfilled a universal desire to adorn the body—a need often secondary to jewelry's more complex and multi-layered functions. This is especially the case in cultures where personal adornment is believed to possess supernatural powers capable of protecting the wearer from potential harm, illness, and the malevolent forces of nature. In Egypt this amuletic function continued even after death, as evidenced by the numerous adornments worn by the deceased in the hope of a successful journey to the afterlife.

There was a wide range of jewelry forms in ancient Egypt. Many were ornaments designed to encircle and magically protect vulnerable parts of the body, such as the neck. Among the earliest forms were diadems worn on the head, necklaces, upper armlets, wrist ornaments, girdles draped around the waist, and anklets. Finger rings were a later development, while earrings appear to be an ornament introduced around 1700 BCE into Egypt from Nubia, Egypt's southern neighbor.

The materials of choice used in jewelry manufacture were precious metal (gold and silver) and semiprecious hardstones, such as carnelian, amazonite, and lapis lazuli. Some of these were available locally, while others—including silver and lapis—were imported from the Middle East or East Asia. All were prized not only for their aesthetic appeal but for their symbolic associations with the gods and the powers inherent in nature. For those unable to afford jewelry made from these rare and high-value materials, less costly ones such as glazed steatite and colorful faience (a quartz-based ceramic) were used.

Our understanding of ancient Egyptian jewelry comes largely from scientific excavations conducted by archaeologists such as Howard Carter, a friend of Mrs. Laura Marrs who is widely known for his discovery of King Tutankhamun's tomb in 1922. It was a find that dazzled the world and provided a framework within which generations of jewelry historians have come to appreciate the meaning, use, and forms of adornment worn by Egypt's ruling elites.

Faience Ball-Bead Necklaces
Full object information on p. 207

1. 1925.632 Ball-bead necklace
2. 1925.633 Ball-bead necklace
3. 1925.634 Ball-bead necklace

Ball-bead necklaces composed of beads of the same size and material were often worn in multiples during the Middle Kingdom. Blue-glazed faience beads were the most popular.

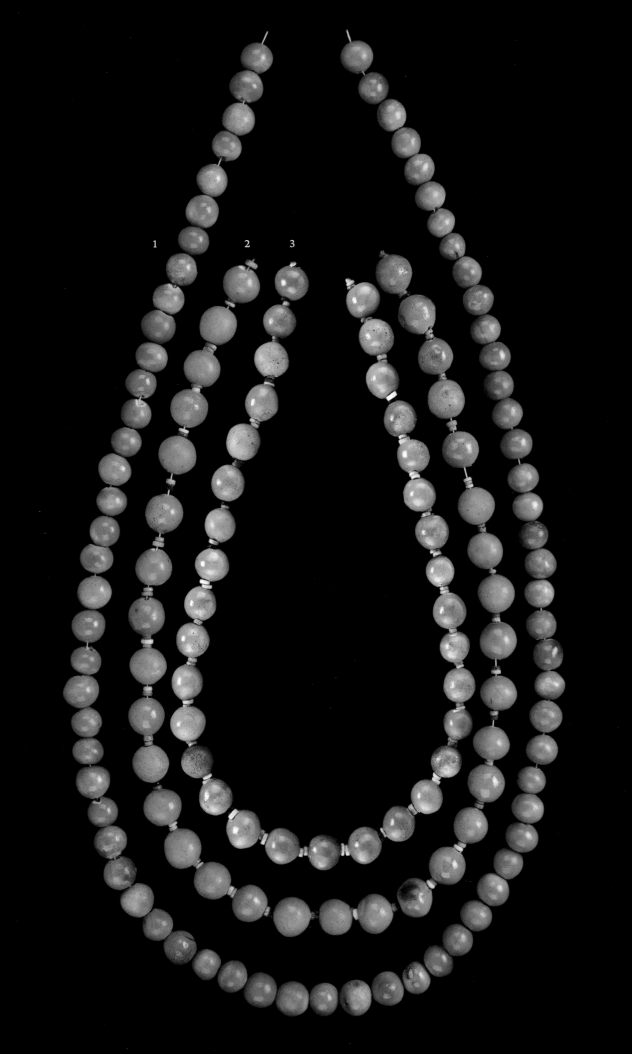

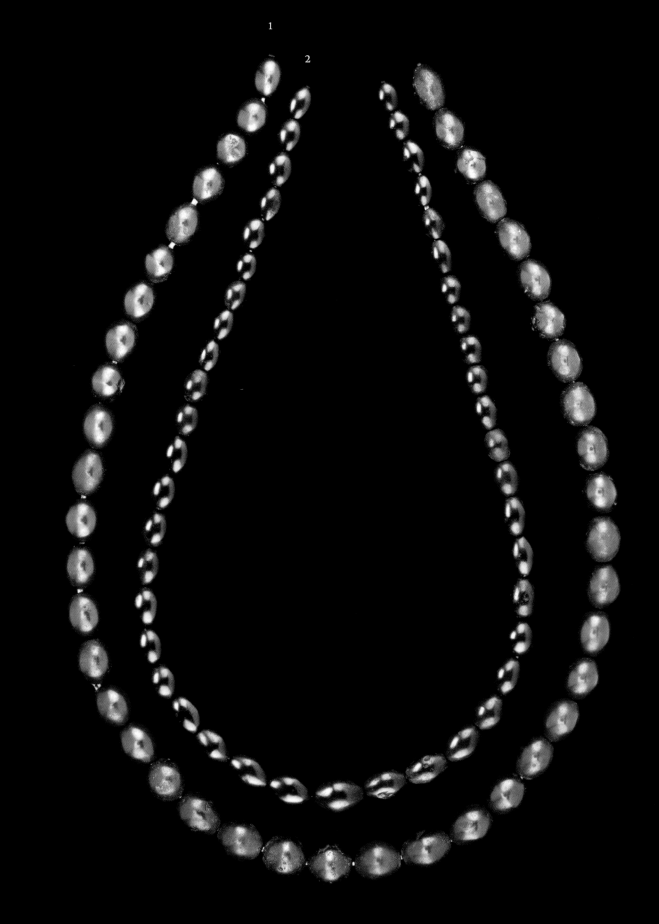

Garnet Necklaces
Full object information on p. 207

1. 2001.114 Graduated garnet beads
2. 2001.139 Graduated barrel-
 shaped garnet beads

The use of garnet in ancient Egyptian jewelry was largely relegated to beads, especially spheres or those with a barrel shape. Garnet was particularly popular during the Middle Kingdom and then later during Classical times when dome-shaped stones (cabochons) were often bezel-set in gold.

Carnelian Bead and Amulet Necklaces
Full object information on p. 207

1. 2001.133 Graduated carnelian
 beads and amulets
2. 2001.116 Carnelian ball beads,
 two gold bi-conical beads, and one
 gold-sheet bead

Carnelian was readily available in ancient
Egypt and was used in jewelry manufacture
over the course of its long history. It
was employed to make a range of bead
types, was used as an inlay material,
and was the substance of choice for
several amulet forms.

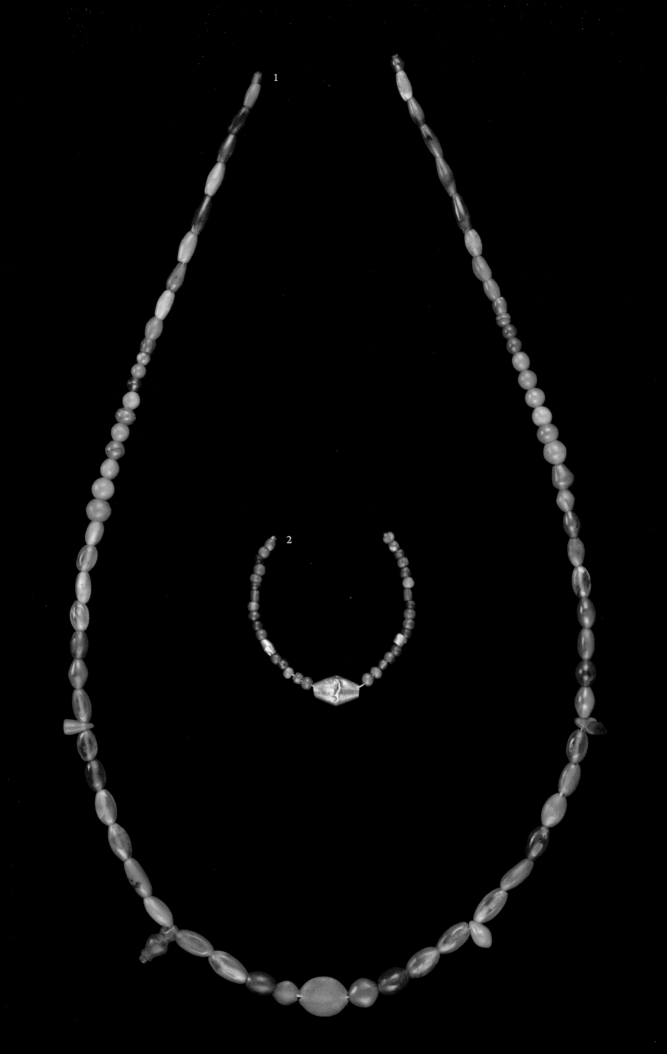

Amethyst Bead and Amulet Necklaces
Full object information on p. 207

1. 2001.135 Graduated amethyst
 beads and amulets
2. 2001.113 Graduated amethyst beads
3. 1925.640 Amethyst beads and amulets

Amethyst was a fashionable stone during
the Middle Kingdom and Ptolemaic
Period. It was not part of the trio of stones
(carnelian, lapis lazuli, and turquoise/
amazonite) that held symbolic significance
for the Egyptians so its use was limited.
It was primarily used in the fabrication of
beads and amulets during dynastic times.

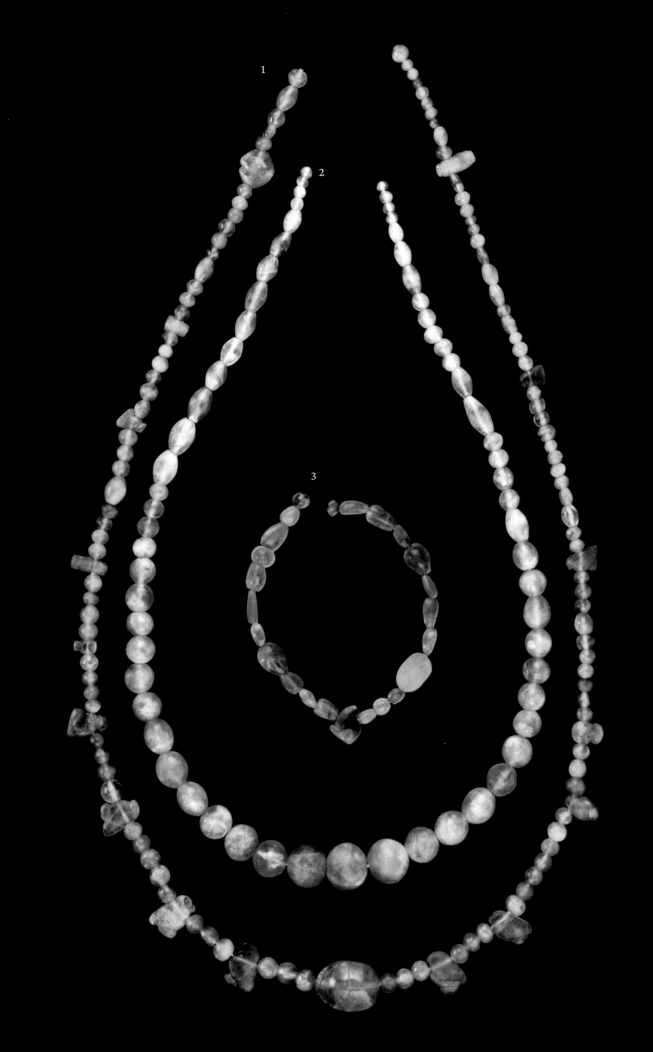

**Strings of Rock Crystal and Amazonite
Beads and Amulets**
Full object information on p. 207

1. 1925.641 Amazonite beads and amulets
2. 1925.639 Rock crystal beads and scarabs

In keeping with their preference for durable
hardstones, the jewelers of Egypt's Middle
Kingdom made outstanding ornaments
carved from rock crystal and amazonite, a
form of green feldspar.

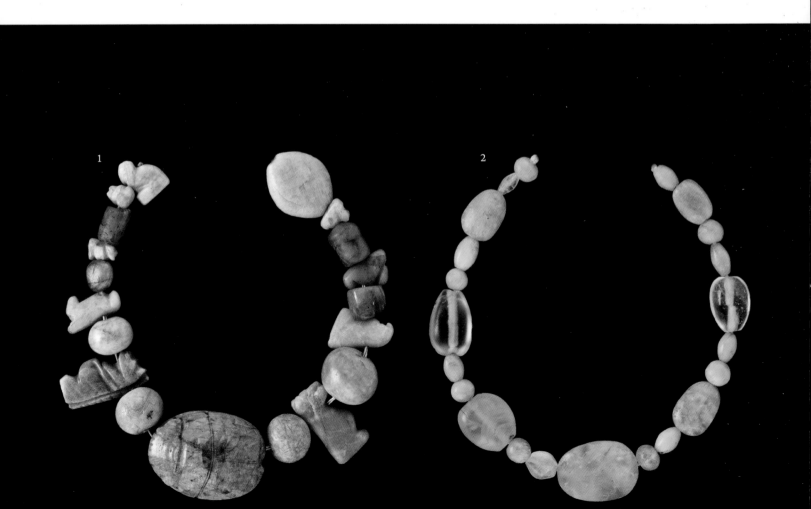

Pair of Claw Anklets
Middle Kingdom, ca. 1980–1760 BCE
Carnelian
Length: 13.3 cm (5 ¼ in.)
Mrs. Kingsmill Marrs Collection, 2001.130
(left), 2001.131 (right)

Anklets composed of beads and claw
pendants were popular adornments
during the Middle Kingdom. In keeping
with the ancient Egyptian preference for
bilateral symmetry, they were often worn
in matched pairs. The claws are believed to
represent either leopard or bird claws whose
symbolism is unknown.

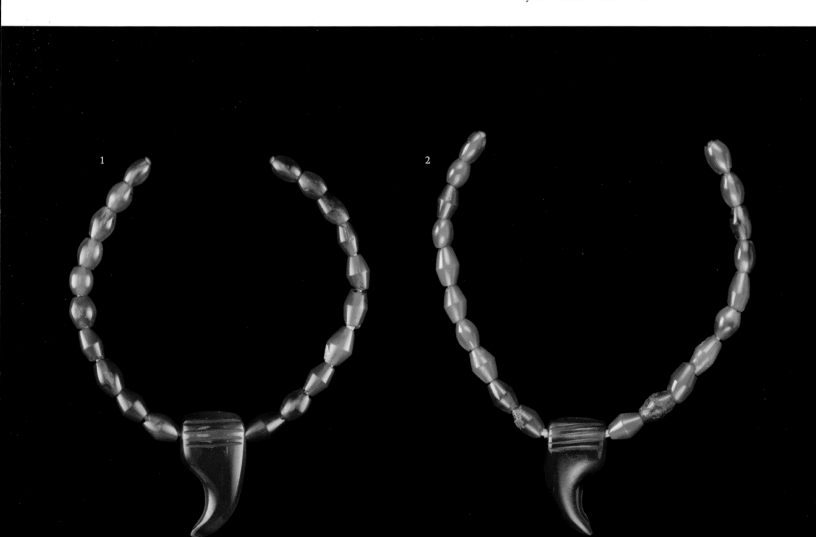

Strings of Gold Amulets
Full object information on p. 207

1. 2001.120 Gold falcons
2. 2001.121 Gold Bat heads

Representations of the god Horus as a
falcon and Bat-head amulets are prominent
elements found in Egyptian jewelry
throughout the course of dynastic history.
The falcon is a complex entity in that the
god has multi-layered affiliations that
change depending upon time and place. Bat,
a cow goddess depicted as having a human
face with cow ears and horns, is a figure of
great antiquity that eventually merges with
Hathor, goddess of love, music, and fertility.

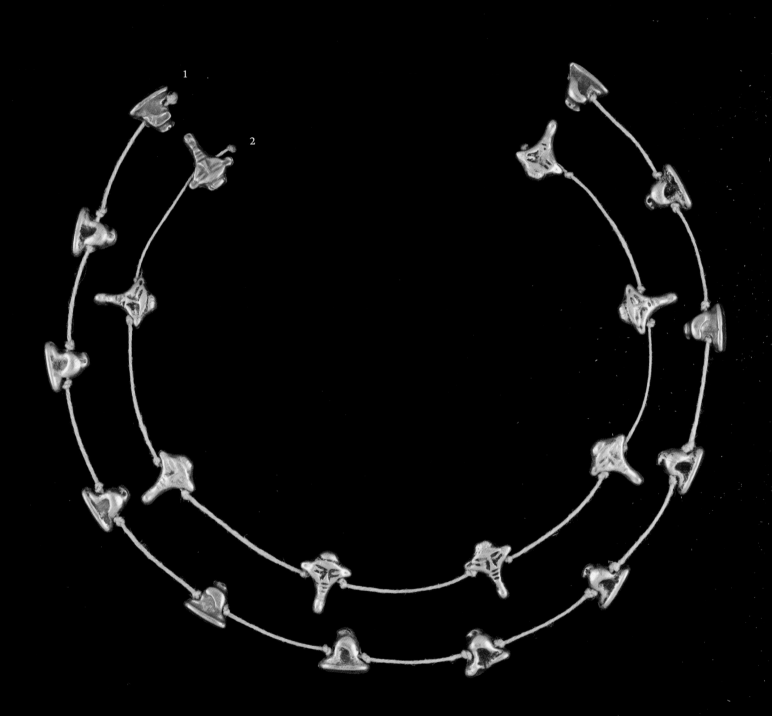

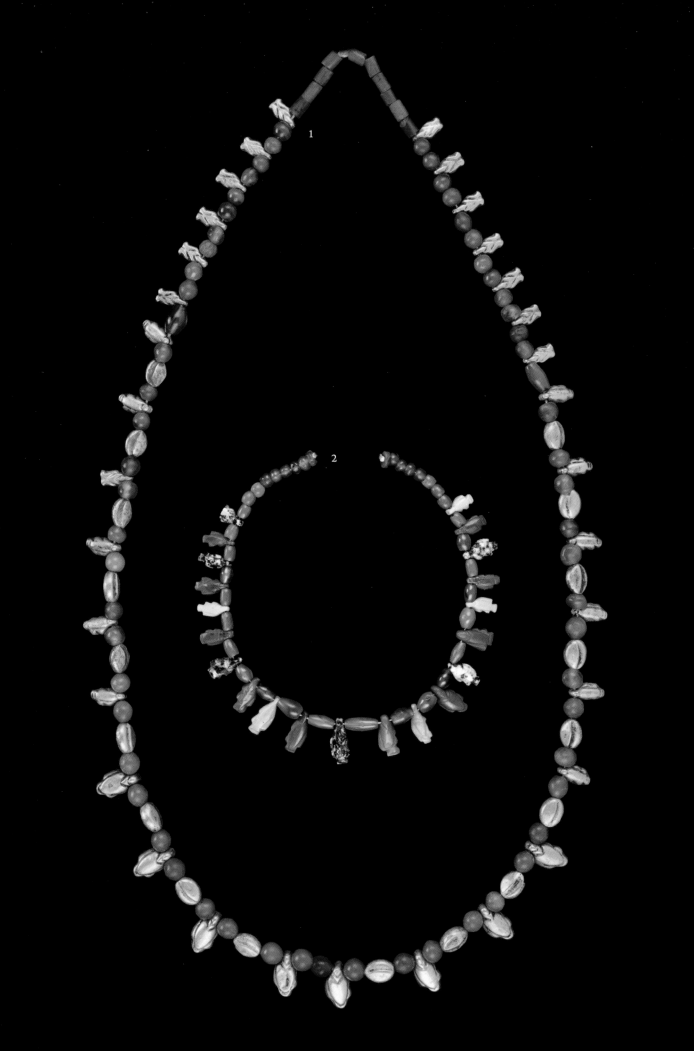

Fish Pendants
Full object information on p. 207

1. 2001.117 Gold fish pendants and cowries with carnelian beads
2. 2001.119 Hardstone fish pendants

Necklaces with multiple fish amulets made of precious metal and hardstones were popular New Kingdom adornments. The fish were typically separated by beads or other amulets such as stylized cowrie shells. The fish represent tilapia (*bolti*), a symbol of rebirth and regeneration recognizable by their long dorsal fin.

String of Disc Beads
New Kingdom, ca. 1539–1077 BCE
Faience
Length: 17.1 cm (6 ¾ in.)
Mrs. Kingsmill Marrs Collection, 1926.117

Close-fitting necklaces (chokers) composed
of large, lenticular disc beads made of
blue faience were worn in single or double
strands during the New Kingdom. Those
made of gold were called *shebyu* or the "Gold
of Honor" award bestowed by the king on
individuals of outstanding merit.

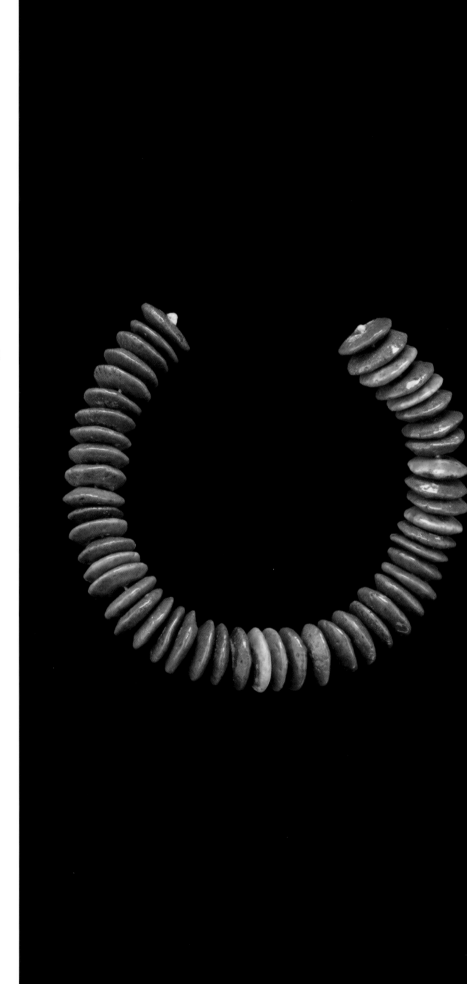

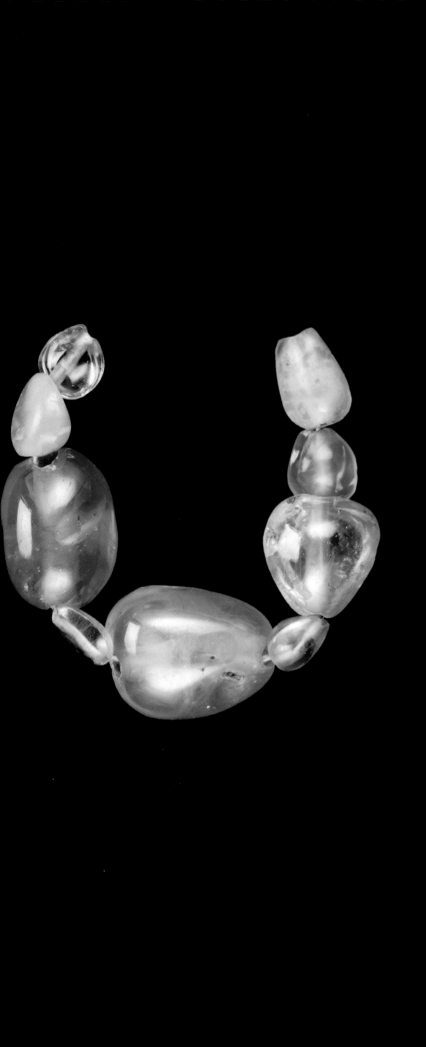

String of Beads
Early Roman Period, 30 BCE–200 CE
Sapphire
Length: 10.7 cm (4 3/16 in.)
Mrs. Kingsmill Marrs Collection, 1925.642

The likely source of sapphire in the ancient
Near East was Anatolia (ancient Turkey).
This blue-hued stone is next to diamond in
hardness and was not used in Egypt during
dynastic times. However, the Romans,
who prized unusual stones of varying
colors, used it in personal adornments and
bejeweled objects.

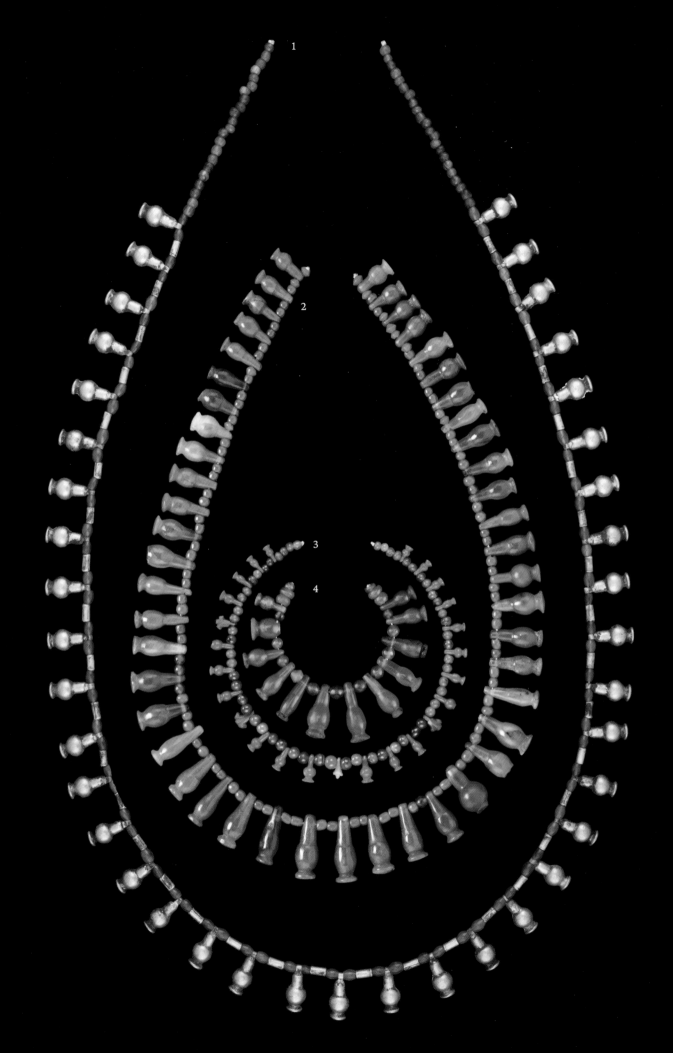

**Strings of Poppy Pendants and
Carnelian Beads**
Full object information on p. 208

1. 2001.115 Gold poppy beads and
 carnelian beads
2. 2001.128 Carnelian poppies and beads
3. 2001.118 Carnelian poppies and ball
 beads (plus one palmette in center)
4. 2001.129 Flat carnelian poppies and
 beads from the Levant

Necklaces composed of poppy beads
interspersed with other bead forms were
fashionable during the late Middle to New
Kingdom. Many were made of orange-red
carnelian, carved in the round, and designed
with the blossom heads facing downwards.
Examples with flat undersides are thought
to have been part of floral broad collars.

**Gold Spacer with the Name of
Queen Tiye**
New Kingdom, Dynasty 18, Reign of
Amenhotep III, ca. 1390–1353 BCE
Gold
1.9 × 1.8 cm (¾ × ¹¹/₁₆ in.)
Mrs. Kingsmill Marrs Collection, 1926.106

Decorative elements intended to keep
multiple strings of beads and amulets
taut and apart were often used by ancient
Egyptian jewelers. This spacer, fabricated
from gold sheet, bears the cartouche of
Queen Tiye, wife of Amenhotep III and
mother of the heretic pharaoh, Akhenaten.

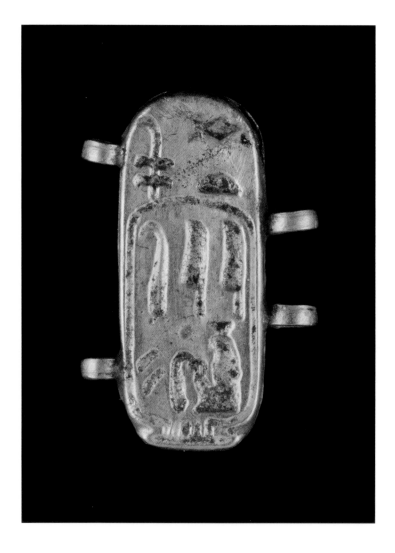

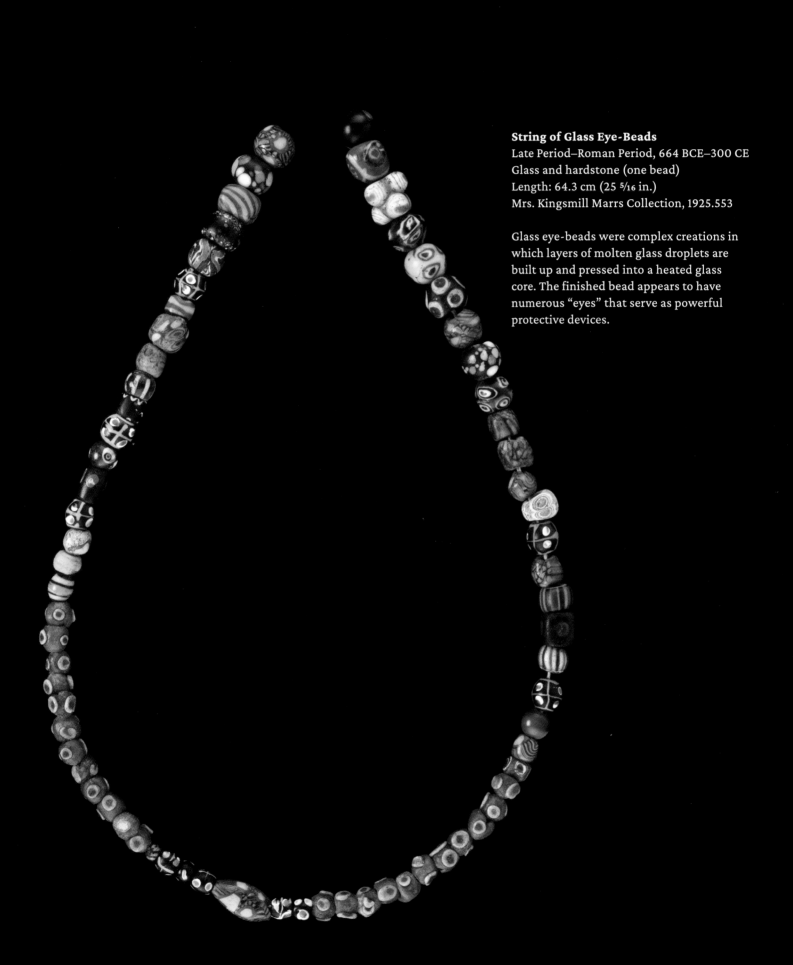

String of Glass Eye-Beads
Late Period–Roman Period, 664 BCE–300 CE
Glass and hardstone (one bead)
Length: 64.3 cm (25 5/16 in.)
Mrs. Kingsmill Marrs Collection, 1925.553

Glass eye-beads were complex creations in which layers of molten glass droplets are built up and pressed into a heated glass core. The finished bead appears to have numerous "eyes" that serve as powerful protective devices.

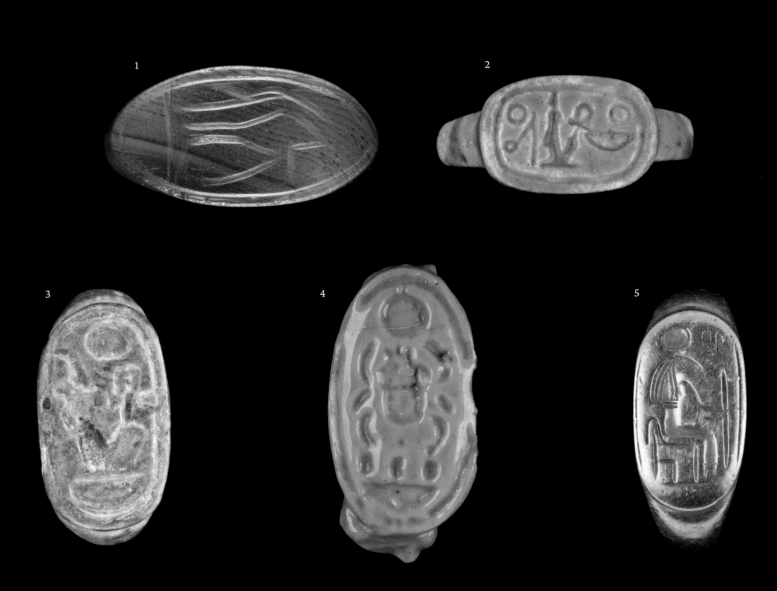

Finger Rings
Full object information on p. 208

1. 1926.96 Carnelian *wedjat*
2. 1925.580 Faience cartouche
of Amenhotep III
3. 1925.581 Faience cartouche
of Amenhotep III
4. 1926.95 Faience
cartouche of Tutankhamun
5. 1926.97 Gold signet of a seated Sekhmet

The earliest finger rings were made
of bands of shell, stone, or metal wire
followed by wires with scarab bezels. By
the New Kingdom, stirrup and signet forms
carved from semiprecious stones or cast in
precious metal were fashionable. Lighter
and less precious variants were made in
colorful faience. Egyptian signs, symbols,
hieroglyphs, and royal cartouches were
favorite motifs.

Polychrome Glass Bangles
Full object information on p. 208

1. 1925.668
2. 1925.669
3. 1925.670

The ancient Romans were master glassmakers who created an impressive range of forms in clear, colored, patterned, and marbleized glass using a range of techniques. They introduced glass blowing around the first century BCE and were the first to mass-produce objects of daily life in glass. Among the glass ornaments popular in the Roman world during the first to third centuries were bangles made of drawn and tooled glass in a range of colors and designs.

1

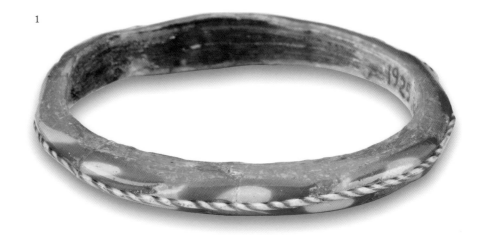

2

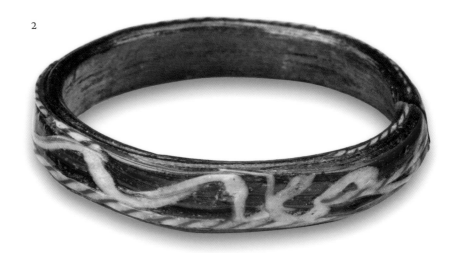

3

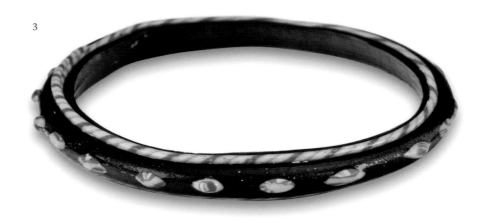

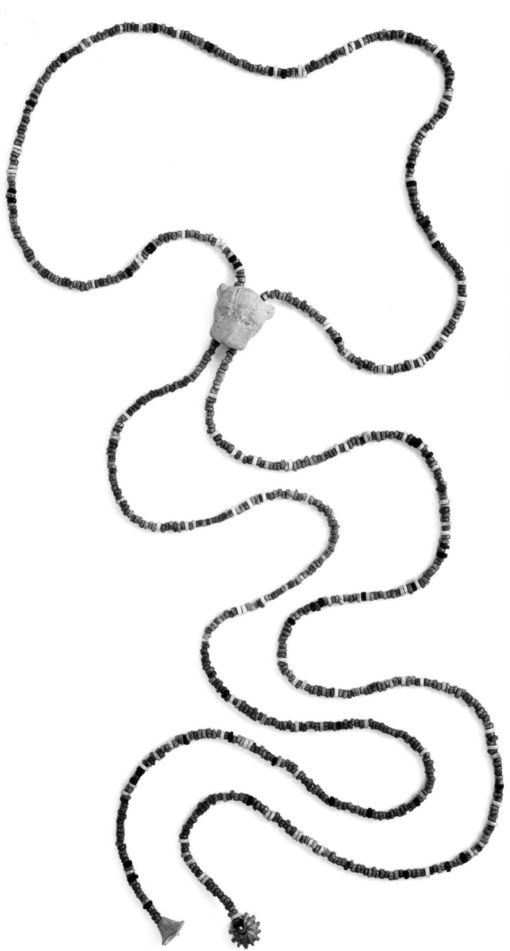

Necklace with Lioness-Head Spacer
New Kingdom, ca. 1539–1077 BCE
Faience
80.5 × 2.3 cm (31 $^{11}/_{16}$ × $^{7}/_{8}$ in.)
Mrs. Kingsmill Marrs Collection, 2019.30

This neckpiece is similar to a modern
bolo-tie ornament in that it features a
central, decorative element that joins one
neck strand. The joining element in this
adornment is a lioness's head while the
beads are made of faience ring beads. An
excavated example dating to Dynasty 18
features jasmine-blossom terminals.

String of Melon and Spherical Beads
New Kingdom, ca. 1539–1077 BCE
Faience
Length: 58.4 cm (23 in.)
Mrs. Kingsmill Marrs Collection, 1915.418

Spherical beads with longitudinal creases or
striations, known as melon beads, are based
on forms associated with lotus buds. They
appear as early as Dynasty 1 and remain
popular throughout Egyptian history. The
most common are made of blue faience.
The use of yellow in this example suggests a
New Kingdom date.

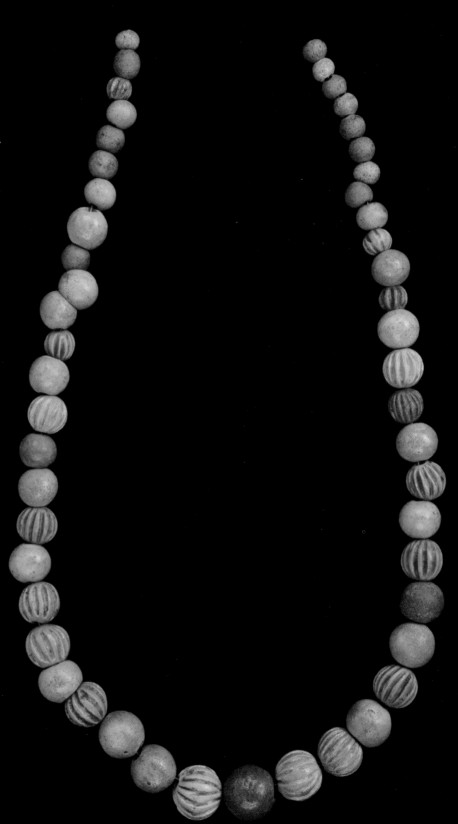

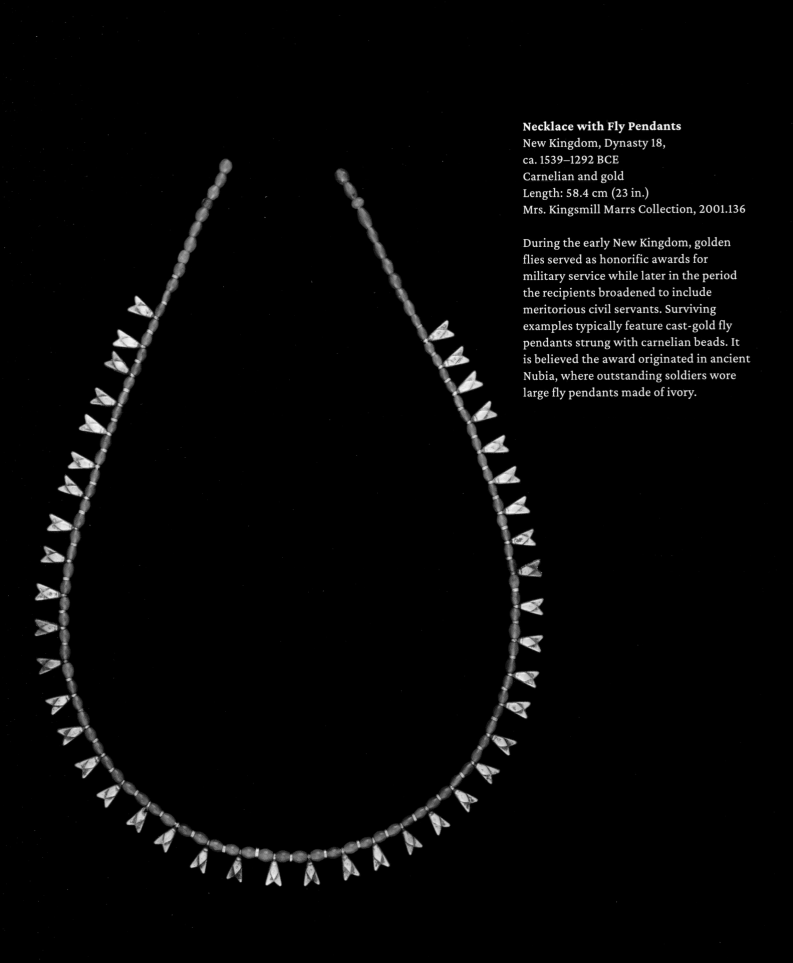

Necklace with Fly Pendants
New Kingdom, Dynasty 18,
ca. 1539–1292 BCE
Carnelian and gold
Length: 58.4 cm (23 in.)
Mrs. Kingsmill Marrs Collection, 2001.136

During the early New Kingdom, golden
flies served as honorific awards for
military service while later in the period
the recipients broadened to include
meritorious civil servants. Surviving
examples typically feature cast-gold fly
pendants strung with carnelian beads. It
is believed the award originated in ancient
Nubia, where outstanding soldiers wore
large fly pendants made of ivory.

Catalogue

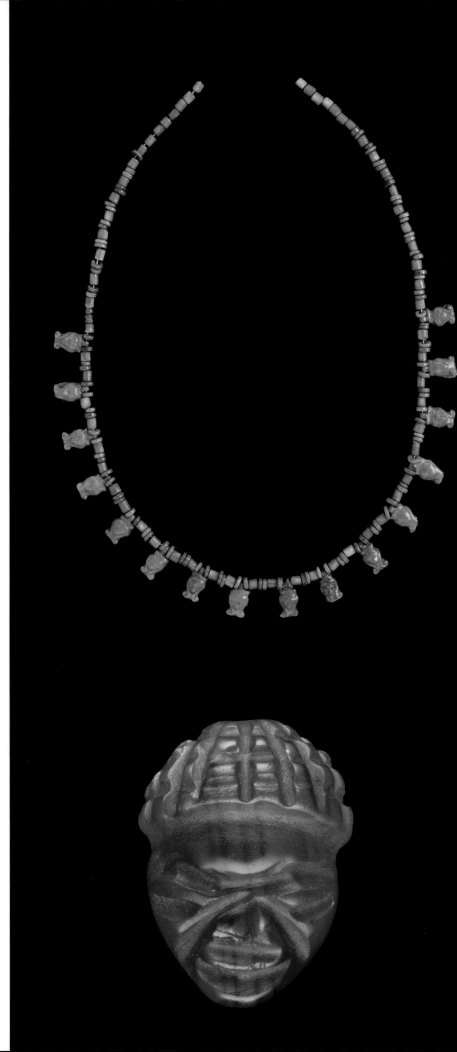

String of Hathor-Head Amulets
Late Period, 664–332 BCE
Faience
Length: 46 cm (18 ⅛ in.)
Mrs. Kingsmill Marrs Collection, 2019.31
This is a new assemblage using
elements from a disassembled necklace
(former 1925.635)

Hathor, a goddess who embodied fertility,
music, and dance, was often represented as
a woman wearing a headdress made up of
cow's horns and sun disc. In this ornament,
composed of multiple Hathor pendants
separated by ring and truncated cylinder
beads, the goddess has curled tresses and a
low modius atop her head.

Head of a Nubian
Probably New Kingdom, 1539–1077 BCE
Carnelian
1.4 × 1.1 × 0.8 cm (⁹⁄₁₆ × ⁷⁄₁₆ × ⁵⁄₁₆ in.)
Mrs. Kingsmill Marrs Collection, 1926.105

Representations of Nubians, inhabitants of
the land beyond Egypt's southern border,
can be found in Egyptian art of nearly all
periods. This is especially the case during
the New Kingdom when images of Nubian
heads appear on ornaments, such as
scaraboids, that were worn on the body.
This three-dimensional carnelian head was
probably once part of a larger construction
that was later flattened at the back of the
head and pierced for stringing.

Faience Broad Collar Pendants
New Kingdom, ca. 1539–1077 BCE
Faience
Various sizes
Mrs. Kingsmill Marrs
Collection, 2019.99.2–27

Faience adornments dating to the New
Kingdom are characterized by an explosion
of color and an emphasis on naturalistic
forms such as local fruits, flowers, and parts
of plants. This was especially the case with
broad collars: neck ornaments that often
incorporated miniature representations of
mandrake fruit, grape clusters, date palm
leaves, lotus petals, and cornflowers. Rows
of amuletic symbols, such as the *ankh* or
nefer sign, were also sometimes part of
the composition.

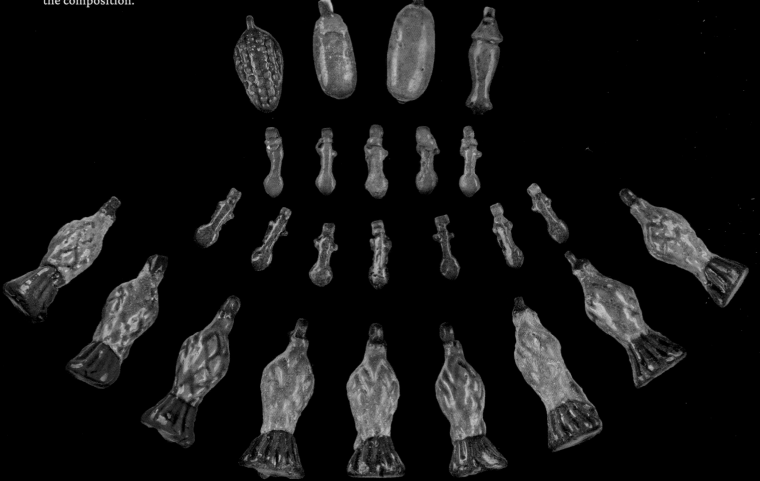

Mummy Bead Necklaces
Full object information on p. 208

1. 1925.538 String of multi-colored faience beads, amulets, and collar pendants
2. 1925.542 Double strand of faience mummy ring beads

Neck ornaments composed of faience "mummy" beads and small amulets were often purchased by Western visitors to Egypt during the late nineteenth and early twentieth centuries. Some necklaces were composed of long strands of beads of varying shapes that could be wrapped around the neck multiple times while others, including close-fitting chokers, reflected popular Edwardian and Deco tastes.

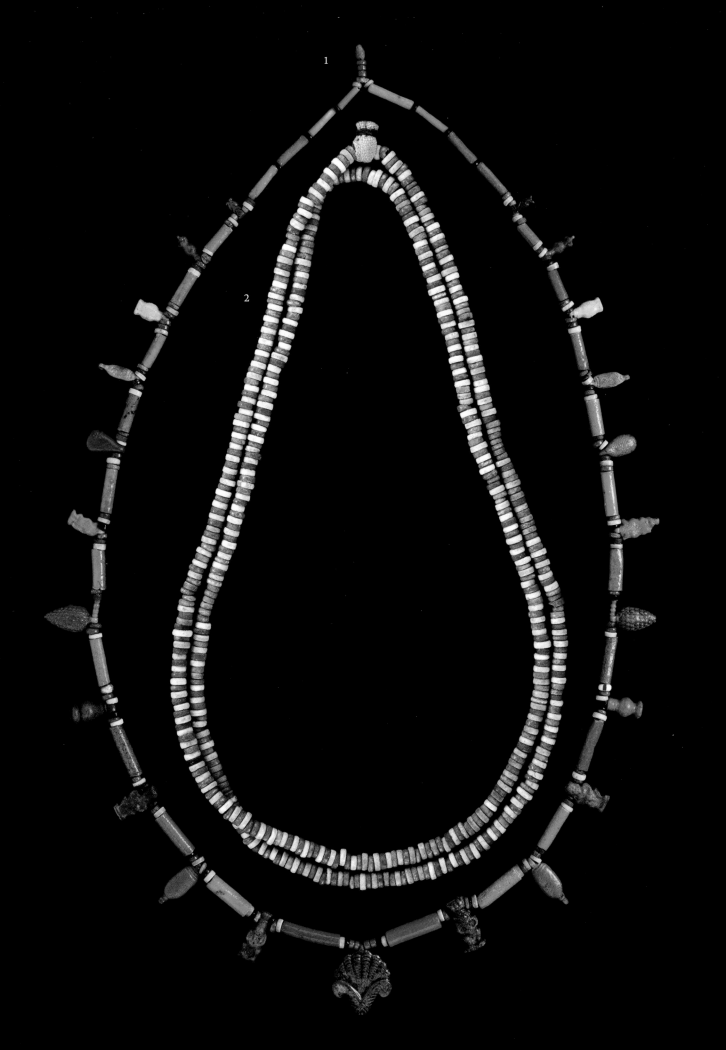

Egyptian Revival Brooches
Full object information on p. 208

1. 1914.2 Ancient plaquette with gold skiff
 and lotus blossoms
2. 1926.86 Steatite scarab in winged
 disc gold mount

During the second half of the nineteenth
century and early decades of the twentieth
century, small antiquities were set in
precious metal mounts—reflecting common
jewelry forms of the modern era. Many of
the artifacts were acquired by travelers to
Egypt, although Western jewelers were
also known to retail adornments with both
real and imitation Egyptian elements.
For fashionable ladies, jewelry featuring
scarabs set in Egyptian-inspired metalwork
was a popular way to demonstrate their
fascination with the ancient past.

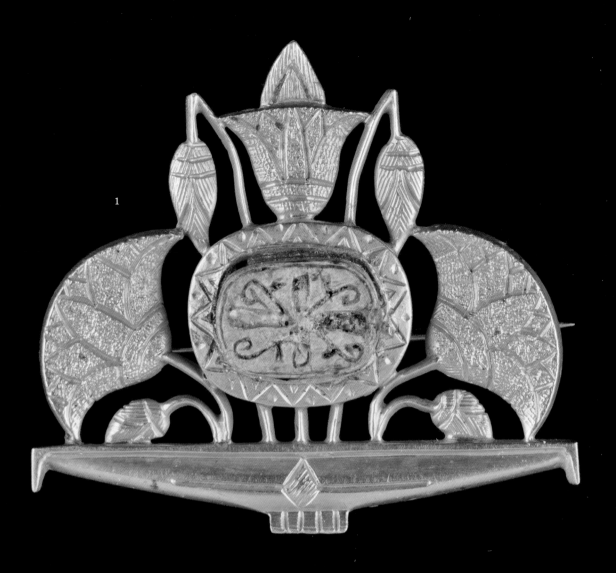

1

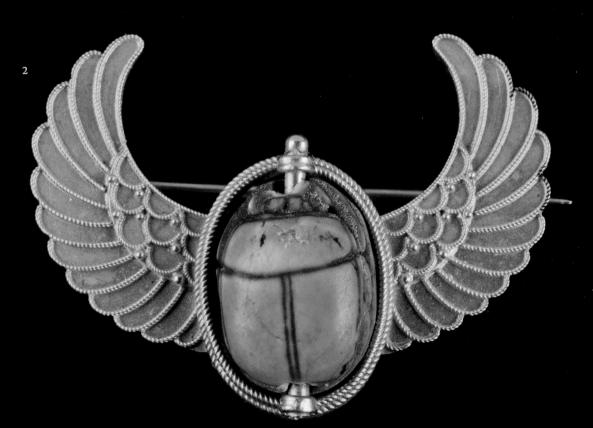

2

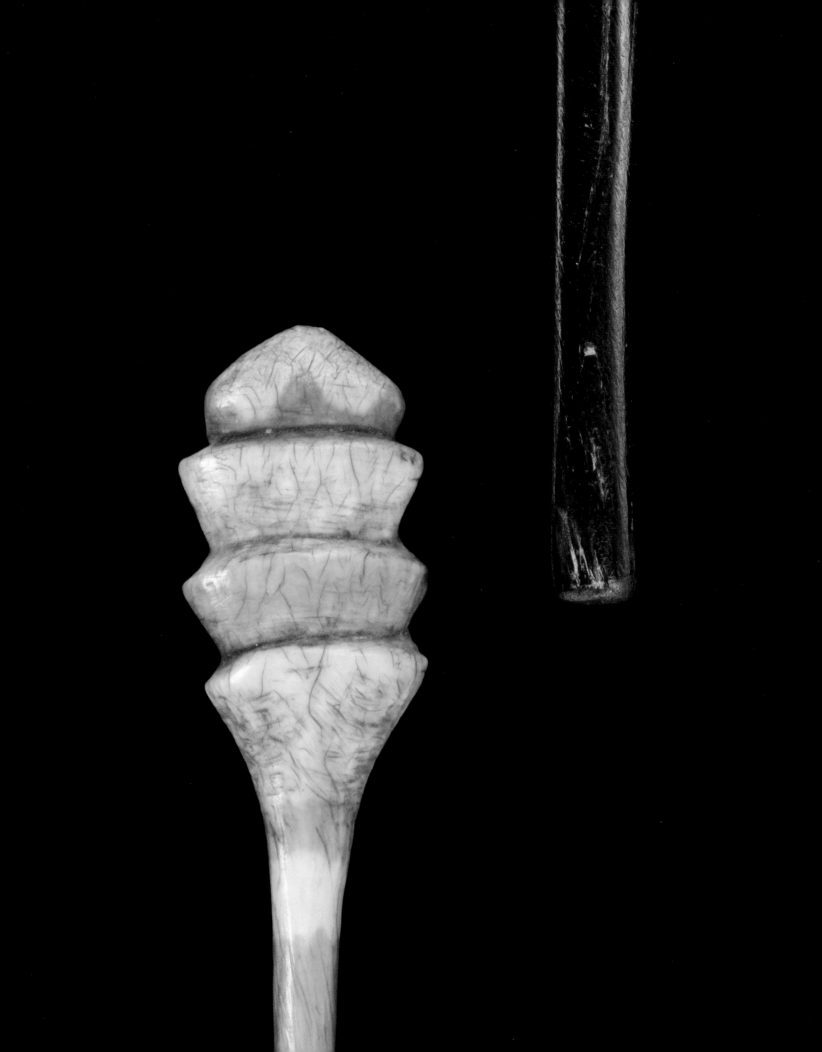

Cosmetics

Women and men in ancient Egypt not only adorned themselves with jewelry but also wore wigs and used cosmetics to enhance their appearance. Skin cream, makeup, and perfumes also served practical purposes to soften the skin, protect from sunburn, and safeguard the eyes from the glare of the sun and infection. Even after death, one was supposed to be presentable: the Book of the Dead, spell 125, mandates that the deceased be "clean, dressed in fresh clothes, shod in white sandals, painted with eye-paint, anointed with the finest oil of myrrh." Along with jewelry, cosmetics are among the most frequent items found in tombs. Creams, oils, and unguents were applied to mummies, just as with living people, to preserve the youthful appearance of smooth, glistening skin. They were applied with the use of spoons, brushes, applicators and, in the case of kohl, a long stick with a bulbous end.

The eyes were enhanced with green mascara or black eye-paint to emphasize their size and shape and to protect them from the blinding Egyptian sun. Ground pigment made from green malachite (a copper ore) was mixed with water to form a paste. In addition to enhancing the appearance, the copper had antibacterial properties. Kohl was used as an eye liner and made from the mineral galena (a lead ore), which came from mines in the region of the Eastern Desert. Recent analysis of this lead ore has shown it could react with salt and moisture to produce laurionite, which also would help fight eye infection. Kohl was quite expensive, but a cheaper variant of the cosmetic could be made by just using carbon black from burnt wood or other organic material.

Scents seem to have also had an important place in daily life. The Egyptians are often depicted sniffing flowers or offering incense to the gods. They also wore a perfume called *kyphi*.

Plutarch recorded that it was composed of sixteen ingredients including honey, wine, raisins, nutmeg, resin, myrrh, fragrant rush, bitumen, fig leaves, sorrel, two species of juniper, large and small, and cardamom.

A number of recipes for deodorants have also survived. One was composed of a combination of an ostrich egg, nuts, tamarisk, and crushed tortoise shell with fat. A prescription from the Hearst Medical Papyrus has instructions to mix lettuce, myrrh, and incense. Beginning in the New Kingdom, scenes show people wearing what have been suggested to be cones of scented wax on the top of their heads that would slowly melt and act as an all-day deodorant. They would be worn on top of elaborate, curled wigs which were made of human hair and often held in place with pins of wood, ivory, or metal.

Because of their value, cosmetics and perfumes would be placed in beautifully crafted stone containers to keep the precious contents from seeping out as they would from pottery vessels. The most frequently found are small pots that would contain kohl. They were usually squat to keep them from tipping over and had narrow mouths, broad rims, and lids to protect the contents. Larger vessels would contain creams and lotions, and their contents were so valuable that tomb robbers would often empty them during their plundering. They were also an important trade item: Egyptian stone cosmetic vessels found their way to—and were imitated throughout—the ancient world. However, with the invention of glass blowing in the Roman Period, these stone vessels were replaced with more easily produced, lighter, and even less porous glass containers.

Woman applying kohl from the Turin Erotic Papyrus (drawing by Paula Artal-Isbrand)

Man with fat cone on his head (detail of WAM 1947.35)

162

Alabastron
Late Period, 664–332 BCE
"Egyptian alabaster"
16.8 cm (6 ⅝ in.)
Mrs. Kingsmill Marrs Collection, 1926.102

Cosmetic vessels such as this were called alabastra by the Greeks, and were made of soft, translucent rocks derived from the mineral calcite, usually travertine. The term alabaster, however, was later used to designate a different kind of stone that was a form of gypsum. Often to avoid confusion, the vessels from the Nile Valley are now called "Oriental alabaster" or "Egyptian alabaster." These vessels were used as containers for perfume and oils and were traded throughout the ancient world from Nubia to Greece, Italy, and Asia Minor. The form was often copied in other media, such as pottery and precious metal.

Anhydrite Cosmetic Vessels
Full object information on pp. 208–209

1. 1925.345 Cosmetic vessel
 with lug handles
2. 1925.342 Cosmetic vessel
 with lug handles
3. 1925.366 Cosmetic vessel
4. 1925.360 Kohl pot and lid
5. 1925.373 Cosmetic vessel
6. 1925.367 Kohl pot

Distinguished by its pale blue-gray color,
anhydrite is a rare form of gypsum that
was popular for stone vessels in the Middle
Kingdom but rarely used before or after.
This group of cosmetic vessels is carved in
a variety of forms and appears to have been
a set. It is paralleled by a similar collection
found at Abydos and now in the Louvre
Museum. The Worcester Art Museum's
collection includes an additional anhydrite
cosmetic vessel not pictured here (1925.365)
that is part of this group.

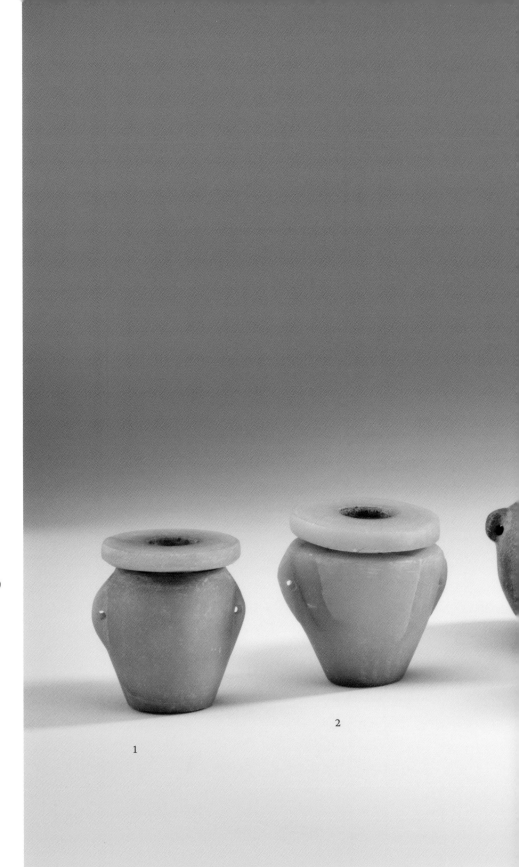

1

2

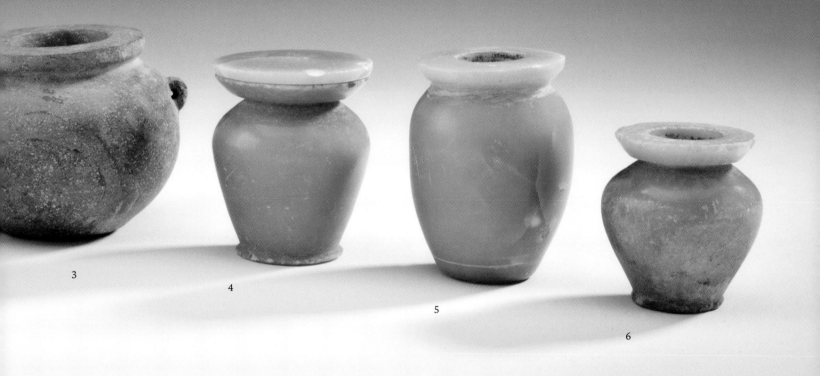

3 4 5 6

Bowl with Spout
Middle Kingdom, ca. 1980–1760 BCE
Steatite
3.3 × 7.9 × 9 cm (1 5/16 × 3 1/8 × 3 9/16 in.)
Mrs. Kingsmill Marrs Collection, 1925.368

Perfumes and cosmetics were made by
mashing up aromatic botanical substances
with oil or fat. They would have been
prepared in a shallow bowl such as this
with a spout to pour off the mixture
into a container.

Cosmetic Implement
New Kingdom, ca. 1539–1077 BCE
"Egyptian alabaster"
13.9 × 2.4 cm (5 1/2 × 15/16 in.)
Mrs. Kingsmill Marrs Collection, 1925.348

This tool would have been used to both
scoop out and apply cosmetics. A similar
example was found along with a group of
cosmetic vessels in a recent excavation of a
New Kingdom settlement in Nubia.

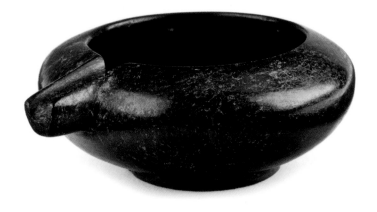

Glass Kohl Stick
New Kingdom, ca. 1539–1077 BCE
Glass
6.7 × 0.6 cm (2 ⅝ × ¼ in.)
Mrs. Kingsmill Marrs Collection, 1925.387

Kohl was applied to the eyes and brows
using a stick with a bulbous end that
produced a smooth and straight line. Many
kohl sticks were made of hematite, an iron
ore, and the choice of black glass for this
example may have been intended to imitate
their appearance.

Hair Pin
New Kingdom, ca. 1539–1077 BCE
Ivory
4.9 × 1.9 cm (1 ¹⁵/₁₆ × ¾ in.)
Mrs. Kingsmill Marrs Collection, 1925.600

Delicately carved pins in wood, ivory,
and metal were worn in the hair and in
wigs. This ivory pin is carved in the shape
of a typical ancient Egyptian bouquet
of bunched lotus flowers topped by a
mandrake fruit and still bears traces of the
pigment that would have colored it.

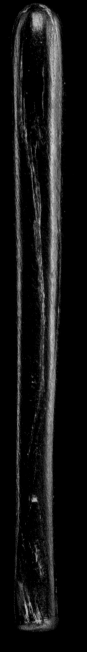

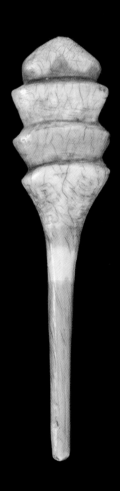

Middle Kingdom Vessels
Full object information on p. 209

1. 1925.370 Cylinder jar
2. 1925.371 Kohl pot
3. 1925.351 Cylinder jar

These finely crafted vessels are typical of the elegant forms one finds in the Middle Kingdom.

A number of sets of cylinder jars have been found in specially made boxes in the tombs of the royal women of the period.

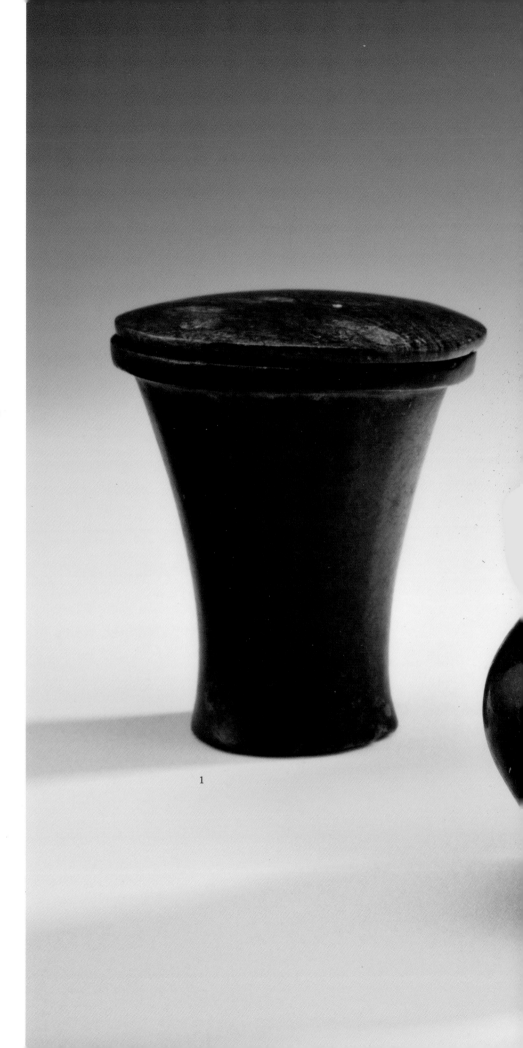

1

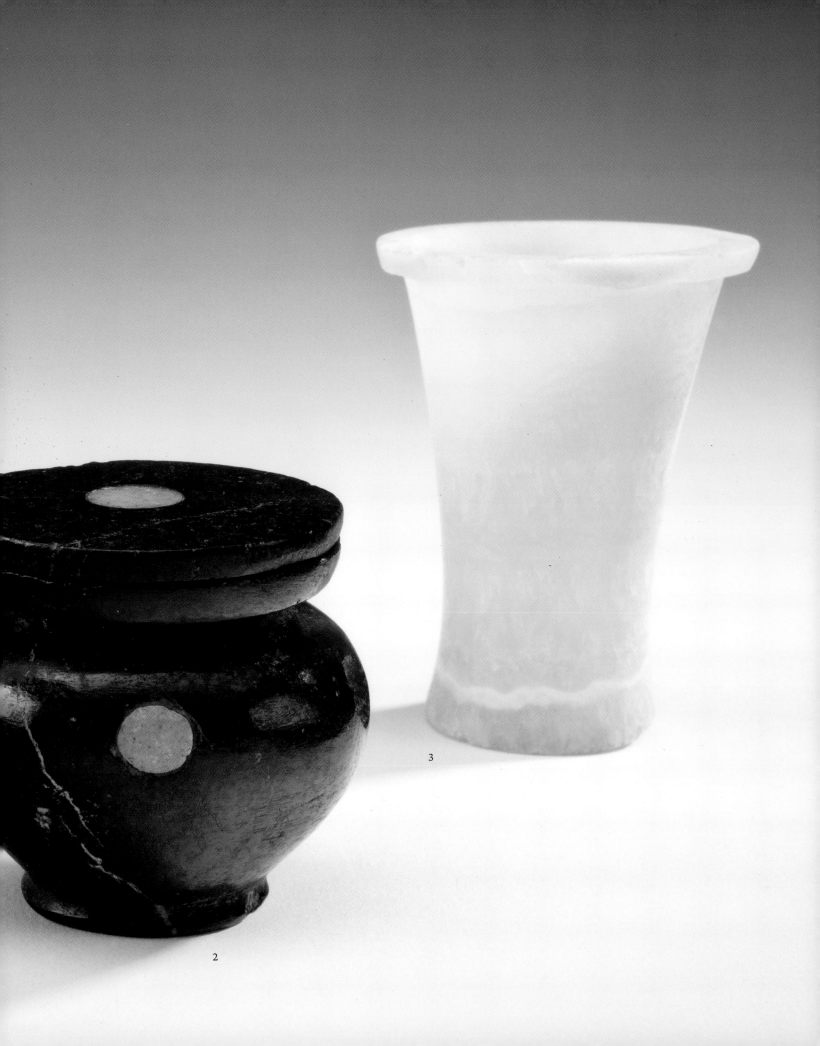

2

3

Mortar and Pestle
New Kingdom or later, ca. 1539–332 BCE
Black stone
mortar: 9.2 × 5.6 × 1.2 cm
(3 5/8 × 2 3/16 × 1/2 in.)
pestle: 2.7 × 2.1 cm (1 1/16 × 13/16 in.)
Mrs. Kingsmill Marrs Collection, 1925.361–2

Cosmetics could be ground in small amounts for daily application on rectangular palettes like this by using a small, domed pestle. Here the oval central well made to hold the material being worked with has been surrounded by a cartouche outline. The cartouche, in which the royal names were usually written, was adapted from an image of a tied, encircling rope symbolizing universal power.

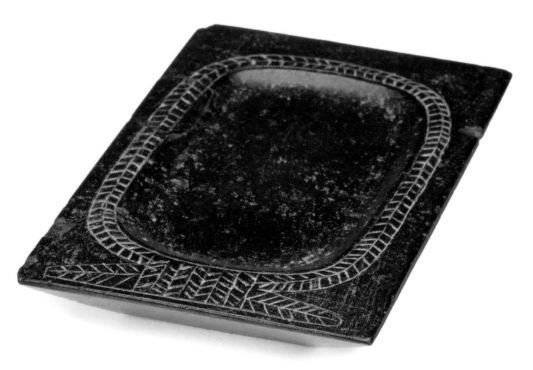

New Kingdom "Egyptian Alabaster" Vessels
Full object information on p. 209

1. 1925.354 Piriform vase
2. 1925.357 Kohl pot on stand
3. 1925.352 Cylinder vase

Cosmetic vessels in the New Kingdom saw an elaboration of types known from the Middle Kingdom as well as new forms, such as the piriform vase, inspired by growing contacts with the wider Mediterranean world.

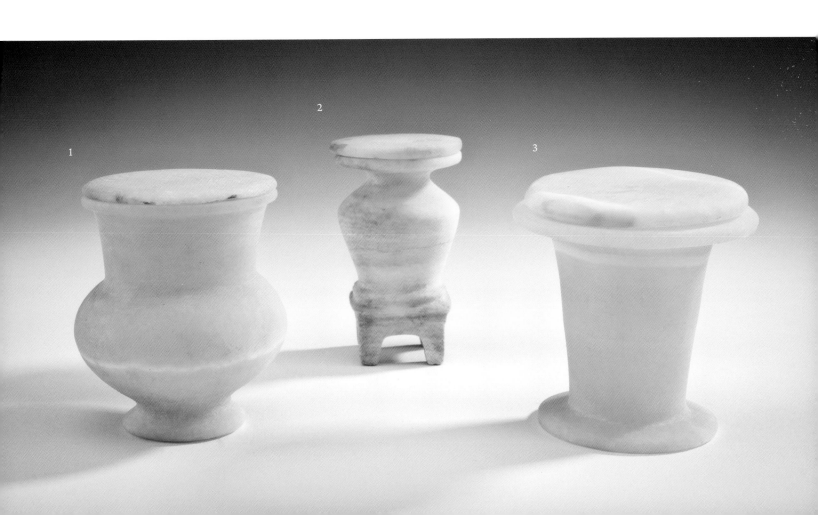

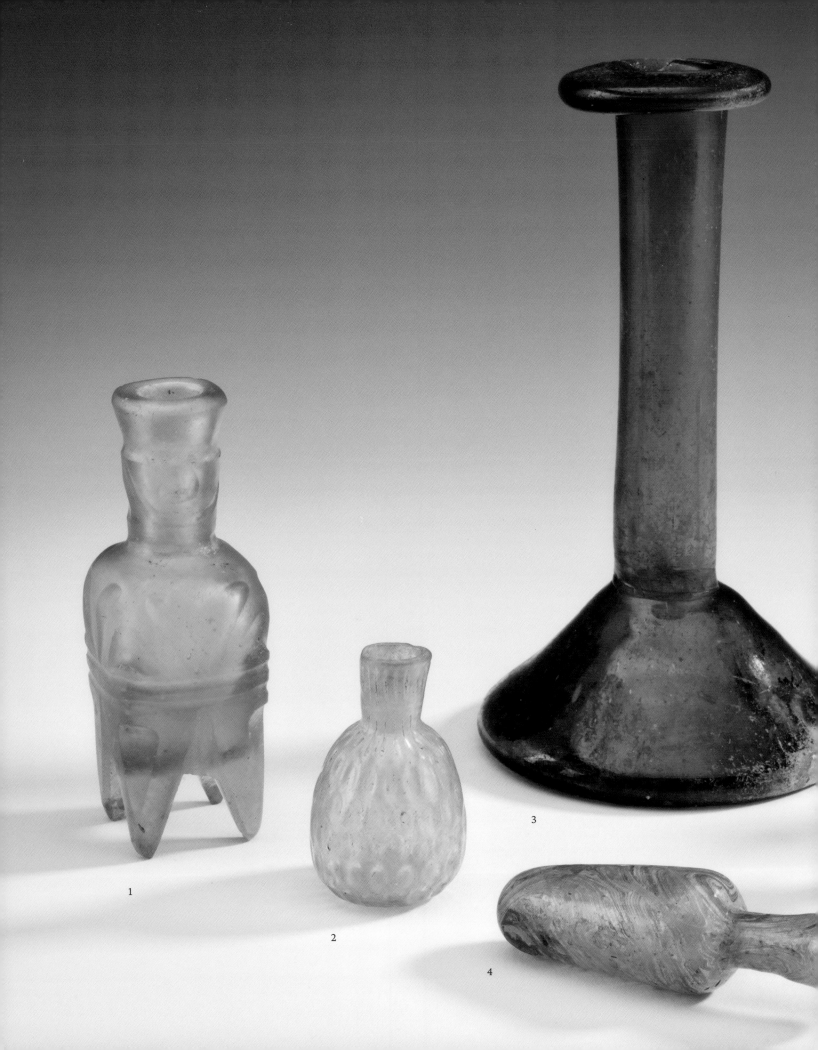

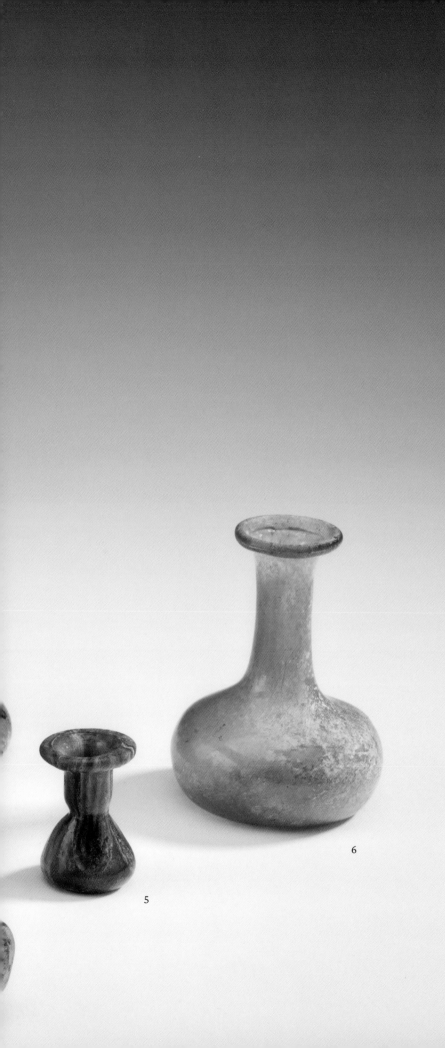

Glass Vessels
Full object information on p. 209

1. 1925.338 Glass vessel
2. 1925.327 Clear glass bottle
3. 1925.339 Glass vessel
4. 1925.330 Glass vessel
5. 1925.331 Blue glass bottle
6. 1925.340 Green glass bottle

Advancements in technology in the Roman Period produced kilns with high enough temperatures to allow glass to be blown, so a medium that had once been difficult and expensive to work was now easy and cheap. Glass vessels could also be blown into molds to create fancy surface patterns, as in the clear glass bottle shown here. They could also be etched and engraved, as seen in the footed vase. A wide variety of colored glass as well as clear glass could be made by adding different mineral pigments. In the dry climate of Egypt, this glass, although very fragile, was often well preserved. In wet ground, the surface would decay, producing an iridescent pattern on the surface, which inspired Louis Comfort Tiffany to create his favrile glass in the 1890s.

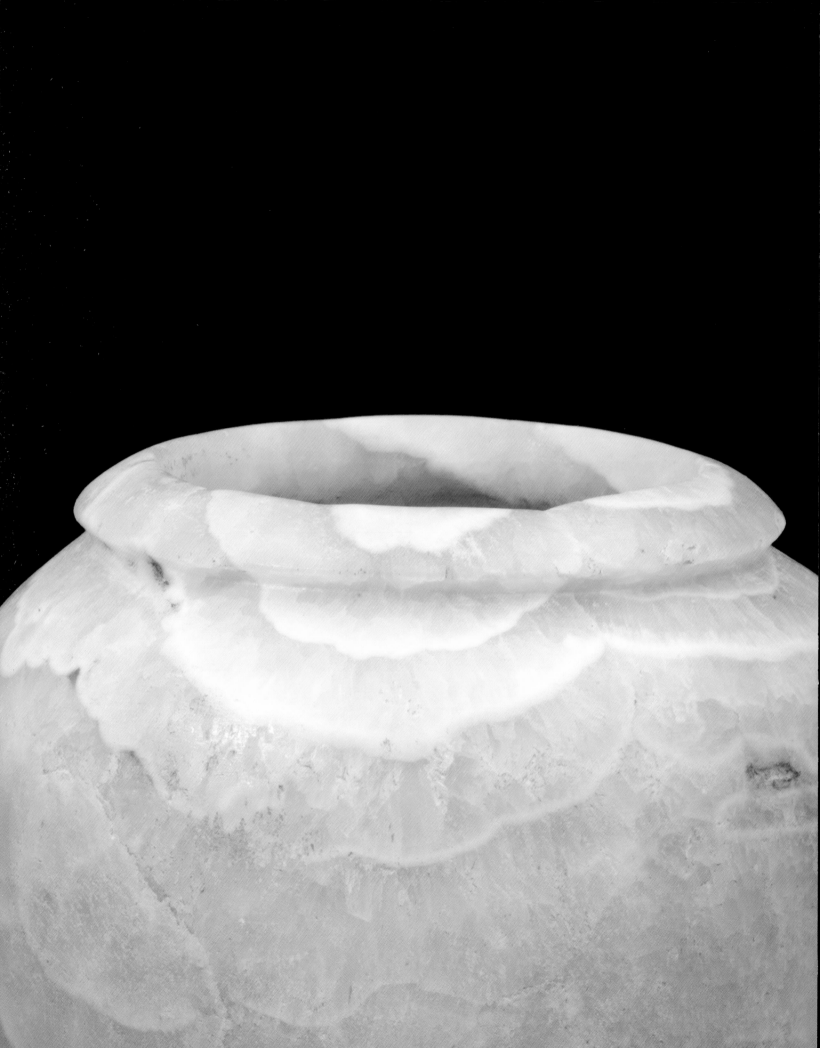

Funerary Art

From the very beginnings of Egyptian civilization, great effort was made to preserve and provide for the dead. It was thought that the spirit of the deceased would need the same things in the next world that were necessary for life in this one. The Egyptians also came to believe that the preservation of the body was essential for the continued existence of the spirit and that both the *ka*, a person's spiritual double, and the *ba*, which was a human-headed bird that was the mobile part of the soul, required a home base on earth. To ensure the survival of the deceased, the corpse was artificially preserved by mummification.

The departed were identified with the god of the dead, Osiris, and like him would become a divine being. After death they could make a journey through the underworld and be judged if they had lived a good life. If they passed the test, they could travel with Ra, the sun god, on his journeys across the skies and through the underworld. To guide the deceased through all the pitfalls of the journey through the underworld, sacred texts, such as the Book of the Dead, were buried with the deceased or their spells written on bandages or coffins or other items of funerary furniture.

Because the Egyptians had a very literal view of the next life, they determined that they would need to be provided with food and all the enjoyments of daily life. To this end, tombs were often stacked with provisions, and depictions or hieroglyphic texts referring to these necessities were placed on the walls of the tomb. The tomb chapel was the above-ground part of the memorial, and friends and relatives were supposed to visit and leave offerings; in case they did not, the mere images or mentions of them on the tomb walls would suffice.

Bronze Cat
Late Period, ca. 664–332 BCE
Bronze
22.9 cm (9 in.)
Museum Purchase, 1947.7

Most Egyptian deities had animal manifestations, and worshippers could offer images of them or even wrapped mummies of their mascot creatures to gain favor with a particular god. One of the most popular goddesses was Bastet, who was associated with the house cat. Thousands of cat mummies were found at the goddess's main temple at Bubastis in the Nile Delta and in other sites. The cat mummies were covered with elaborate linen wrappings and then sometimes placed in wooden or bronze images, like this example.

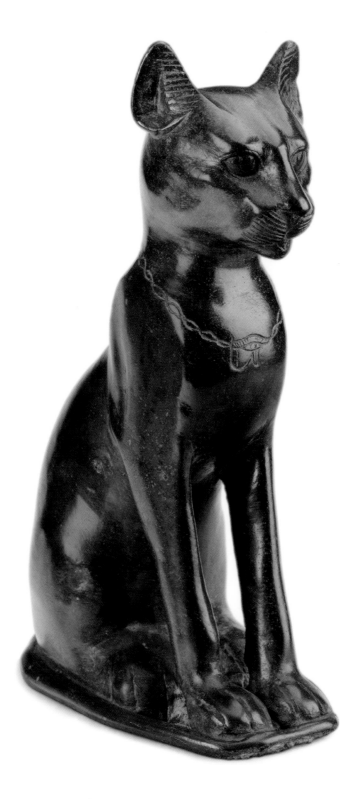

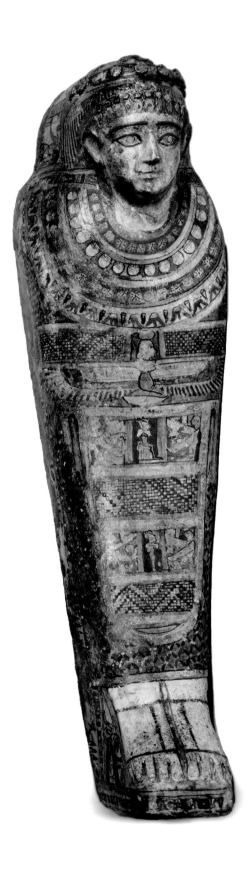

Child's Mummy Case
Early Roman Period, 30 BCE–200s CE
Cartonnage
104.8 × 31.1 × 24.1 cm (41 ¼ × 12 ¼ × 9 ½ in.)
Museum Purchase, 2000.49

The ancient Egyptians believed it was essential to preserve the body as a home for the soul on earth. It was for this reason that mummification was developed, as well as elaborate measures to protect the preserved body. For those who could afford it, a coffin was not only intended to physically house the mummy but also to magically protect it and assist in its journey to the next life. To accomplish this, coffins were decorated with protective spells, symbols, and images. This particular example was produced for a child around the third century CE and shows the blending of Hellenistic art with Egyptian traditions. It is made of cartonnage, a material like papier mâché that is composed of layers of linen coated with plaster and molded to shape over a form.

In death, the Egyptians believed they would be united with Osiris, the god of the dead, and that as divine beings their flesh would be gold; the face on coffins would often therefore be covered with gold leaf, as in this instance. An elaborate broad collar frames the face and a wreath of flowers is modeled on the head, along with a frieze of protective cobras. A winged goddess spreads her wings across the chest of the mummy case to protect the deceased. Osiris is shown enthroned and standing in his mummy wrappings on center panels on the front of the coffin and flanked by the mourning goddesses, Isis and Nephthys. No inscriptions record the name of the child for whom the coffin was made, and, as they were often made in advance, they are usually genderless so that they could be used by anyone.

Falcon Figure
Late Period, ca. 664–332 BCE
Painted wood
6.2 × 5 × 15 cm (2 7/16 × 1 15/16 × 5 7/8 in.)
Mrs. Kingsmill Marrs Collection, 1925.573

Wood figures such as this were placed on
coffins or other items of funerary furniture
in the Late Period. They represent a
mummified falcon, symbolizing the funerary
god Sokar, who was depicted as a falcon.
Toward the end of the New Kingdom, Sokar
was more often represented as another
funerary deity, a counterpart to Osiris, and
sometimes combined with him and the god
Ptah in a composite god, Ptah-Sokar-Osiris.

Large Jar
Archaic Period, ca. 2900–2544 BCE
"Egyptian alabaster"
15 × 11.5 cm (5 7/8 × 4 1/2 in.)
Mrs. Kingsmill Marrs Collection, 1925.364

The tombs of the kings and elites of the first
few dynasties were stocked with thousands
of stone vessels, many of which seem to
have been made specially for burial and
had no contents. Some also appear to have
been ritually broken before being placed
in the tombs. The shape of the vessel itself
is inspired by copper prototypes with
hammered, flattened rims. By the beginning
of the Old Kingdom, these full-size vessels
were often replaced by miniature examples
that would be magically transformed into
their large-size equivalents in the next life.

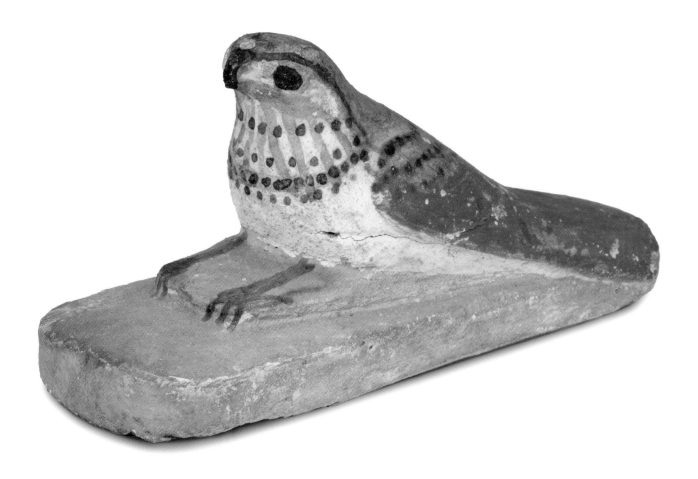

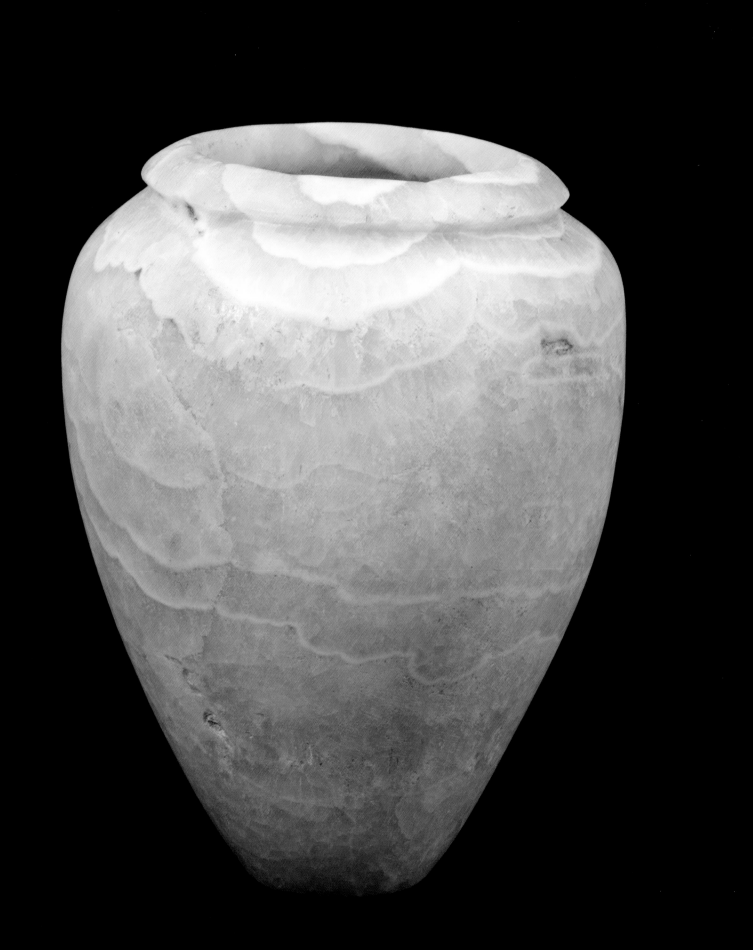

Portrait of Woman with Pearl Jewelry
Early Roman Period, 2nd century CE
Encaustic on wood panel
17.5 × 20.3 cm (6 ⅞ × 8 in.)
Gift of Channing Hare and Mountford
Coolidge, 1935.140

During the Roman Period, as a substitute
for a mummy mask on occasion, a panel
portrait of the individual was placed over
the face of the deceased instead. These
paintings, often called "Fayum portraits"
after the area where they were frequently
found, were painted in tempera paint or in
encaustic (colored wax). This portrait of a
woman depicts her wearing gold and pearl
earrings and a pearl necklace, along with a
gold and stone-bead necklace.

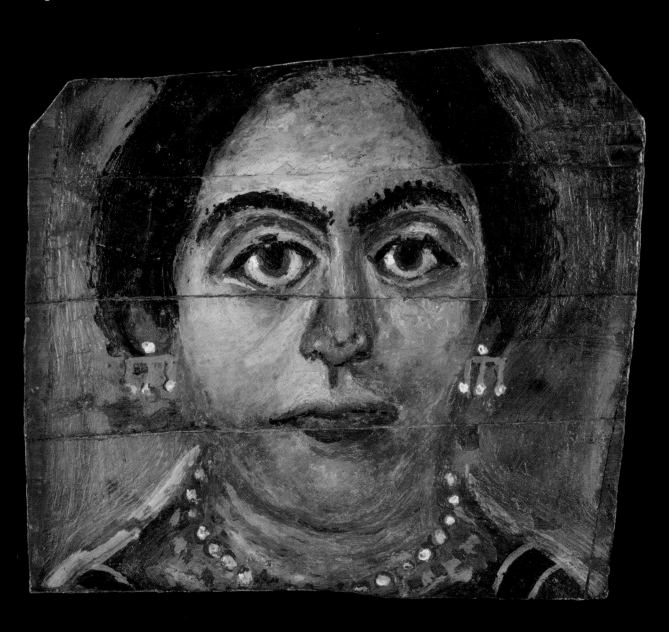

Flying Bird Relief
Middle Kingdom, Reign of Mentuhotep II,
ca. 2009–1959 BCE
Painted limestone
19.3 × 29.5 × 10.8 cm (7 ⅝ × 11 ⅝ × 4 ¼ in.)
Museum Purchase, 1958.10

Egyptian kings had large mortuary temples
that served to memorialize the departed
ruler and also provide him with food, drink,
and the necessities of life. Like private
tomb chapels, but on a much grander scale,
their walls were covered with texts and
depictions of everything they might need
in the next life. One of the largest and most
famous of these mortuary temples was that
of Mentuhotep II, the founder of the Middle
Kingdom, located in the great bay in the
cliffs at Deir el-Bahri in Western Thebes.
This temple has been excavated for over a
century, and this relief of a flying goose was
discovered by a British expedition in 1906. It
was sent to the Metropolitan Museum and
was later sold to the Worcester Art Museum.

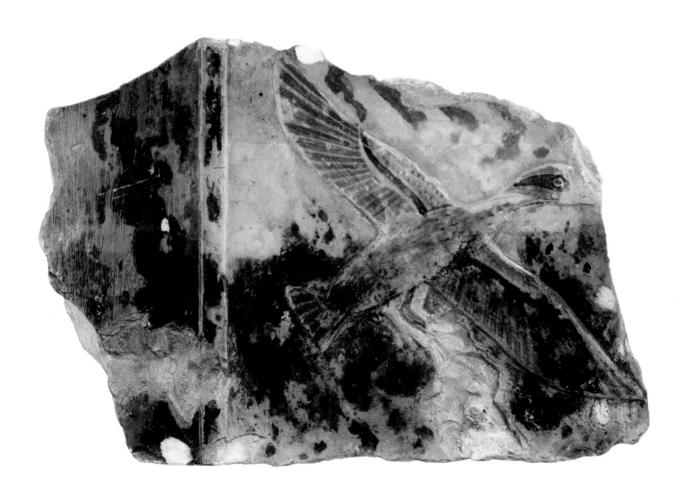

Pair of Shabtis
Full object information on p. 209

1. 1925.616
2. 1925.617

Set of Shabtis
Full object information on p. 209

1. 1925.563
2. 1925.564
3. 1925.565
4. 1925.566
5. 1925.567

During the Middle Kingdom and Second Intermediate Period a new type of funerary object was created. These were small mummiform figurines that are called shabtis, ushabtis, or shawabtis after the ancient Egyptian word for them, which meant "answerer." They would often have an inscription on them which said that, if the deceased was called upon to perform any labors in the next world, the figure would do it for them. At first there were just a few made for each tomb, but by the Third Intermediate Period they were mass-produced in faience so that each tomb would have 365, one for every day of the year. In addition, middle-ranking shabtis with little whips were added to make sure the other shabtis performed their duties. Some shabtis had abbreviated texts with just the name and titles of the deceased, and, by the Ptolemaic Period, many were not inscribed at all.

1

2

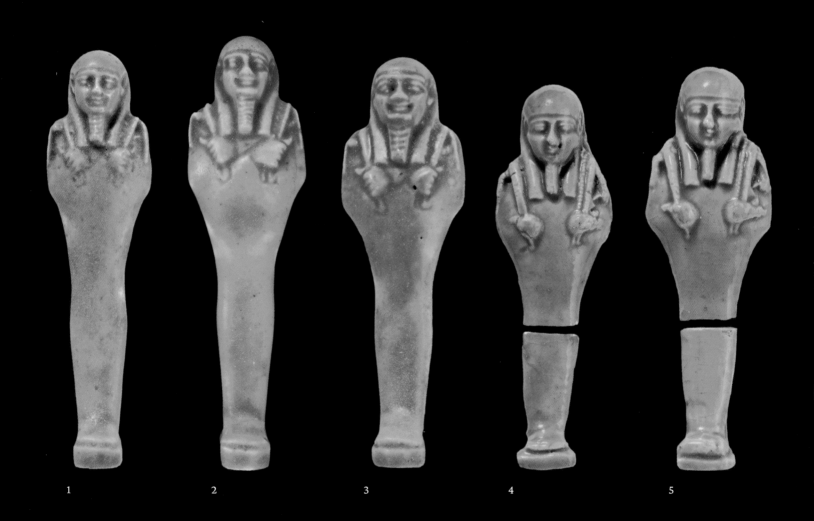

1 2 3 4 5

Wooden Stela of Ankhefmut
Third Intermediate Period, ca. 1076–655 BCE
Pigment and gesso on wood
34.3 × 22.9 cm (13 ½ × 9 in.)
Gift of Alexander H. Bullock, 1947.35

Egyptian graves were often marked with
stelae, which were essentially tombstones
that recorded the names and titles of the
person buried there. They were usually
carved in stone and then painted. However,
in the impoverished times of the Third
Intermediate Period stelae made of wood
were shaped and painted to give them the
appearance of stone. In this example, a
man named Ankhefmut is depicted making
offerings to Osiris, god of the dead and judge
of the underworld. Osiris is shown wrapped
as a mummy and seated on a low chair. He
wears a sun-disc flanked by ostrich plumes
on his head and holds the flail and the
crook, symbols of power. The hieroglyphic
caption on them asks for offerings to be
made to the soul of Ankhefmut. At the top
of the stela is the scarab-beetle god Khepri,
a form of the sun god Ra who is flanked by
praying baboons.

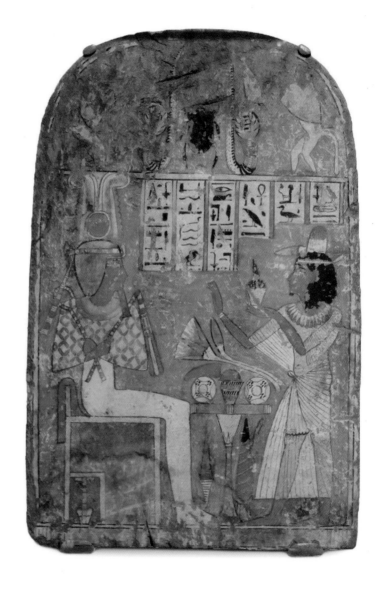

Wooden Lion Legs from a Funerary Bier
Early Roman Period, 30 BCE–200s CE
Painted and carved wood
38.1 cm (15 in.)
Mrs. Kingsmill Marrs Collection, 1925.410.1.2

These carved and painted legs are fashioned in the form of stylized lions and would have been at the end of a funerary bier. Behind each lion's head is a large slot which would have accommodated the bed's side rail, and further down are smaller mortise holes. The head of each lion is framed by a mane, and a panel painted with a feather pattern reaches down to the paws. They would have been brightly painted and attached to side panels painted with images of protective gods and goddesses.

Obsidian Fist
New Kingdom, Dynasty 18, Reign of
Amenhotep III, ca. 1390–1353 BCE
Obsidian
10.1 × 8.9 cm (4 × 3 ½ in.)
Mrs. Kingsmill Marrs Collection, 1925.429

Egyptian sculptors used a variety of stones
in royal commissions, often for their
symbolic value. This fist of volcanic glass
or obsidian was used for its black color to
equate the king with the god Osiris and the
fertile Nile soil. It was part of a composite
statue with the body probably made of
wood and other elements joined to it. An
obsidian face in the Cairo Museum and an
ear in the Museum of Fine Arts, Boston, have
been identified as going with the Worcester
fist. Analysis has shown that the source of
this obsidian was Ethiopia.

**Glass Fragment from the Valley
of the Kings**
New Kingdom, Dynasty 18, Reign of
Amenhotep III, ca. 1390–1353 BCE
Glass
4.6 × 3.3 × 0.9 cm (1 13/16 × 1 5/16 × 3/8 in.)
Diameter 12 cm (4 6/8 in.)
Mrs. Kingsmill Marrs Collection, 1925.656

Glass was first made in Egypt during the
Eighteenth Dynasty and was highly valued
because of the difficulty of making it. Glass
workshops have been found associated with
the royal palaces, and few could afford the
precious material. This fragment comes
from a large (40 cm tall) glass vessel found
in fragments in the tomb of Amenhotep III
in the Valley of the Kings. The vessel had
a colorful surface decoration created by
inlaying bits of different colored glass into a
white glass body.

Painted Wood Figures
Full object information on p. 210

1. Butcher 1958.11
2. Cook 1958.12
3. Stove 1958.13

During the impoverished times of the
First Intermediate Period, people could
no longer afford to have large stone tomb
chapels decorated with scenes of the daily
life activities they wished to enjoy in the
next life, so instead they were provided with
wooden models that depicted the same
types of household production formerly
depicted on the tomb chapel walls. This
tradition persisted into the early Middle
Kingdom, but, as seen here, the models
tended to be larger and much more finely
executed. This pair of models depicts a
butcher holding a knife about to slaughter a
cow and a cook holding a fan to intensify the
fire in the stove before him on top of which a
large bowl of food is being heated.

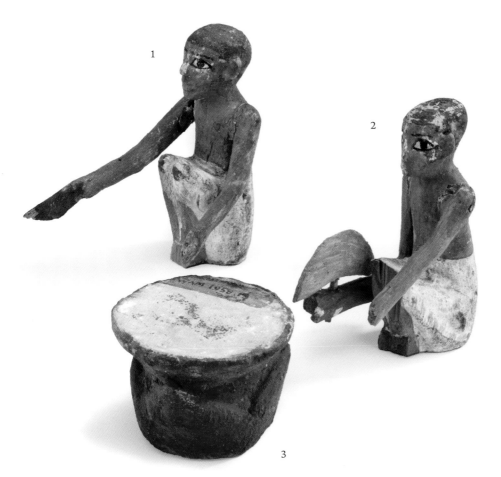

ANALYSIS OF EGYPTIAN PLAQUETTE MOUNTED AS A BROOCH

Erin R. Mysak and Richard Newman

SUMMARY

The Egyptian plaquette (1914.2; see p. 158) examined in this study is a carved ancient stone mounted in a more modern metallic brooch. Small fragments of an ancient glaze or glass are also readily visible on the surface (fig. 1). The goals of this analytical work were to determine the composition of the ancient stone and glaze/glass on the plaquette, how the object was carved and, if possible, its method of fabrication. The more modern metal was analyzed for composition but its fabrication was not of interest in this study.

Analysis revealed that the plaquette is made of glazed steatite, a material first produced in Egypt, the Near East, and the Indus Valley sometime towards the end of the fifth millennium BCE. The stone begins as soapstone, or steatite, composed mostly of talc, a magnesium silicate, which is soft and easily carved. After firing, as in the process of glazing, the steatite is converted to enstatite and cristobalite and becomes a much harder and more robust material. There are remnants of undegraded and degraded bluish green glaze mostly in the carved lines of the plaquette.

The glaze contains a mixed alkali flux, with potassium being more abundant than sodium. The colorant is copper with a trace of tin, suggesting that the source of the copper may have been bronze metal. Although very few analyses of glazes from Egyptian glazed steatite objects have been published, the composition of the glaze on this plaquette most closely resembles glazes that have been found on some New Kingdom objects. The alkali source was probably plant ash.[1]

The more modern gold mount is 86% gold, 8% silver, and 4% copper (the remaining 2% is sulfur and chlorine, likely corrosion products on the surface).

METHODS

Experimental details

Scanning electron microscopy/energy-dispersive X-ray spectrometry (SEM/EDS) was chosen so that both imaging and elemental analysis could be performed on the object. Given the small size of the brooch, it could easily be analyzed inside of an SEM chamber designed to accommodate small objects. The use of analytical standards during SEM analysis helped provide quantitative information on all of the materials used in the object: stone, glaze, and metal.

The object was transported to the Museum of Fine Arts, Boston for analysis, and was examined in a JEOL JSM-6460LV SEM with an attached Oxford Instruments X-MaxN energy-dispersive X-ray spectrometer (EDS). The SEM was operated at 20 kV with a beam current of 1 nA and the sample chamber was kept at a pressure of 35 Pa to avoid sample charging. The object was

observed with the back-scattered electron (BSE) detector for imaging purposes, and energy-dispersive X-ray spectroscopy (EDS) analyses were carried out on small areas of interest on the stone inlay, the glaze, and the gold mount. The regions of interest that were imaged with the BSE and in some cases also analyzed with EDS are marked in black boxes in fig. 1 below.

Quantitation was carried out with glass, mineral, and metal standards that were chosen based on the fact that the stone and glaze are silicates. Quantitation results for the stone may be somewhat less accurate than for the glaze because the standards are optimized for silicates with lower magnesium than what is found in this object's stone. For the gold brooch, pure element standards for gold, silver, and copper were used. Results could be improved using binary gold-silver and gold-copper standards.

SEM analysis locations

Fig. 1

The highlighted regions were imaged with the back-scattered electron detector and in some cases analyzed for elemental composition with EDS. Image taken by Paula Artal-Isbrand, annotated by authors to describe analysis locations.

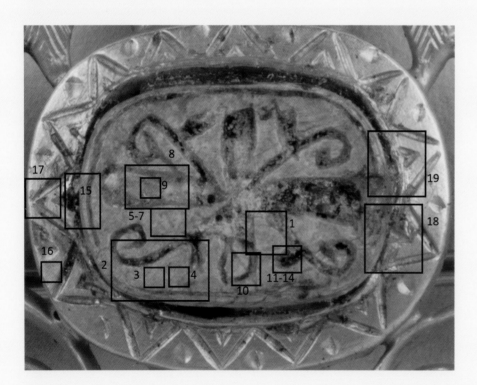

30μm

Fig. 2

SEM/EDS spectrum of the plaquette substrate

Fig. 3

Back-scattered electron image from analysis location 6 (see fig. 1) shows prismatic crystals, which most likely consist mainly of enstatite. The bright spots are gold metal. Orientation of the crystals varies on the surface.

RESULTS

Ancient stone inlay

The stone contains mainly magnesium and silicon, with small quantities of sodium, aluminum, phosphorous, sulfur, potassium, calcium, iron, and copper. A representative SEM/EDS spectrum is shown in fig. 2. The inlay appears to be composed of prismatic crystals (fig. 3) oriented in various directions. The stone was likely originally steatite, or soapstone, the major mineral component of which is talc, a platy hydrated magnesium silicate, $Mg_3(OH)_2Si_4O_{10}$. Other minerals may also be present. Talc is a soft mineral (Mohs hardness of 1), meaning that a rock in which it is the major component can be very easily scraped and carved.[2] Steatite may be hardened (Mohs hardness of 6–7) by firing, as would happen during the process of glazing. Firing converts the talc to enstatite ($MgSiO_3$) and cristobalite, SiO_2 (the high-temperature form of silica).[3] Another much harder type of rock that was used in Egypt to make small objects that were subsequently glazed consists of the mineral quartz.

SEM/EDS analyses of the substrate showed Si/Mg atomic ratios of about 3:2. This ratio is too high for talc (Si/Mg is 4:3) and enstatite (Si/Mg is 1:1), and may be explained by the probability that other silicate minerals were present in the original stone.

Ancient green glaze

SEM examination of the glaze shows multiple small areas of seemingly unaltered or only slightly degraded material. One image revealed scratch marks in the unaltered glaze, possibly remaining from fabrication and finishing (fig. 4). The areas of unaltered glaze are surrounded by areas of degraded glaze, which is hydrated and can be visualized in back-scattered SEM images as the darker

Fig. 4

Back-scattered electron image of a relatively large area of unaltered glaze corresponding to analysis location 9 (see fig. 1). Lighter gray areas are unaltered glaze, darker areas are degraded glaze. Scratch marks are visible on the unaltered glaze.

Fig. 5

Back-scattered electron image of glaze. Lighter gray areas are unaltered material, darker circular areas are degraded glaze, and the dark spot off center is surface dirt on the object.

Fig. 6

Back-scattered electron image of glaze. Lighter gray areas are unaltered material, while darker circular areas show crack patterns consistent with degraded glassy material.

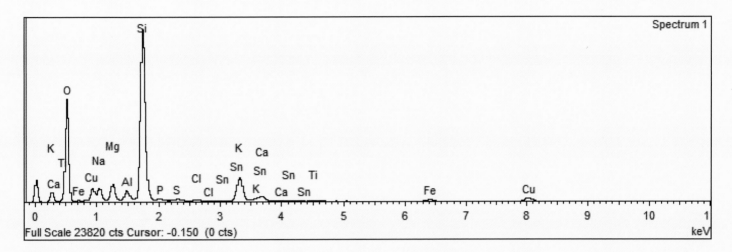

Fig. 7

SEM/EDS spectrum of a representative area of original, or undegraded, glaze

regions with circular cracking patterns (figs. 5, 6). A spectrum of what is considered to be essentially unaltered glaze is shown in fig. 7. Thirteen areas of undegraded glaze were analyzed and found to be consistent in composition with one another. The normalized oxide weight percent with standard deviations were determined to be: Na_2O: 4.2 ± 0.5, MgO: 5.2 ± 0.8, Al_2O_3: 2.9 ± 0.2, SiO_2: 63.1 ± 0.3, P_2O_5: 1.0 ± 0.1, SO_3: 0.8 ± 0.2, Cl: 0.4, K_2O: 8.4 ± 0.4, CaO: 2.1 ± 0.1, TiO_2: 0.2 ± 0.1, FeO: 2.2 ± 0.2, CuO: 8.7 ± 0.9, SnO_2: 1.0 ± 0.1.

Modern metal brooch

Several areas of the brooch mount were analyzed and yielded quantitative values with an average of 86% gold, 8% silver, and 4% copper. The difference from 100% is due to the presence of sulfur and chlorine, likely corrosion products, on the surface (which is what is being analyzed with SEM). There are two areas that contain higher silver (ca. 12%) at the stone and gold interface and are likely areas of solder.

DISCUSSION

Ancient stone inlay

The earliest glazed steatite beads, dating to the Badarian phase of the Predynastic Period, fifth millennium BCE, were in the form of disc beads, which are short cross sections of a cylinder.[4] Most of the holes in these beads were drilled from both ends (as opposed to faience, in which most holes are conical). In the rectangular plaquette in this study, the holes are located through the long side of the object. The holes cannot be directly observed because they are obscured by the modern mount and solder used to adhere the ancient plaquette to the

mount. X-radiography of the object could be useful for determining how the hole was made.

Various kinds of glazed steatite objects were made from the Predynastic Period until the Late Period (664–332 BCE).[5] The closest known parallel to the plaquette discussed in this report is one that has been dated by curatorial assessment to the Second Intermediate Period (ca. 1759–1539 BCE).[6] However, the plaquette in this study could date to an earlier or later period.

Ancient green glazes

Both sodium and potassium are present in significant quantities in the plaquette's glaze (Na_2O 4.2 \pm 0.5 wt % and K_2O 8.1 \pm 0.4 wt %). This finding indicates the use of plant ash rather than natron for the flux source. Natron, which contains very little potassium, was a commonly utilized alkali source in ancient Egypt, and appears to have been the alkali used in Badarian glazed steatite beads. Two of three analyses of glazes from steatite objects from the New Kingdom had similar mixed alkali contents to the plaquette examined here, while sodium was more abundant than potassium in the third. However, the available analyses are very few, and it is not certain when plant ash was initially used in these glazes. An unpublished XRF study referenced in Tite et al. suggests that natron as well as plant ash were used in vitreous materials from the Predynastic Period through to the First Intermediate Period.[7]

In the literature, two main glazing techniques for producing glazed steatite have been suggested.[8] Steatite can be glazed either by the cementation method, in which the body is fired while buried in a glazing mixture, or by direct application, where a fritted or raw glaze mixture is applied to the surface prior to firing. Studies of cross sections and replication experiments show that the cementation method (rather than application of a glazing mixture) was used on Badarian Period glazed steatite beads, while later objects were glazed by direct application. However, because of the paucity of analyzed examples, it is not certain when the application method was first utilized. On an object such as the plaquette, application is a more logical procedure, and this is all the more likely given the fact that glaze seems only to have been applied to certain areas. SEM analysis of cross sections, in which the microstructure of the glaze can be examined, would provide more certainty on the plaquette glazing technique, but a sample for this type of examination could not be taken for the present project.

As has been reported in the published examples of glazed steatite objects, we observed crystals just below the glaze surface (fig. 8) that are likely forsterite, Mg_2SiO_4. The morphology of the crystals correlates well with published SEM/BSE images of forsterite,[9] but the composition of the crystals could not be accurately determined in the SEM as they are covered by a thin glaze layer.

60μm

Fig. 8

Back-scattered electron image of glaze showing elongated crystals under the surface of the glazes. Lighter gray areas are unaltered glaze, darker areas degraded glaze.

One other possible method by which the colored material could have been applied would have been by grinding up glass, packing it in the carved regions, then firing the object to fuse the glass particles together. This method seems less likely, but once again a cross section could provide more insight.

Tin (Sn) was detected in the glaze and indicates that the copper (Cu) used as the greenish blue colorant on the plaquette was in the form of bronze rather than pure Cu. Sn was not reported in literature references for SEM analysis of glazed steatite,[10] but, as noted already, the published analyses to date are very limited.

CONCLUSIONS

The plaquette is a glazed steatite object. The magnesium silicate stone is likely composed of steatite that has been converted to enstatite during firing. The carvings were made prior to firing, when the soft steatite could be easily worked, and the glaze was (likely) applied by direct application. Firing of the object resulted in a much harder material than the original steatite. The colorant for the glaze is copper, and the glaze contains some trace tin suggesting bronze as the copper colorant source. The alkali flux is consistent with plant ash. Without sampling and further SEM analysis, it is not possible to precisely characterize the type of glazing process used.

Endnotes
1. Tite and Bimson 1989; Tite and Shortland 2008.
2. Matin 2014.
3. Tite and Shortland 2008.
4. Tite and Shortland 2008; Vandiver 1983.
5. Tite and Shortland 2008.
6. Haynes and Markowitz 1991.
7. Tite and Shortland 2008.
8. Tite and Bimson 1989; Tite and Shortland 2008.
9. Tite and Bimson 1989; Tite and Shortland 2008.
10. Tite and Bimson 1989; Tite and Shortland 2008.

Bibliography

Adams 2013
Adams, John M. *The Millionaire and the Mummies: Theodore Davis's Gilded Age in the Valley of the Kings*. New York: St. Martin's Press, 2013.

Aldred 1971
Aldred, Cyril. *Jewels of the Pharaohs*. New York and Washington: Praeger Publishers, 1971.

Andrews 1990
Andrews, Carol. *Ancient Egyptian Jewellery*. London: British Museum Publications, 1990.

Artal-Isbrand 2018
Artal-Isbrand, Paula. "So Delicate yet so Strong and Versatile: The Use of Paper in Objects Conservation." *Journal of the American Institute for Conservation* 57, no. 3 (2018): 112–26.

Baehre et al. 2019
Baehre, O., G. Kloess, D. Raue, T. Muenster, and A. Franz. "From Talc to Enstatite: Archaeometric Investigations on an Ancient Egyptian Whitish Bead." *Archaeological and Anthropological Sciences* 11 (2019): 1621–29.

Baillot de Guerville 1905
Baillot de Guerville, Amédée. "Introduction." In *New Egypt*, pg. xiii. London: W. Heinemann, 1905.

Beck et al. 2018
Beck, Lucile, et al., "Absolute Dating of Lead Carbonates in Ancient Cosmetics by Radiocarbon." *Communications Chemistry* 1, no. 34 (2018), https://doi.org/10.1038/s42004-018-0034-y.

Budge 1906
Budge, E. A. Wallis. *Cook's Handbook for Egypt and the Sudan*. London: T. Cook & Son, 2nd edition, 1906.

Carter 1916
Carter, Howard. "Report on the Tomb of Zeser-Ka-Ra Amenhetep I, Discovered by the Earl of Carnarvon in 1914." *The Journal of Egyptian Archaeology* 3, no. 2/3 (April–July 1916): 147–54.

Carnarvon and Carter 1912
Carnarvon, Earl, and Howard Carter. *Five Years' Explorations at Thebes: A Record of Work Done, 1907–1911*. London: Oxford University Press, 1912.

Carter and Mace 1923a
Carter, Howard, and A. C. Mace. *The Tomb of Tutankhamen*. New York: George H. Doran Company, 1923.

Carter and Mace 1923b
Carter, Howard, and A. C. Mace. *The Tomb of Tut-Ankh-Amen Discovered by the Late Earl of Carnarvon and Howard Carter*. Vols I–III. London: Cassell, 1923.

Carter et al. 1900
Carter, Howard, M. W. Blackenden, Percy Brown, and Percy Buckman. *Beni Hasan, Part IV: Zoological and other Details*. London: Egypt Exploration Society, 1900.

Champollion 2001
Champollion, Jean-François. *The Codebreaker's Secret Diaries*. Translated by Martin Rynja. London: Gibson Square Publishing, 2001.

Dawson and Uphill 1995
Dawson, Warren R., and Eric Uphill, revised by M. L. Bierbrier. *Who Was Who in Egyptology*. London: Egypt Exploration Society, 1995.

Edwards 1976–77
Edwards, I. E. S. "Tutankhamun." *Metropolitan Museum of Art Bulletin* 34, no. 3 (1976–77): 1–48.

Freed et al. 2009
Freed, Rita E., et al. *Secrets of Tomb 10A: Egypt 2000 BC*. Boston: MFA Publications, 2009.

Friedman 1998
Friedman, Florence Dunn. "Faience: The Brilliance of Eternity." In *Gifts of the Nile: Ancient Egyptian Faience*, edited by Florence Dunn Friedman, 15–21. London and Providence, RI: Thames and Hudson in association with the Museum of Art, Rhode Island of Design, 1998.

Gänsicke and Newman 2014
Gänsicke, Susanne, and Richard Newman. "Materials and Techniques in Nubian Jewelry." In Yvonne J. Markowitz and Denise M. Doxey, *Jewels of Ancient Nubia*, 142–51. Boston: MFA Publications, 2014.

Hess and Wight 2005
Hess, Catherine, and Karol Wight. *Glass: A Guide to Terms, Styles, and Techniques*. Los Angeles: Getty Publications, 2005.

Hagen and Ryholt 2015
Hagen, Fredrik, and Kim Ryholt. *The Antiquities Trade in Egypt 1880–1930: The H. O. Lange Papers*. Scientia Danica, Series H, Humanistica 4, vol. 8. Copenhagen: Royal Danish Academy of Sciences and Letters, 2015.

Haynes and Markowitz 1991
Haynes, J., and Y. Markowitz. *Scarabs and Design Amulets: A Glimpse of Ancient Egypt in Miniature.* New York: NFA Classical Auctions, 1991.

Hindley 2015
Hindley, Meredith. "King Tut: A Classic Blockbuster Museum Exhibition that Began as a Diplomatic Gesture." *Humanities, the Magazine of the National Endowment for the Humanities* 36, no. 5 (September/October 2015): 1–12.

Hornung, Kraus, and Warburton 2006
Hornung, Eric, Rolf Kraus, and David A. Warburton, with the assistance of Marianne Eaton-Kraus. *Ancient Egyptian Chronology.* Leiden and Boston: Brill, 2006.

James 1982
James, T. G. H., ed. *Excavating in Egypt: The Egypt Exploration Society 1882–1982.* Chicago and London: University of Chicago Press, 1982.

James 1992
James, T. G. H. *Howard Carter: The Path to Tutankhamun.* London: Tauris Parke Paperbacks, 1992.

James 1996
James, T. G. H. "Howard Carter and Mrs. Kingsmill Marrs." In *Studies in Honor of William Kelly Simpson*, Vol. I, edited by Peter Der Manuelian and Rita E. Freed, 415–28. Boston: Dept. of Ancient Egyptian, Nubian, and Near Eastern Art, Museum of Fine Arts, 1996.

Koob 2006
Koob, Stephen P. *Conservation and Care of Glass Objects.* Corning, NY: Archetype Publications in association with The Corning Museum of Glass, 2006.

Lacovara and Johnson 2003
Lacovara, Peter, and William Raymond Johnson. "A Composite Statue of Amenhotep III in the Cairo Museum." In *Egyptian Museum Collections around the World*, Vol. 1, edited by Mamdouh Eldamaty and Mai Trad, 591–94. Cairo: Supreme Council of Antiquities, 2003.

Lacovara and Markowitz 2019
Lacovara, Peter, and Yvonne J. Markowitz. *Nubian Gold: Ancient Jewelry from Sudan and Egypt.* Cairo and New York: The American University in Cairo Press, 2019.

Lilyquist and Brill 1995
Lilyquist, C., and R. H. Brill. *Studies in Early Egyptian Glass.* New York: Metropolitan Museum of Art, 1995.

Loring 2002
Loring, John. *Louis Comfort Tiffany at Tiffany & Co.* New York: Harry N. Abrams, 2002.

Loring 2004
Loring, John. *Tiffany Timepieces.* New York: Harry N. Abrams, 2004.

Matin 2014
Matin, M. "An Experimental Investigation into the Accidental Invention of Ceramic Glazes." *Archaeometry* 56 (2014): 591–600.

Mysak 2019
Mysak, Erin. "FTIR Analysis of Egyptian Head Amenhotep III," and "XRF Spectrum of Egyptian Bead's Rod." Unpublished reports, January 2019.

Nicholls 2006
Nicholls, Dale Reeves, with Shelly Foote and Robin Allison. *Egyptian Revival Jewelry and Design.* Atglen, PA: Schiffer Publishing, 2006.

Nicholson 2000
Nicholson, Paul T., with Edgar Peltenburg. "Egyptian Faience." In Nicholson and Shaw 2000, 186–92.

Nicholson and Henderson 2000
Nicholson, Paul T., and Julian Henderson. "Glass." In *Ancient Egyptian Materials and Technology*, edited by Paul Nicholson and Ian Shaw, 195–96. Cambridge: Cambridge University Press, 2000.

Nicholson and Jackson 2013
Nicholson, Paul T., and Caroline Jackson. "Glass of Amenhotep II from Tomb KV 55 in the Valley of the Kings." *The Journal of Egyptian Archaeology* 99 (2013): 85–99.

Nicholson and Shaw 2000
Nicholson, Paul T., and Ian Shaw, eds. *Ancient Egyptian Materials and Technology.* Cambridge, UK: Cambridge University Press, 2000.

Ogden 1982
Ogden, Jack. *Jewelry of the Ancient World.* New York: Rizzoli, 1982.

Ogden 1990–91
Ogden, Jack. "Gold in a Time of Bronze and Iron." *Journal of Ancient Chronology Forum* 4 (1990–91): 6–14.

Ogden 2000
Ogden, Jack. "Metals." In Nicholson and Shaw 2000, 148–76.

Petrie 1901
Petrie, W. M. Flinders. *The Royal Tombs of the Earliest Dynasties, Part II*. London: Egypt Exploration Fund, 1901.

Phillips 2006
Phillips, Clare, ed. *Bejewelled by Tiffany, 1837–1987*. New Haven and London: Yale University Press in association with the Gilbert Collection Trust and Tiffany & Co., 2006.

Pool 2018
Pool, Leslie K. "Feathered Friend." *Winter Park Magazine*, Winter 2018.

Porter and Moss 1964
Porter, Bertha, and Rosalind Moss. *Topographical Bibliography of Ancient Egyptian Hieroglyphic Texts, Statues, Reliefs and Paintings*, Vol. I: *The Theban Necropolis, Part 2. Royal Tombs and Smaller Cemeteries*. Oxford: Griffith Institute, 1964.

Reeves 2015
Reeves, Nicholas. "Tutankhamun's Mask Revisited." In *The Art and Culture of Ancient Egypt: Studies in Honor of Dorothea Arnold*, edited by A. Oppenheim and O. Goelet, Bulletin of the Egyptological Seminar 19, 511–26. New York: Egyptological Seminar of New York, 2015.

Reeves and Taylor 1992
Reeves, Nicholas, and John H. Taylor. *Howard Carter before Tutankhamun*. London: British Museum Press, 1992.

Reisner 1912
Reisner, George A. "Solving the Riddle of the Sphinx." *Cosmopolitan Magazine* 53 (1912): 4–13.

Riccardelli 2001
Riccardelli, Carolyn. "That Which is Brilliant and Sparkling: Characterizing Egyptian Faience Inlay Techniques." Senior Specialization Project, Art Conservation Department, Buffalo State College, 2001.

Riggs 1977–78
Riggs, Timothy A. "Mr. Koehler and Mrs. Marrs: The Formation of the Mrs. Kingsmill Marrs Collection." *Worcester Art Museum Journal* 1 (1977–78): 2–13.

Shortland, Rogers, and Eremin 2007
Shortland, A., N. Rogers, and K. Eremin. "Trace Element Discriminants between Egyptian and Mesopotamian Late Bronze Age Glasses." *Journal of Archaeological Science* 34 (2007): 781–89.

Tite and Bimson 1989
Tite, M. S., and M. Bimson. "Glazed Steatite: An Investigation of the Methods of Glazing Used in Ancient Egypt." *World Archaeology* 21 (1989): 87–100.

Tite and Shortland 2008
Tite, M. S., and A. J. Shortland, with A. Bouquillon. "Glazed Steatite." In *Production Technology of Faience and Related Early Vitreous Materials*, edited by M. S. Tite and A. J. Shortland, 23–36. Oxford: Oxford University School of Archaeology, 2008.

Vandiver 1983
Vandiver, P. "Appendix A: The Manufacture of Faience." In *Ancient Egyptian Faience: An Analytical Survey of Egyptian Faience from Predynastic to Roman Times*, edited by Alexander Kaczmarczyk and Robert E. M. Hedges, A1–A139. Warminster, England: Aris & Phillips, 1983.

Watterson 1984
Watterson, Barbara. *The Gods of Ancient Egypt*. New York and Bicester, UK: Facts on File Press, 1984.

Wilkinson 1971
Wilkinson, Alix. *Ancient Egyptian Jewellery*. London: Methuen & Co., 1971.

Wilkinson 1994
Wilkinson, Richard H. *Symbol and Magic in Egyptian Art*. London: Thames & Hudson, 1994.

Winlock 1934
Winlock, Herbert E. *The Treasure of El Lahun*. New York: The Metropolitan Museum of Art, 1934.

Winthrop 1883
Winthrop, Robert C. *Annual Address*. Boston: Annual Meeting of the Bunker Hill Monument Association, June 18, 1883.

Young-Sanchez 2014
Young-Sanchez, Margaret. *Cartier in the 20th Century*. New York and Colorado: Vendome Press and the Denver Art Museum, 2014.

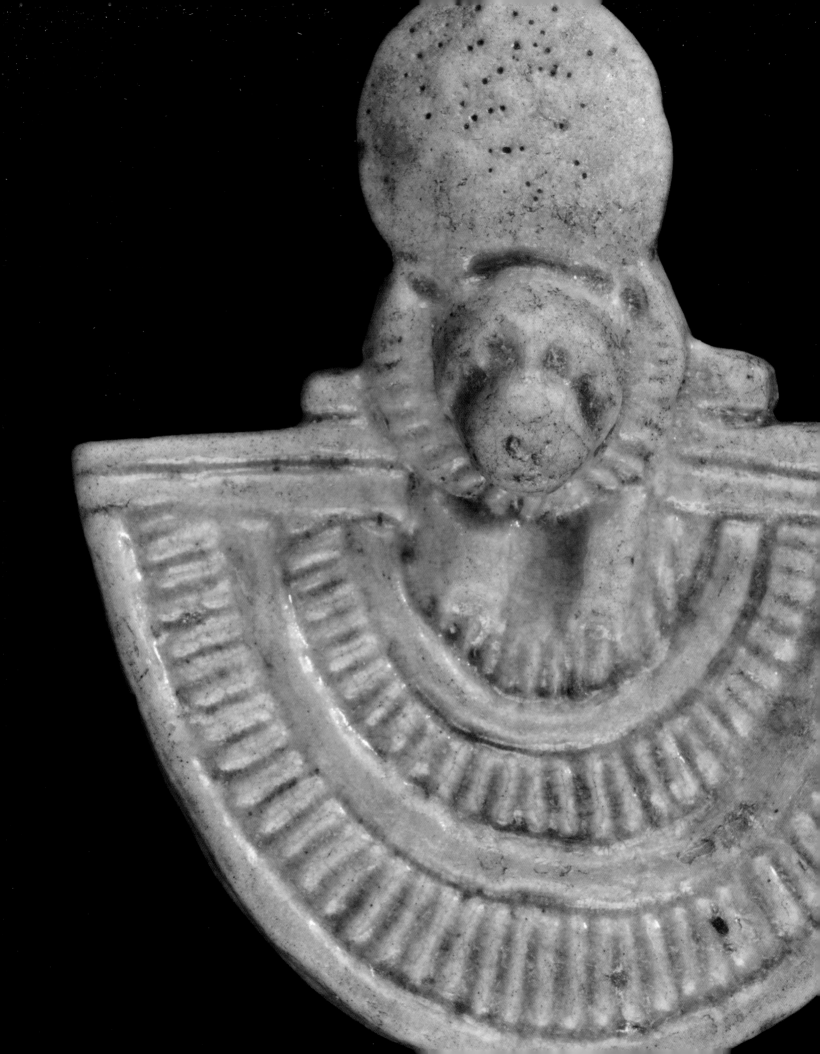

Additional Object Information

Amulets

1. Khnum
Late Period, 664–332 BCE
Faience
2.5 × 0.6 cm (1 × ¼ in.)
1925.649

2. Horus and Isis
Third Intermediate Period, ca. 1076–655 BCE
Faience
2.2 × 0.9 cm (⅞ × ⅜ in.)
1925.652

3. Khonsu
Late Period, 664–332 BCE
Faience
1.8 × 0.9 cm (¹¹⁄₁₆ × ⅜ in.)
1925.650

4. Sekhmet
Late Period, 664–332 BCE
Faience
3 × 0.7 cm (1 ³⁄₁₆ × ¼ in.)
1925.651

5. Horus
Late Period, 664–332 BCE
Faience
2.9 × 0.7 × 1 cm (1 ⅛ × ¼ × ⅜ in.)
1925.589

1. Baboon
Middle Kingdom, ca. 1980–1760 BCE
Faience
5.3 × 3 × 3 cm (2 ¹⁄₁₆ × 1 ³⁄₁₆ × 1 ³⁄₁₆ in.)
1925.614

2. Ibis
Late Period, 664–332 BCE
Faience
2.2 × 2.3 × 0.9 cm (⅞ × ⅞ × ⅜ in.)
1925.585

3. Cobra (Wadjet) Wearing Red Crown
New Kingdom, ca. 1539–1077 BCE
Red jasper
1.9 × 1.2 cm (¾ × ½ in.)
1925.646

4. Falcon
Third Intermediate Period, ca. 1076–655 BCE
Faience
1.8 × 0.7 cm (¹¹⁄₁₆ × ¼ in.)
1925.647

5. Baboon
Late Period, 664–332 BCE
Faience
1.2 × 0.7 cm (½ × ¼ in.)
1925.648

1. Seated Cat Amulets with Mummy Beads
Late Period, 664–332 BCE
Faience and unglazed pottery
2.5 × 42.5 cm (1 × 16 ¾ in.)
1925.534

2. Seated Cat
Late Period, 664–332 BCE
Bronze
2.3 × 0.8 × 1.5 cm (¹⁵⁄₁₆ × ⁵⁄₁₆ × ⁹⁄₁₆ in.)
1925.586

3. Seated Cat
Third Intermediate Period, ca. 1076–655 BCE
Faience
3.3 × 1.1 × 2.1 cm (1 ⁵⁄₁₆ × ⁷⁄₁₆ × ¹³⁄₁₆ in.)
1925.626

4. Bastet with Kittens
Late Period, 664–332 BCE
Faience
5.4 × 1.1 × 3.3 cm (2 ⅛ × ⁷⁄₁₆ × 1 ⁵⁄₁₆ in.)
1926.124

1. Pataikos
Late Period, 664–332 BCE
Faience
1.7 × 1 cm (¹¹⁄₁₆ × ⅜ in.)
1925.653

2. Pataikos
Late Period, 664–332 BCE
Faience
6.8 × 2.8 × 2.2 cm (2 ¹¹⁄₁₆ × 1 ⅛ × ⅞ in.)
1925.584

3. Pataikos Amulets with Ball Beads
Middle Kingdom, ca. 1980–1760 BCE
Faience and steatite
41.2 cm (16 ¼ in.)
1925.630

4. Bes
Late Period, 664–332 BCE
Faience
5.1 × 1.9 × 1 cm (2 × ¾ × ⅜ in.)
1926.123

5. Bes Head
Late Period, 664–332 BCE
Polychrome faience
3.8 × 2.6 cm (1 ½ × 1 in.)
1925.665

6. Bes
Late Period, 664–332 BCE
Faience
3.6 × 1.6 × 0.8 cm (1 ⁷⁄₁₆ × ⅝ × ⁵⁄₁₆ in.)
1926.113

7. Son of Horus (Qebehsenuef)
Late Period, 664–332 BCE
Faience
6.6 × 1.3 × 0.4 cm (2 ⅝ × ½ × ⅛ in.)
1925.620

8. Son of Horus (Imsety)
Late Period, 664–332 BCE
Faience
6.5 × 1.3 × 0.3 cm (2 ⁹⁄₁₆ × ½ × ⅛ in.)
1925.619

9. Son of Horus (possibly Hapi)
Late Period, 664–332 BCE
Faience
4.4 × 1.6 cm (1 ¾ × ⅝ in.)
1925.673

10. Heart
Middle Kingdom, ca. 1980–1760 BCE
Carnelian
2.1 × 1.4 × 1 cm (¹³/₁₆ × ⁹/₁₆ × ⅜ in.)
2001.126

11. Heart
New Kingdom, ca. 1539–1077 BCE
Carnelian
2.3 × 1.2 cm (⅞ × ½ in.)
1925.601

12. Heart
New Kingdom, ca. 1539–1077 BCE
Carnelian
1.3 × 0.8 cm (½ × ⁵/₁₆ in.)
1925.602

13. Heart
Late Period, 664–332 BCE
Feldspar
1.7 × 1 × 0.6 cm (¹¹/₁₆ × ⅜ × ¼ in.)
1926.109

14. *Wedjat*
Late Period, 664–332 BCE
Faience
2.4 × 3.5 cm (¹⁵/₁₆ × 1 ⅜ in.)
1925.672

15. Openwork *Wedjat*
Third Intermediate Period, ca. 1076–655 BCE
Polychrome faience
3.8 × 3.5 cm (1 ½ × 1 ⅜ in.)
1925.675

16. Multiple Eye
Third Intermediate Period, ca. 1076–655 BCE
Bichrome faience
2.8 × 2 cm (1 ⅛ × ¹³/₁₆ in.)
1925.609

17. *Wedjat*
Third Intermediate Period, ca. 1076–655 BCE
Bichrome faience
3.5 × 1 cm (1 ⅜ × ⅜ in.)
1925.590

18. *Wedjat*
Middle Kingdom to New Kingdom,
ca. 1980–1292 BCE
Carnelian
1.6 × 2.2 cm (⅝ × ⅞ in.)
2001.125

19. *Wedjat*
Late Period, 664–332 BCE
Faience
1.3 × 2 cm (½ × ¹³/₁₆ in.)
1925.599

20. *Wedjat*
Third Intermediate Period to Late Period,
ca. 1076–332 BCE
Lapis lazuli
2.2 × 2.4 cm (⅞ × ¹⁵/₁₆ in.)
1925.644

21. *Wedjat*
Late Period, 664–332 BCE
Faience
2.3 × 1 cm (⅞ × ⅜ in.)
1925.587

22. Aegis
Late Period, 664–332 BCE
Faience
4.1 × 3.8 × 1 cm (1 ⅝ × 1 ½ × ⅜ in.)
1925.582

23. Isis Knot
Late Period, 664–332 BCE
Faience
6.9 × 3 cm (2 ¹¹/₁₆ × 1 ³/₁₆ in.)
1925.386

Amulets of Power, Assimilation, and Fertility,
pp. 115–117

1. Lapis *Djed*
New Kingdom, ca. 1539–1077 BCE
Lapis lazuli
2.5 × 1.2 cm (1 × ½ in.)
1925.645

2. Faience *Djed*
Late Period, 664–332 BCE
Faience
9.2 × 2.4 × 1.2 cm (3 ⅝ × ¹⁵/₁₆ × ½ in.)
1925.562

3. Papyrus Column
Late Period, Dynasty 26, 664–525 BCE
Faience
5.4 × 1.3 cm (2 ⅛ × ½ in.)
1925.674

4. Monkey
Middle Kingdom, ca. 1980–1760 BCE
Carnelian
1.6 × 0.9 × 0.7 cm (⅝ × ⅜ × ¼ in.)
2001.123

5. Frog
New Kingdom, ca. 1539–1077 BCE
Glass
0.8 × 0.5 cm (⁵/₁₆ × ³/₁₆ in.)
1925.594

6. Monkey
Middle Kingdom, ca. 1980–1760 BCE
Carnelian
2 × 0.7 × 1.5 cm (¾ × ¼ × ⅝ in.)
2001.124

7. Double Lion
Third Intermediate Period, ca. 1076–655 BCE
Faience
1.6 × 2.1 × 0.4 cm (⅝ × ¹³/₁₆ × ⅛ in.)
2019.99.1

8. *Bolti* Fish
New Kingdom, ca. 1539–1077 BCE
Carnelian
3.4 × 2.6 × 0.7 cm (1 ⁵/₁₆ × 1 × ¼ in.)
1926.122

Amulets Mounted as Modern Scarf/Cravat Pins, p. 117

1. Baboon
Late Period, 664–332 BCE
Faience in modern gold mount
7.5 × 0.9 × 1.6 cm (2 $^{15}/_{16}$ × $^{3}/_{8}$ × $^{5}/_{8}$ in.)
1926.100

2. *Wedjat*
Third Intermediate Period to Late Period,
ca. 1076–332 BCE
Faience in modern gold mount
7.8 × 1.7 cm (3 $^{1}/_{16}$ × $^{11}/_{16}$ in.)
1926.98

3. *Wedjat*
Third Intermediate Period to Late Period,
ca. 1076–332 BCE
Faience in modern gold mount
5.3 × 1.1 cm (2 $^{1}/_{16}$ × $^{7}/_{16}$ in.)
1926.99

Scarabs

Hardstone Scarabs, pp. 120–121

1. Scarab
Possibly Second Intermediate Period,
ca. 1759–ca. 1539 BCE
Carnelian
1.1 × 0.9 cm ($^{7}/_{16}$ × $^{3}/_{8}$ in.)
1926.31

2. Scarab
Late Period, 664–332 BCE
Carnelian
1.6 × 1.1 cm ($^{5}/_{8}$ × $^{7}/_{16}$ in.)
1926.30

3. Scarab
Middle Kingdom, ca. 1980–1760 BCE
Carnelian
1.6 × 1.3 cm ($^{5}/_{8}$ × $^{1}/_{2}$ in.)
1926.28

4. Scarab
Middle Kingdom, ca. 1980–1760 BCE
Carnelian
1.6 × 1.3 cm ($^{5}/_{8}$ × $^{1}/_{2}$ in.)
1926.29

5. Scarab
Middle Kingdom, ca. 1980–1760 BCE
Carnelian
1.3 × 1.9 cm ($^{1}/_{2}$ × $^{3}/_{4}$ in.)
2001.122

6. Scarab
Possibly Etruscan, ca. 300 BCE
Carnelian
1.9 × 1.4 cm ($^{3}/_{4}$ × $^{9}/_{16}$ in.)
1926.33

7. Scarab
Possibly Etruscan, ca. 300 BCE
Carnelian
1.6 × 1.1 cm ($^{5}/_{8}$ × $^{7}/_{16}$ in.)
1926.32

8. Scarab
Middle Kingdom, ca. 1980–1760 BCE
Carnelian
1.5 × 1 cm ($^{9}/_{16}$ × $^{3}/_{8}$ in.)
1926.76

9. Scarab
Possibly New Kingdom, ca. 1539–1077 BCE
Carnelian
1.3 × 0.9 cm ($^{1}/_{2}$ × $^{3}/_{8}$ in.)
1926.73

10. Scarab
Possibly Late Period, 664–332 BCE
Carnelian
1.2 × 0.9 cm ($^{1}/_{2}$ × $^{3}/_{8}$ in.)
1925.603

11. Scarab
Middle Kingdom, ca. 1980–1760 BCE
Amethyst
1.1 × 0.8 cm ($^{7}/_{16}$ × $^{5}/_{16}$ in.)
1926.41

12. Scarab
Middle Kingdom, ca. 1980–1760 BCE
Amethyst
1.7 × 0.9 cm ($^{11}/_{16}$ × $^{3}/_{8}$ in.)
1926.39

13. Scarab
Middle Kingdom, ca. 1980–1760 BCE
Amethyst
1.8 × 1.3 cm ($^{11}/_{16}$ × $^{1}/_{2}$ in.)
1926.72

14. Scarab
Middle Kingdom, ca. 1980–1760 BCE
Amethyst
1.1 × 0.8 cm ($^{7}/_{16}$ × $^{5}/_{16}$ in.)
1926.40

15. Scarab
Middle Kingdom, ca. 1980–1760 BCE
Amethyst
1.6 × 1.1 cm ($^{5}/_{8}$ × $^{7}/_{16}$ in.)
1926.38

16. Scarab
Middle Kingdom, ca. 1980–1760 BCE
Amazonite
1.7 × 1.1 cm ($^{11}/_{16}$ × $^{7}/_{16}$ in.)
1926.37

17. Scarab
Middle Kingdom, ca. 1980–1760 BCE
Amazonite
1.8 × 1 cm ($^{11}/_{16}$ × $^{3}/_{8}$ in.)
1926.69

18. Scarab
Probably Middle Kingdom, ca. 1980–1760 BCE
Amazonite
1 × 0.7 cm ($^{3}/_{8}$ × $^{1}/_{4}$ in.)
1926.36

19. Scarab
Probably Middle Kingdom, ca. 1980–1760 BCE
Amazonite
1.4 × 1 cm ($^{9}/_{16}$ × $^{3}/_{8}$ in.)
1926.35

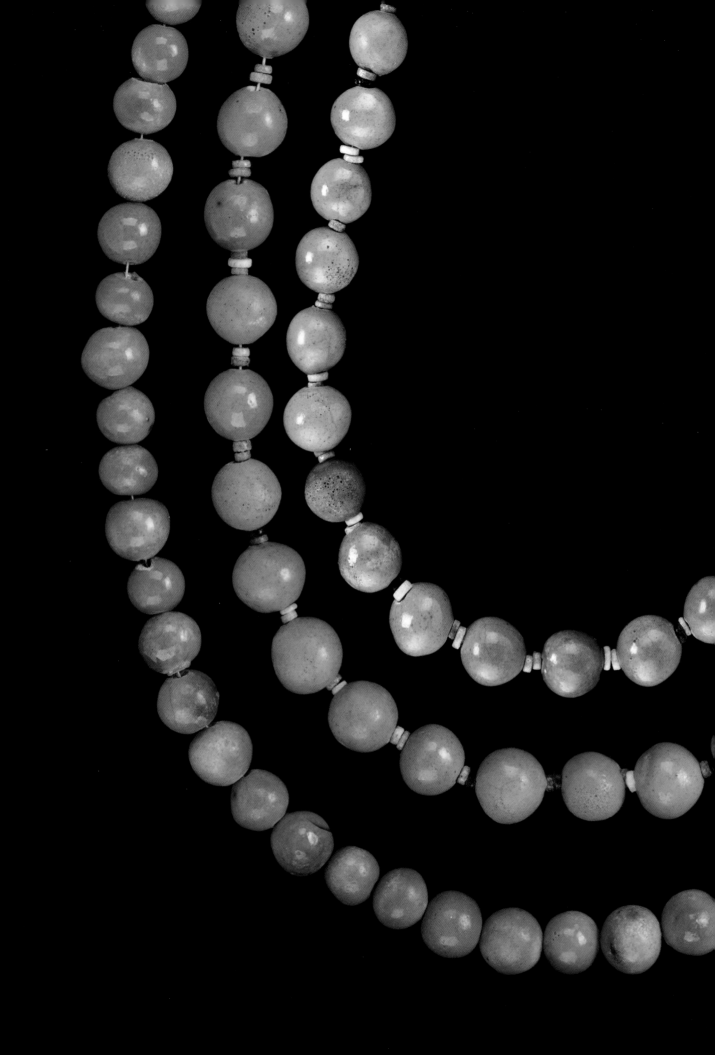

20. Scarab
Probably Middle Kingdom, ca. 1980–1760 BCE
Amazonite
1.6 × 1.1 cm (5/8 × 7/16 in.)
1926.34

21. Scarab
Middle Kingdom, ca. 1980–1760 BCE
Rock crystal
1.8 × 1 cm (11/16 × 3/8 in.)
1926.77

22. Scarab
Probably New Kingdom, ca. 1539–1077 BCE
Amazonite
1.6 × 1.1 cm (5/8 × 7/16 in.)
1926.67

23. Scarab
Middle Kingdom, ca. 1980–1760 BCE
Rock crystal
1.3 × 1 cm (1/2 × 3/8 in.)
1926.42

24. Scarab
Early Roman Period, 30 BCE–200 CE
Sapphire
1.2 × 0.9 cm (1/2 × 3/8 in.)
1926.43

25. Scarab
Probably New Kingdom, ca. 1539–1077 BCE
Lapis lazuli
1.3 × 0.9 cm (1/2 × 3/8 in.)
1926.71

26. Scarab
Middle Kingdom, ca. 1980–1760 BCE
Hematite
1.4 × 1 cm (9/16 × 3/8 in.)
1926.70

27. Scarab
Possibly Middle Kingdom, ca. 1980–1760 BCE
Hematite
1.1 × 0.8 cm (7/16 × 5/16 in.)
1926.74

28. Scarab
Second Intermediate Period,
ca. 1759–ca. 1539 BCE
Hematite
1.4 × 1 cm (9/16 × 3/8 in.)
1926.75

Glazed Steatite/Faience Scarabs, pp. 122–123

1. Scarab
New Kingdom, ca. 1539–1077 BCE
Steatite
0.8 × 0.5 cm (5/16 × 3/16 in.)
1926.58

2. Scarab
New Kingdom, ca. 1539–1077 BCE
Faience
1.4 × 1.1 cm (9/16 × 7/16 in.)
1926.61

3. Scarab
New Kingdom, ca. 1539–1077 BCE
Steatite
1.8 × 1.6 cm (11/16 × 5/8 in.)
1926.53

4. Scarab
Second Intermediate Period,
ca. 1759–ca. 1539 BCE
Steatite
2.4 × 1.8 cm (15/16 × 11/16 in.)
1926.50

5. Scarab
Probably New Kingdom, ca. 1539–1077 BCE
Steatite
1.5 × 1.1 cm (9/16 × 7/16 in.)
1926.45

6. Scarab
New Kingdom, ca. 1539–1077 BCE
Faience
1.5 × 1.1 cm (9/16 × 7/16 in.)
1926.54

7. Scarab
New Kingdom, ca. 1539–1077 BCE, or later
Steatite
1.1 × 0.7 cm (7/16 × 1/4 in.)
1926.78

8. Scarab
New Kingdom, ca. 1539–1077 BCE
Faience
1.8 × 0.7 cm (11/16 × 1/4 in.)
1926.59

9. Scarab
New Kingdom, ca. 1539–1077 BCE
Faience
1.8 × 1.7 cm (11/16 × 11/16 in.)
1926.68

10. Scarab
New Kingdom, ca. 1539–1077 BCE
Faience
2.3 × 1.7 cm (7/8 × 11/16 in.)
1926.51

11. Scarab
Third Intermediate Period to Late Period,
ca. 1076–332 BCE
Faience
1.6 × 1.7 cm (5/8 × 11/16 in.)
1926.56

12. Scarab
New Kingdom, ca. 1539–1077 BCE
Steatite
2.2 × 1.6 cm (7/8 × 5/8 in.)
1926.52

13. Scarab
Second Intermediate Period to New Kingdom,
ca. 1759–1077 BCE
Steatite
1.9 × 1.3 cm (3/4 × 1/2 in.)
1926.49

14. Scarab
Second Intermediate Period to New Kingdom,
ca. 1759–1077 BCE
Steatite
1.7 × 1.1 cm (11/16 × 7/16 in.)
1926.47

15. Scarab
New Kingdom, ca. 1539–1077 BCE
Steatite
0.6 × 0.5 cm (1/4 × 3/16 in.)
1926.63

16. Scarab
New Kingdom, ca. 1539–1077 BCE
Faience
1.3 × 1 cm (½ × ⅜ in.)
1926.48

17. Scarab
New Kingdom, ca. 1539–1077 BCE
Steatite
1.5 × 1.1 cm (⁹⁄₁₆ × ⁷⁄₁₆ in.)
1926.46

18. Scarab
New Kingdom, ca. 1539–1077 BCE
Faience
1 × 0.8 cm (⅜ × ⁵⁄₁₆ in.)
1926.64

19. Scarab
Third Intermediate Period, ca. 1076–655 BCE
Faience
0.9 × 0.6 cm (⅜ × ¼ in.)
1926.65

20. Winged Scarab
Third Intermediate Period, ca. 1076–655 BCE
Faience
6.4 × 15.1 cm (2 ½ × 5 ¹⁵⁄₁₆ in.)
1925.618

Glass Scarabs, p. 123

1. Scarab
Roman Period, ca. 100 BCE
Mottled glass
1.5 × 1.1 cm (⁹⁄₁₆ × ⁷⁄₁₆ in.)
1926.55

2. Scarab
New Kingdom, ca. 1539–1077 BCE
Glass
0.9 × 0.5 cm (⅜ × ³⁄₁₆ in.)
1926.57

3. Scarab
New Kingdom, ca. 1539–1077 BCE
Glass
1 × 0.7 cm (⅜ × ¼ in.)
1926.44

4. Scarab
New Kingdom, ca. 1539–1077 BCE
Glass
1.6 × 1 cm (⅝ × ⅜ in.)
1926.62

Scarabs Mounted as Modern Rings, p. 124

1. Lapis Lazuli Scarab Ring
New Kingdom, ca. 1539–1077 BCE
Lapis lazuli and gold (modern)
2.7 × 2.7 cm (1 ¹⁄₁₆ × 1 ¹⁄₁₆ in.)
1926.79

2. Faience Scarab Ring
New Kingdom, ca. 1539–1077 BCE
Faience and gold (modern)
2.6 × 2.1 cm (1 × ¹³⁄₁₆ in.)
1926.83

3. Carnelian Scarab Ring
Second Intermediate Period,
ca. 1759–ca. 1539 BCE
Carnelian and gold (modern)
2.7 × 2.5 cm (1 ¹⁄₁₆ × 1 in.)
1926.80

4. Faience Scarab Ring
Second Intermediate Period,
ca. 1759– ca. 1539 BCE
Faience and gold (modern)
2.8 × 2.5 cm (1 ⅛ × 1 in.)
1926.81

5. Amethyst Scarab Ring
Possibly Middle Kingdom, ca. 1980–1760 BCE
Amethyst and gold (modern)
2.5 × 2.9 cm (1 × 1 ⅛ in.)
1926.82

6. Carnelian Scarab Ring with a Human Face
New Kingdom, ca. 1539–1077 BCE
Carnelian and gold (modern)
2.6 × 2.2 cm (1 × ⅞ in.)
1926.85

7. Faience Scarab Ring
New Kingdom, ca. 1539–1077 BCE
Faience and gold (modern)
2.6 × 2.3 cm (1 × ⅞ in.)
1926.84

Scarabs Mounted as Modern Scarf/Cravat Pins, p. 124

1. Cravat Pin with Lapis Lazuli Scarab
Possibly New Kingdom, ca. 1539–1077 BCE
Lapis lazuli and gold (modern)
6.3 × 1.4 cm (2 ½ × ⁹⁄₁₆ in.)
1926.90

2. Cravat Pin with Faience Scarab
Possibly New Kingdom, ca. 1539–1077 BCE
Faience and gold (modern)
7.3 × 1 cm (2 ⅞ × ⅜ in.)
1926.88

3. Cravat Pin with Rock Crystal Scarab
Probably Middle Kingdom, ca. 1980–1760 BCE
Rock crystal and gold (modern)
8.5 × 1.4 cm (3 ⅜ × ⁹⁄₁₆ in.)
1926.92

4. Cravat Pin with Amethyst Scarab
Middle Kingdom, ca. 1980–1760 BCE
Amethyst and gold (modern)
8.2 × 1.1 cm (3 ¼ × ⁷⁄₁₆ in.)
1926.91

5. Cravat Pin with Steatite Scarab
New Kingdom, ca. 1539–1077 BCE
Steatite and gold (modern)
8.1 × 1.1 cm (3 ³⁄₁₆ × ⁷⁄₁₆ in.)
1926.87

6. Hardstone Scarab Cravat Pin
New Kingdom, ca. 1539–1077 BCE
Amazonite and gold (modern)
7 × 0.8 cm (2 ¾ × ⁵⁄₁₆ in.)
1926.89

Scaraboids and Design Amulets, p. 125

1. Duck with Reversed Head
New Kingdom, ca. 1539–1077 BCE
Carnelian
1.3 × 2.4 cm (½ × ¹⁵⁄₁₆ in.)
1926.107

2. Circular Design with Scarab Beetles and Flies
Late Period, 664–332 BCE
Glazed steatite
1.3 × 2.4 cm (½ × ⁵⁄₁₆ in.)
1926.111

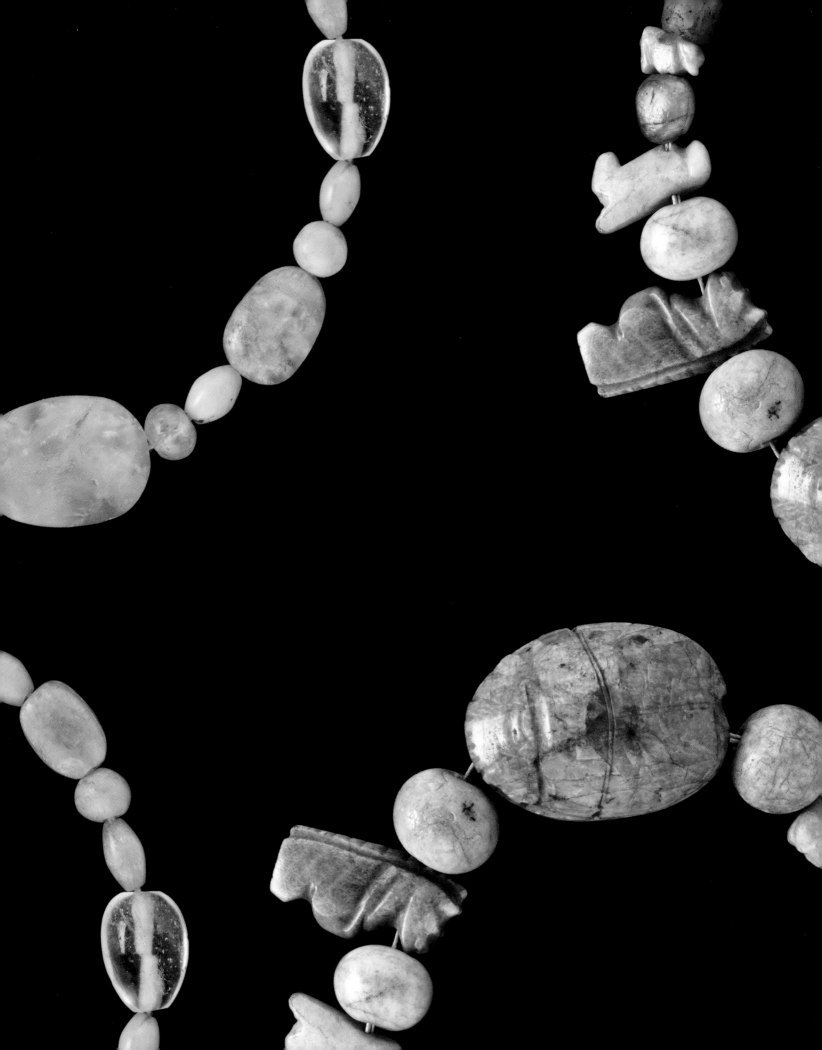

3. Cowroid
New Kingdom, ca. 1539–1077 BCE
Faience
1.6 × 0.6 cm (⅝ × ¼ in.)
1926.93

4. Fish
New Kingdom, ca. 1539–1077 BCE
Blue-glazed steatite
1.1 × 0.8 × 0.5 cm (⁷⁄₁₆ × ⁵⁄₁₆ × ³⁄₁₆ in.)
1926.94

Ancient Egyptian Jewelry

Faience Ball-Bead Necklaces, pp. 128–129

1. Ball-Bead Necklace
Middle Kingdom, ca. 1980–1760 BCE
Faience
Length: 84 cm (33 ¹⁄₁₆ in.)
1925.632

2. Ball-Bead Necklace
Middle Kingdom, ca. 1980–1760 BCE
Faience
Length: 52 cm (20 ½ in.)
1925.633

3. Ball-Bead Necklace
Middle Kingdom, ca. 1980–1760 BCE
Faience
Length: 56.6 cm (22 ⁵⁄₁₆ in.)
1925.634

Garnet Necklaces, pp. 130–131

1. Necklace
Middle Kingdom, ca. 1980–1760 BCE
Garnet
Length: 48.9 cm (19 ¼ in.)
2001.114

2. Necklace
Middle Kingdom, ca. 1980–1760 BCE
Garnet
Length: 48.3 cm (19 in.)
2001.139

Carnelian Bead and Amulet Necklaces, pp. 132–133

1. Necklace with Beads and Amulets
Middle Kingdom, ca. 1980–1760 BCE
Carnelian
Length: 78.7 cm (31 in.)
2001.133

2. String of Beads
Middle Kingdom, ca. 1980–1760 BCE
Carnelian and gold
Length: 14.3 cm (5 ⅝ in.)
2001.116

Amethyst Bead and Amulet Necklaces, pp. 134–135

1. Necklace
Middle Kingdom, ca. 1980–1760 BCE
Length: 69.9 cm (27 ½ in.)
2001.135

2. Bead Necklace
Middle Kingdom, ca. 1980–1760 BCE
Length: 54.6 cm (21 ½ in.)
2001.113

3. Necklace
Middle Kingdom, ca. 1980–1760 BCE
Length: 27 cm (10 ⅝ in.)
1925.640

Strings of Rock Crystal and Amazonite Beads and Amulets, p. 136

1. String of Beads and Amulets
Middle Kingdom, ca. 1980–1760 BCE
Amazonite (green feldspar)
Length: 19.7 cm (7 ¾ in.)
1925.641

2. String of Beads and Scarabs
Middle Kingdom, ca. 1980–1760 BCE
Rock crystal
Length: 25.7 cm (10 ⅛ in.)
1925.639

Strings of Gold Amulets, pp. 138–139

1. Falcon Necklace
Middle Kingdom, ca. 1980–1760 BCE
Gold
Length: 22.9 cm (9 in.)
2001.120

2. Bat-Head Necklace
Middle Kingdom, ca. 1980–1760 BCE
Gold
Length: 19.1 cm (7 ½ in.)
2001.121

Fish Pendants, pp. 140–141

1. Necklace with Fish Pendants and Cowrie Shells
New Kingdom, ca. 1539–1077 BCE
Carnelian and gold
Length: 54 cm (21 ¼ in.)
2001.117

2. Necklace with Fish Pendants
New Kingdom, ca. 1539–1077 BCE
Carnelian, various hardstones, and glass frit
Length: 21 cm (8 ¼ in.)
2001.119

1. Necklace with Poppy Pendants
New Kingdom, ca. 1539–1077 BCE
Carnelian and gold
Length: 74.3 cm (29 ¼ in.)
2001.115

2. String of Graduated Poppy Pendants
New Kingdom, ca. 1539–1077 BCE
Carnelian
Length: 47 cm (18 ½ in.)
2001.128

3. String of Poppy and Palmette Pendants
New Kingdom, ca. 1539–1077 BCE
Carnelian and glass frit
Length: 27 cm (10 ⅝ in.)
2001.118

4. Necklace of Flat Poppy Pendants
New Kingdom, ca. 1539–1077 BCE
Carnelian
Length: 13.7 cm (5 ⅜ in.)
2001.129

1. Ring with *Wedjat*
New Kingdom, ca. 1539–1077 BCE
Carnelian
2.5 × 2.3 × 1 cm (1 × ¹⁵/₁₆ × ⁷/₁₆ in.)
1926.96

2. Ring Inscribed for Amenhotep III
New Kingdom, Reign of Amenhotep III,
ca. 1539–1077 BCE
Faience
2.1 × 0.9 cm (¹³/₁₆ × ⅜ in.)
1925.580

3. Ring Inscribed for Amenhotep III
New Kingdom, Reign of Amenhotep III,
ca. 1539–1077 BCE
Faience
2 × 2 × 1 cm (¾ × ¹³/₁₆ × ⁷/₁₆ in.)
1925.581

4. Ring Inscribed for Tutankhamun
New Kingdom, ca. 1539–1077 BCE
Faience
2.2 × 2.5 cm (⅞ × 1 in.)
1926.95

5. Ring of Sekhmet
New Kingdom, ca. 1539–1077 BCE
Gold
2.2 × 2.2 × 0.8 cm (⅞ × ⅞ × ⁵/₁₆ in.)
1926.97

1. Bracelet
Roman Period, 100–300 CE
Polychrome glass
6.6 × 0.9 cm (2 ⁹/₁₆ × ⅜ in.)
1925.668

2. Bracelet
Roman Period, 100–300 CE
Polychrome glass
5.6 × 0.9 cm (2 ¼ × ⅜ in.)
1925.669

3. Bracelet
Roman Period, 100–300 CE
Polychrome glass
7.1 × 0.7 cm (2 ¹³/₁₆ × ¼ in.)
1925.670

1. Necklace with Beads and Amulets
New Kingdom to Late Period, ca. 1539–332 BCE
Faience
Length: 78.6 cm (30 ¹⁵/₁₆ in.)
1925.538

2. Mummy Beads
Late Period, 664–332 BCE
Faience
Length: 91.6 cm (36 ¹/₁₆ in.)
1925.542

1. Brooch Featuring a Skiff with Blossoms and an Ancient Plaquette
Unmarked, (plaquette) New Kingdom, ca. 1539–1077 BCE; (gold mount) late 1800s–early 1900s
Glazed steatite and gold (modern)
Brooch: 3.2 × 3.7 cm (1 ¼ × 1 ⁷/₁₆ in.)
Plaquette: 1.1 × 0.8 cm (⁷/₁₆ × ⁵/₁₆ in.)
1914.2

2. Brooch Featuring an Ancient Scarab in a Modern Winged Mount
Unmarked, (plaquette) New Kingdom, ca. 1539–1077 BCE; (gold mount) late 1800s–early 1900s
Glazed steatite and gold (modern)
2.6 × 3.6 × 1.5 cm (1 × 1 ⁷/₁₆ × ⁹/₁₆ in.)
1926.86

Cosmetics

1. Cosmetic Pot with Lug Handles
Middle Kingdom, ca. 1980–1760 BCE
Anhydrite
4 × 3.5 × 3.1 cm (1 ⁹/₁₆ × 1 ⅜ × 1 ¼ in.)
1925.345

2. Cosmetic Vessel with Lug Handles
Middle Kingdom, ca. 1980–1760 BCE
Anhydrite
4.1 × 4.4 cm (1 ⅝ × 1 ¾ in.)
1925.342

3. Cosmetic Vessel
Middle Kingdom, ca. 1980–1760 BCE
Anhydrite
4.8 × 7.2 cm (1 ⅞ × 2 ¹³/₁₆ in.)
1925.366

4. Kohl Pot and Lid
Middle Kingdom, ca. 1980–1760 BCE
Anhydrite
4.8 × 4 cm (1 ⅞ × 1 ⁹/₁₆ in.)
1925.360

5. Cosmetic Vessel
Middle Kingdom, ca. 1980–1760 BCE
Anhydrite
3.9 × 3.8 cm (1 $\frac{9}{16}$ × 1 $\frac{1}{2}$ in.)
1925.373

6. Kohl Pot
Middle Kingdom, ca. 1980–1760 BCE
Anhydrite
5.3 × 3.8 cm (2 $\frac{1}{16}$ × 1 $\frac{1}{2}$ in.)
1925.367

Middle Kingdom Vessels, pp. 168–169

1. Cylinder Jar
Middle Kingdom, ca. 1980–1760 BCE
Serpentine
5.5 × 4.8 cm (2 $\frac{3}{16}$ × 1 $\frac{7}{8}$ in.)
1925.370

2. Kohl Pot
Middle Kingdom, ca. 1980–1760 BCE
Granite with limestone inlay
4.1 × 4.7 cm (1 $\frac{5}{8}$ × 1 $\frac{7}{8}$ in.)
1925.371

3. Cylinder Jar
Middle Kingdom, ca. 1980–1760 BCE
Alabaster
6.4 × 5.1 cm (2 $\frac{1}{2}$ × 2 in.)
1925.351

New Kingdom "Egyptian Alabaster" Vessels, p. 171

1. Piriform Vase
New Kingdom, ca. 1539–1077 BCE
Alabaster
5.9 × 4.9 cm (2 $\frac{5}{16}$ × 1 $\frac{15}{16}$ in.)
1925.354

2. Kohl Pot on Stand
New Kingdom, ca. 1539–1077 BCE
Alabaster
6.3 × 3.7 cm (2 $\frac{1}{2}$ × 1 $\frac{7}{16}$ in.)
1925.357

3. Cylinder Vase
New Kingdom, ca. 1539–1077 BCE
Alabaster
6 × 6 cm (2 $\frac{3}{8}$ × 2 $\frac{3}{8}$ in.)
1925.352

Glass Vessels, pp. 172–173

1. Vessel
Roman Period, 30 BCE–200s CE
Glass
8.3 × 3.1 cm (3 $\frac{1}{4}$ × 1 $\frac{1}{4}$ in.)
1925.338

2. Bottle
Roman Period, 30 BCE–200s CE
Glass
4.3 × 2.8 cm (1 $\frac{11}{16}$ × 1 $\frac{1}{8}$ in.)
1925.327

3. Vessel
Roman Period, 30 BCE–200s CE
Glass
13.2 × 8 cm (5 $\frac{3}{16}$ × 3 $\frac{1}{8}$ in.)
1925.339

4. Vessel
Roman Period, 30 BCE–200s CE
Glass
6.4 × 2 cm (2 $\frac{1}{2}$ × $\frac{13}{16}$ in.)
1925.330

5. Bottle
Roman Period, 30 BCE–200s CE
Glass
2.2 × 1.8 cm ($\frac{7}{8}$ × $\frac{11}{16}$ in.)
1925.331

6. Bottle
Roman Period, 30 BCE–200s CE
Glass
5.4 × 4.1 cm (2 $\frac{1}{8}$ × 1 $\frac{5}{8}$ in.)
1925.340

Funerary Art

Pair of Shabtis, p. 182

1. Shabti
Third Intermediate Period, ca. 1076–655 BCE
Faience
11 × 3.6 × 2.3 cm (4 $\frac{5}{16}$ × 1 $\frac{7}{16}$ × $\frac{7}{8}$ in.)
1925.616

2. Shabti
Third Intermediate Period, ca. 1076–655 BCE
Faience
16 × 5.3 × 5.5 cm (6 $\frac{5}{16}$ × 2 $\frac{1}{16}$ × 2 $\frac{3}{16}$ in.)
1925.617

Set of Shabtis, pp. 182–183

1. Shabti
Ptolemaic Period, 305–30 BCE
Faience
12.8 × 3.5 × 2.6 cm (5 $\frac{1}{16}$ × 1 $\frac{3}{8}$ × 1 in.)
1925.563

2. Shabti
Ptolemaic Period, 305–30 BCE
Faience
13.6 × 4 × 3 cm (5 $\frac{3}{8}$ × 1 $\frac{9}{16}$ × 1 $\frac{3}{16}$ in.)
1925.564

3. Shabti
Ptolemaic Period, 305–30 BCE
Faience
12.6 × 4.1 × 3.1 cm (4 $\frac{15}{16}$ × 1 $\frac{5}{8}$ × 1 $\frac{1}{4}$ in.)
1925.565

4. Shabti
Ptolemaic Period, 305–30 BCE
Faience
10.8 × 3.6 × 2.5 cm (4 $\frac{1}{4}$ × 1 $\frac{7}{16}$ × 1 in.)
1925.566

5. Shabti
Ptolemaic Period, 305–30 BCE
Faience
10.8 × 3.6 × 2.3 cm (4 $\frac{1}{4}$ × 1 $\frac{7}{16}$ × $\frac{7}{8}$ in.)
1925.567

Painted Wood Figures, p. 187

1. Model of a Butcher
Middle Kingdom, ca. 1980–1760 BCE
Painted wood
12 × 7.4 × 11.9 cm (4 3/4 × 2 15/16 × 4 11/16 in.)
Museum Purchase, 1958.11

2. Model of a Cook
Middle Kingdom, ca. 1980–1760 BCE
Painted wood
11.8 × 4.8 × 8.2 cm (4 5/8 × 1 7/8 × 3 1/4 in.)
Museum Purchase, 1958.12

3. Model of a Stove
Middle Kingdom, ca. 1980–1760 BCE
Painted wood
5.1 × 7.2 cm (2 × 2 13/16 in.)
Museum Purchase, 1958.13

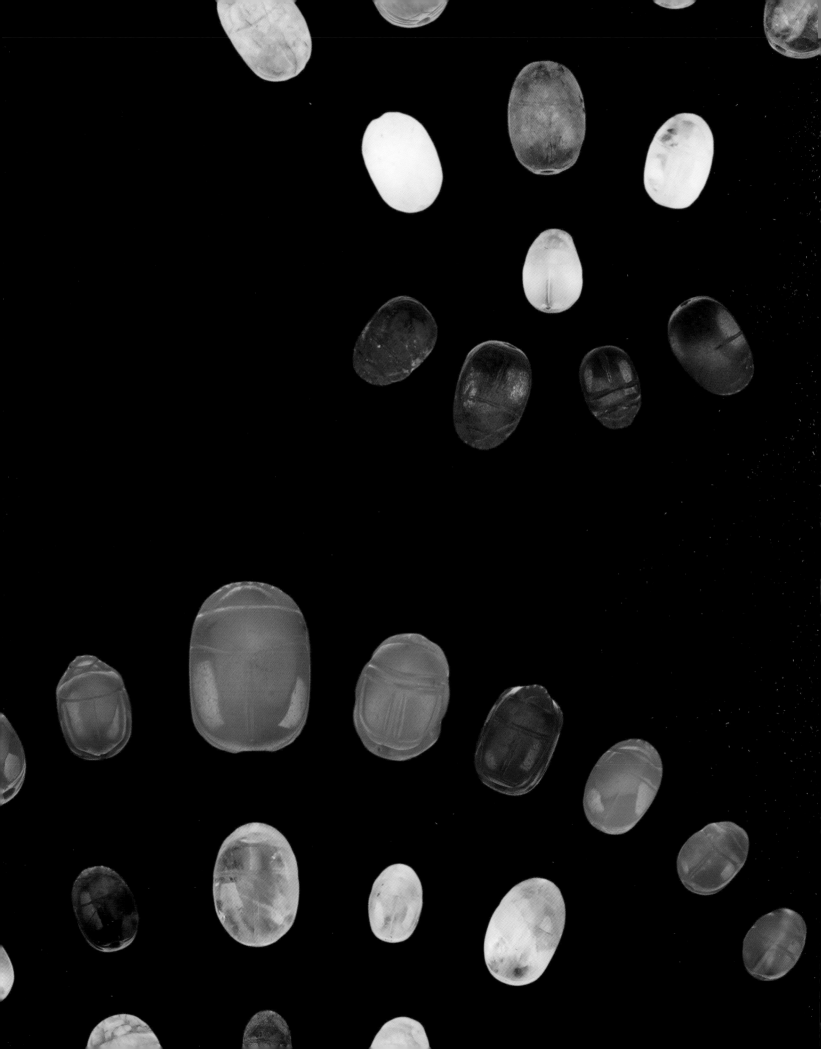

Index

Photo Credits

© Andrew Boyce: pp. 12–13

© The Trustees of the British Museum: fig. 14 p. 66

Brooklyn Museum: fig. 16 p. 70, fig. 25 p. 78

© Collection of the Corning Museum of Glass, Corning, NY:
fig. 17 p. 72

Detroit Institute of Art, Gift of Frederick K. Stearns /
Bridgeman Images: fig. 18 p. 100

Douglas Cairns, Gaspee Sales, RI: fig. 29 p. 81

Egyptian Exploration Society: fig. 8 p. 36, fig. 9 p. 37

Nils Herrmann, Cartier Collection © Cartier: fig. 28 p. 80

Massachusetts Historical Society, Boston, MA, USA/
Bridgeman Images: fig. 1 p. 32, fig. 2 p. 32, fig. 3 p. 33,
fig. 4 p. 33, fig. 5 p. 34, fig. 6 p. 34, fig. 10 p. 39

Metropolitan Museum of Art, New York: fig. 4 p.
56, fig. 5 p. 56, fig. 6 p. 57, fig. 13 p. 65, fig. 2 p. 87,
fig. 12 (right) p. 96, fig. 18 p. 100

Mineralogical & Geological Museum at Harvard
University: p. 69

Museum of Fine Arts, Boston: fig. 2 p. 54, fig. 3 p. 55,
fig. 9 p. 61, fig. 10 p. 62, fig. 15 p. 67,

New York Public Library: fig. 21 p. 76

Tiffany & Co. Archives 2020: fig. 22 p. 77, fig. 23 p. 77,
fig. 24 p. 78, fig. 26 p. 79, fig. 27 p. 79

Photograph courtesy of Sandro Vannini: fig. 7 p. 58